DREAMING

IN PRINT

A DECADE OF VISIONAIRE

1 SPRING APRIL 1991 We set out to create an album of inspiration, a limited-edition art and fashion publication no one had ever done before. SPRING was our first issue. It also provided us with the theme—innocence, a fresh beginning. We were inspired, in part, by Irving Penn's book of flowers, but convincing a photographer like Penn to let a fledgling publication like ours print even one of his images proved impossible. So the cover image was photographed by Stephen Gan, in natural daylight, with Cecilia Dean holding up the rose in front of a yellow background. (The beige blur towards the lower-right-hand corner of the frame is actually her out-of-focus hand.) Most of the contributing artists were friends, who lent their time, their work, and their unlimited support. No two pages were printed on the same paper stock because we were using all the printer's remnants. There are images on vellum (printed under stealth of night on a regular copy machine at the office of Stephen's sister Elaine), and artwork, like Ruben Toledo's insect story, done on plain old brown kraft paper. We couldn't afford the luxury of binding, so the issue is unbound, the loose pages forming a sort of folio of tear sheets of favorite images. Bill Cunningham (who contributed to our first fashion report), Annie Flanders (Stephen's former boss at *Details* magazine), and many others came over to Stephen's two-room apartment to help hand assemble a thousand copies, which we sold for ten dollars a piece. It was Bill who later showed us some of the very first illustrated fashion magazines, like *Gazette du Bon Ton*, as well as the albums of Paul Poiret, by Paul Iribe and Georges Lepape, which had also been printed portfolio-style on loose pages. When the issue came out, fashion designer Isaac Mizrahi sent us a note saying, "Congratulations, you're doing a *Flair* for the '90s!" We had no idea what he was talking about until Richard Martin and Harold Koda, then curators at the Fashion Institute of Technology, showed us editions of that legendary magazine several months later.

cover Stephen Gan

VISIONAIRE

No. 1

SPRING 1991

2 TRAVEL JULY 1991 From the beginning, we thought of Visionaire as an album of inspiration, a collection of our favorite images, which could take on any number of possible themes and formats. Looking at this issue (and later at Issue 6, THE SEA), people took to describing it as a cross between *National Geographic*, a children's book (*The Little Prince* comes to mind), and a fashion magazine. This seemed pretty accurate. At that time, travel—physical travel around the globe as well as metaphysical travel of the mind—seemed a natural topic for our second issue (more than a decade later, it's hard to remember why). But studying Mats Gustafson's Istanbul watercolors and Juan Botas's Spanish bullfight, we were reminded how one can find the romance of a faraway land, mythical or real, so alluring. With the first issue to show, it was much easier to convince artists and photographers we didn't know or had never worked with to let us publish their personal work. Mats Gustafson, Bruce Weber, Kenny Scharf, Serge Lutens, and Todd Oldham appeared in Visionaire for the very first time. The designer Isabel Toledo (who is also the wife of contributor Ruben Toledo) insisted on tying up each individual issue with black thread that mimicked the string Ruben had drawn around the sun on the cover. The *Washington Post* called it "Paper and ink as performance art"—as great a compliment then as it is today.

cover Ruben Toledo

3 EROTICA OCTOBER 1991 Jean-Paul Goude showed us his sexy drawings—naughty "doodles" stashed away in his *carnets intimes*. Also around that time, Mats Gustafson showed us a couple of the first male nudes he had ever done. And so the idea for our next issue was born. To us, the brown corrugated box sleeve held shut by a black elastic band represented a certain rawness and reminded us of those raunchy magazines that arrive in the mail in a plain brown-paper envelope. Mats also provided the "illustrated" writing for the cover. (We did not realize that he had also drawn the logos for *Interview* and *Mirabella*.) Inside, the credits were written out on a rickety old typewriter. They say sex sells, and EROTICA flew out of the stores (after Issue 1, it is the hardest issue to come by). In printing Steven Meisel's anatomical close-up we came to an important realization. Namely, that Visionaire was here to print things that no other publication would. We were worried that some of the material might shock our printers until we found out that they had dealt in hard-core pornography. Compared to what they were used to seeing, our stuff was nothing.

calligraphy Mats Gustafson case Stephen Gan

VISIONAIRE

No.3
FALL
1991

4 HEAVEN DECEMBER 1991 This is another very difficult issue to come by and to us it is perhaps the most precious. We can no longer recall which came first: coming up with the theme or seeing the *Saints* of Pierre et Gilles. Either way, their work makes up the backbone—and the cover—of this issue. We got very excited by the idea that an issue could come together with parts from all over the world. Todd Oldham's embroidered-silk clouds, for example, were made in India, and we then cut them up together in his New York showroom. Certainly, the surprise of the issue came from Martin Margiela. He did not want to reveal to us what his contribution was going to be. One day the doorbell rang, we answered it only to find four huge boxes that had been sent via FedEx from Paris. Inside were a thousand bags of white confetti—one for each copy of HEAVEN. We could not have imagined a nicer Christmas present. Needless to say, at this point we were finding our collaborations with fashion designers to be a source of both encouragement and inspiration.

cover Pierre et Gilles confetti Martin Margiela and Maison Margiela

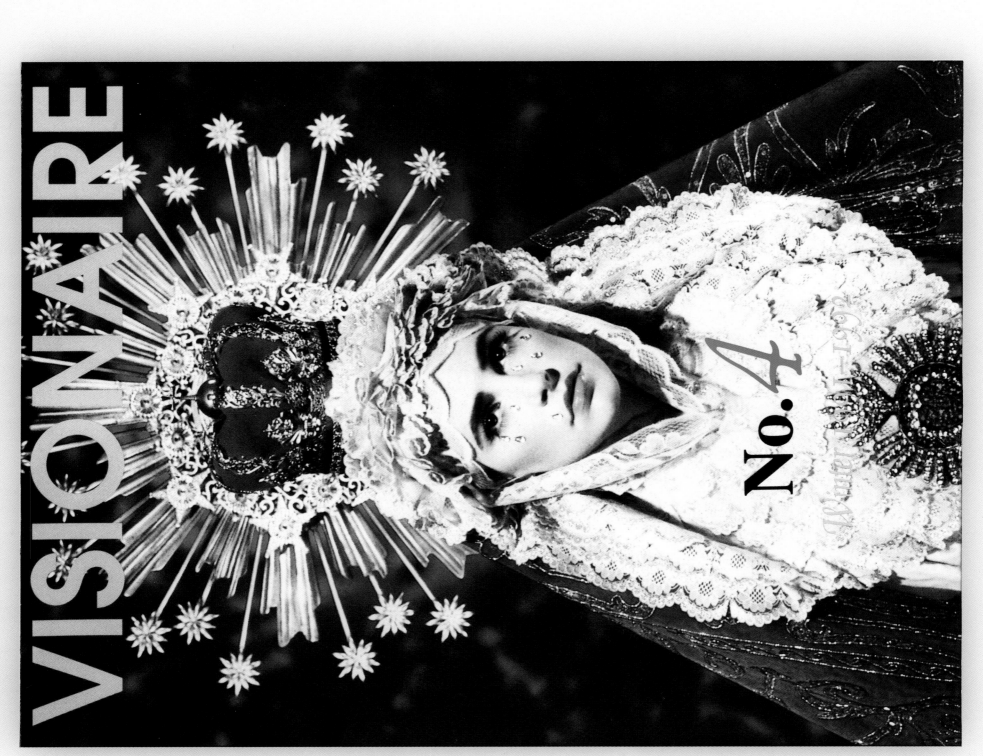

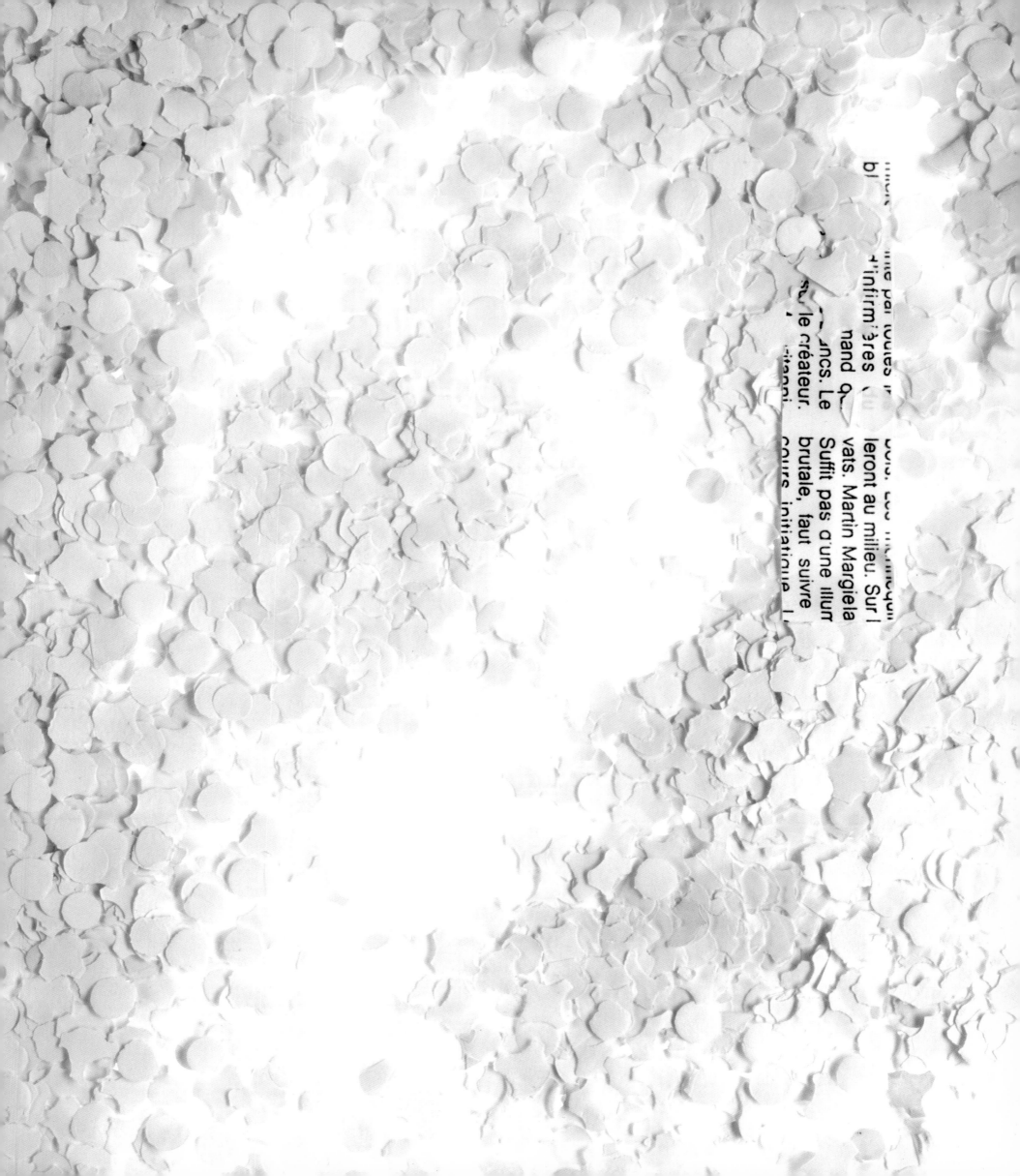

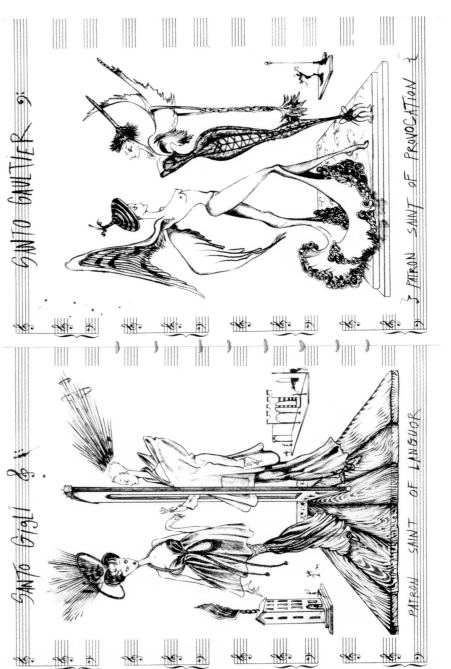

We were inspired by the invitation from the team at Visionaire in the first place and foremost by the great freedom of expression that Visionaire offered and affords creative people. This freedom is not only born from the ever changing format of Visionaire but also from the total lack of creative boundaries inherent in the very concept and realization. It became immediately clear to us that it would have been too limiting to restrict our realization of heaven or paradise to a single image. We preferred to solicit a gesture, a moment of joy, rather than a pictorial representation of what heaven could mean. The confetti, for us, could offer a moment of joy and abandon to anyone who received it. We were very happy with the outcome and satisfied that the challenge given to us was met head on. It is always very pleasant and surprising to see how so many creative people express themselves on the same theme. MARTIN MARGIELA AND MAISON MARGIELA

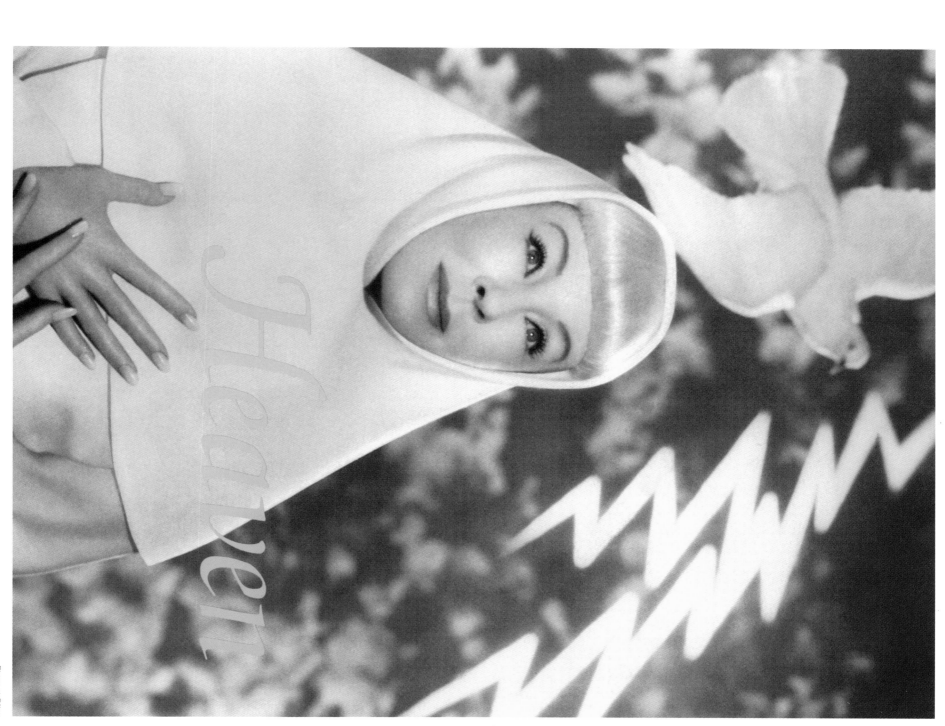

Pierre et Gilles

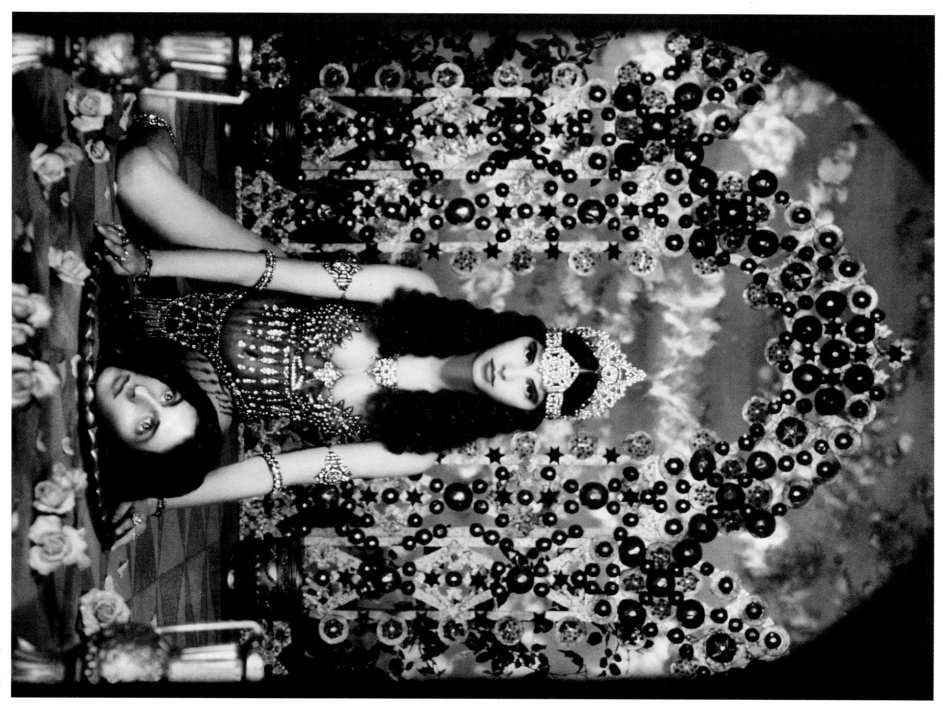

5 THE FUTURE MARCH 1992 We imagined the future and doing something that lived up to our name, Visionaire. With this issue, we moved up to 1,500 copies and started experimenting with more expensive materials, like Plexiglas, which had to be bent by hand to make the hard sleeves that held the contents. A die-cut circle on the cover enabled different images to "peek" through, so we delivered issues with different first pages to different stores: a reduced version of Stephane Sednaoui's collaged faces, a Mats Gustafson spiral, a face photographed by Steven Meisel, and a fashion shot by Satoshi Saikusa. All took their turn as part of our cover on bookshelves. THE FUTURE was also the first time we used metallic foil stamping on the cover, which is something we've done again and again since then.

cover Stephane Sednaoui

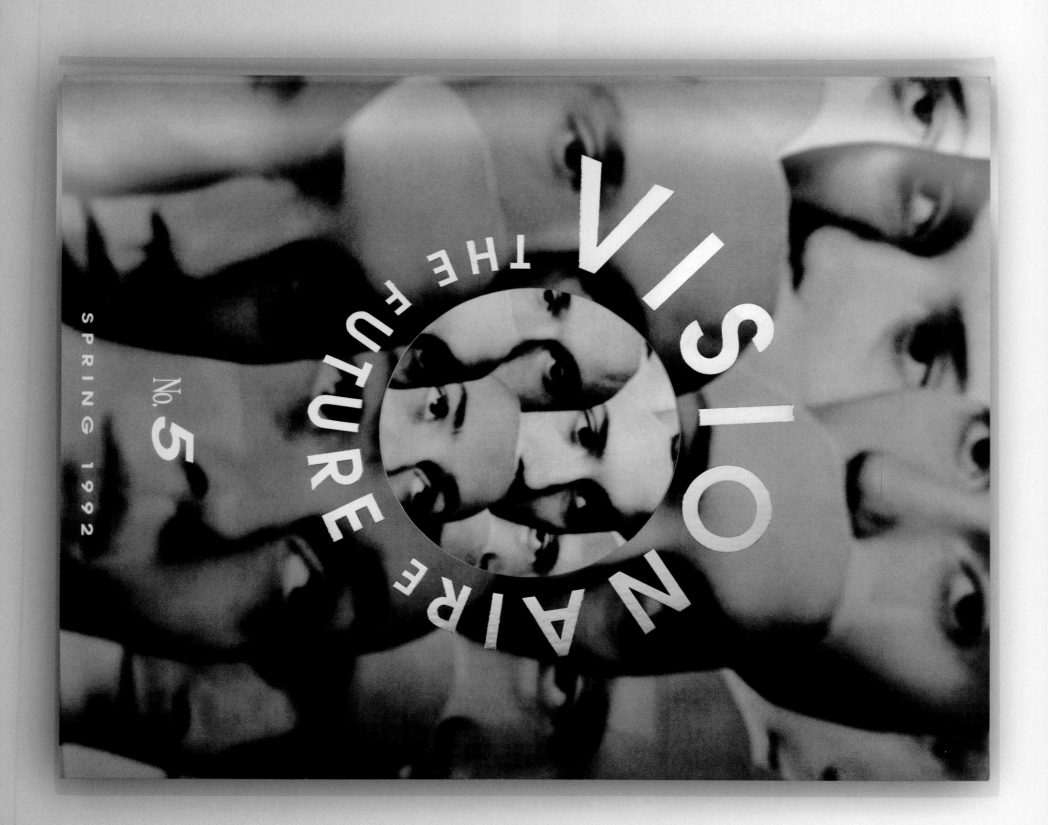

VISIO
NAIRE

THE FUTURE
THE FUTURE

SPRING 1992

No. 5

VISIONAIRE

The Sea

No. **6**

SUMMER 1992

6 THE SEA JULY 1992 We were inspired by ancient Oriental watercolor books, Egyptian manuscripts, and children's books, and imagined a long, long, (long) accordion fold with pop-ups. The construction, devised by Stephen, consisted of two panels glued back to back with the pop-up elements built right in. This seemed to be a clever, streamlined strategy as it avoided having to print on both sides, but in the end, it was complicated enough that the factory could only produce fifty or so copies a day. At any rate, it was our first issue that could be considered "bound" or "booklike" because all the pages were connected. We tracked down a special underwater photographer who gave us the close-up of the fish on the cover, and for our own part, spent quite a bit of time at the New York Aquarium tracking the white whale that appears inside. The issue ends with a metal fish made for us by the Spanish designer Sybilla, which came embedded in a foam-core final page. When the issue appeared, people asked us, "if this is a fashion publication, why all the pictures of fish?" We tried to explain it with answers like "Visionaire is a fashion publication that is not only about clothes." A self-fulfilling prophecy?

cover: Jeff Roman fish sculpture Sybilla

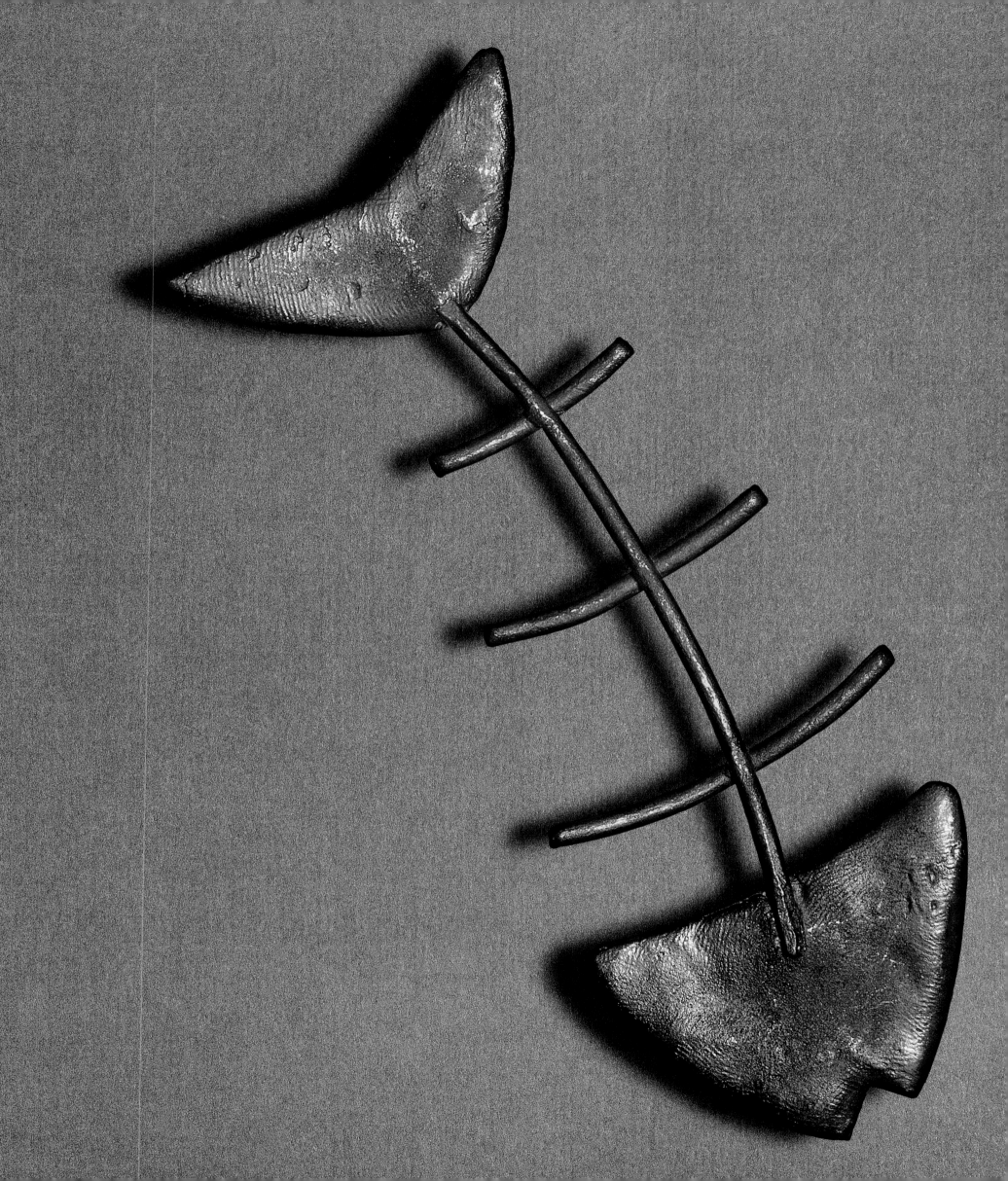

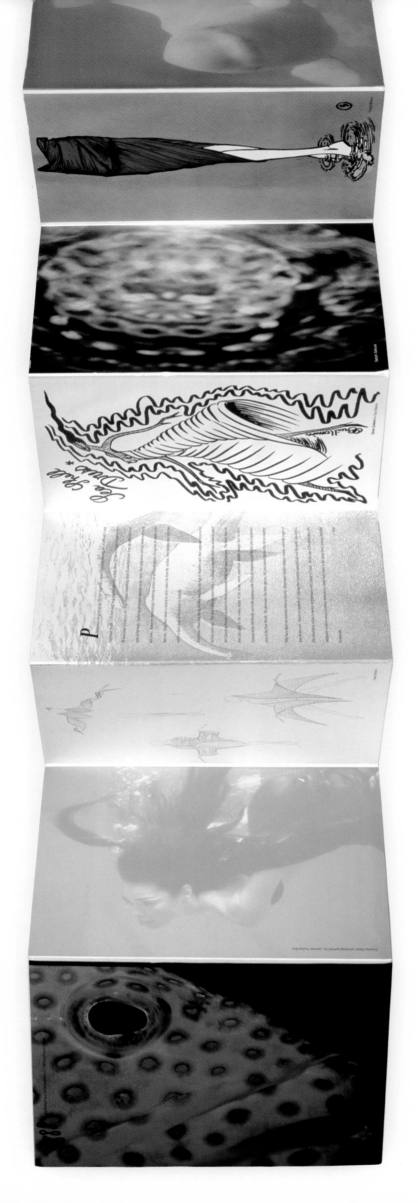

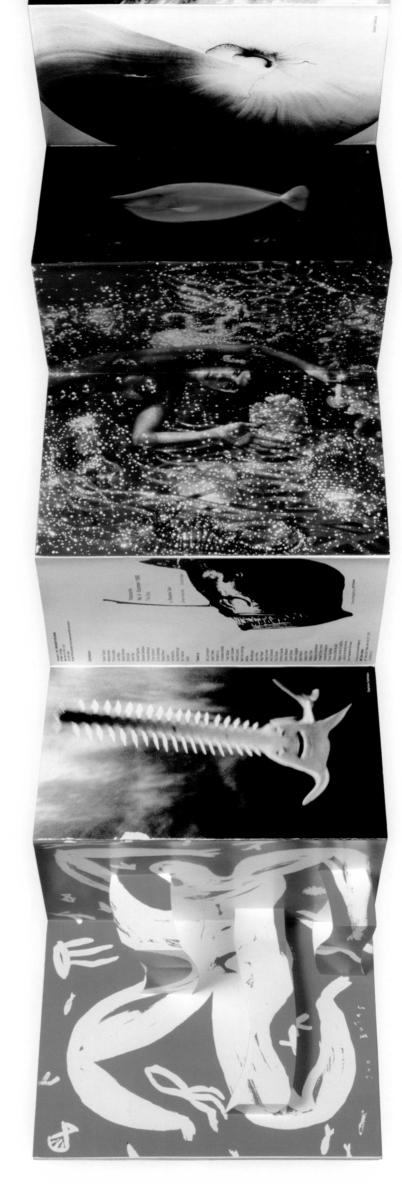

top, from left: Jeff Rotman, James Kaliardos, Frederic Molenac, Cecilia Dean, Olivier Guillemin, Satoshi Saikusa, Françcois Berthoud, Stephen Gan, JC de Castelbajac, Francis Giacobetti (photo), Adeline André (text), Guzman, Don Freeman

bottom, from left: Juan Botas, Stephane Sednaoui, contributors' page, Pierre et Gilles, Stephen Gan, Satoshi Saikusa, Edward Maxey, Bernard Figueroa, Ruben Toledo, Sybilla

42

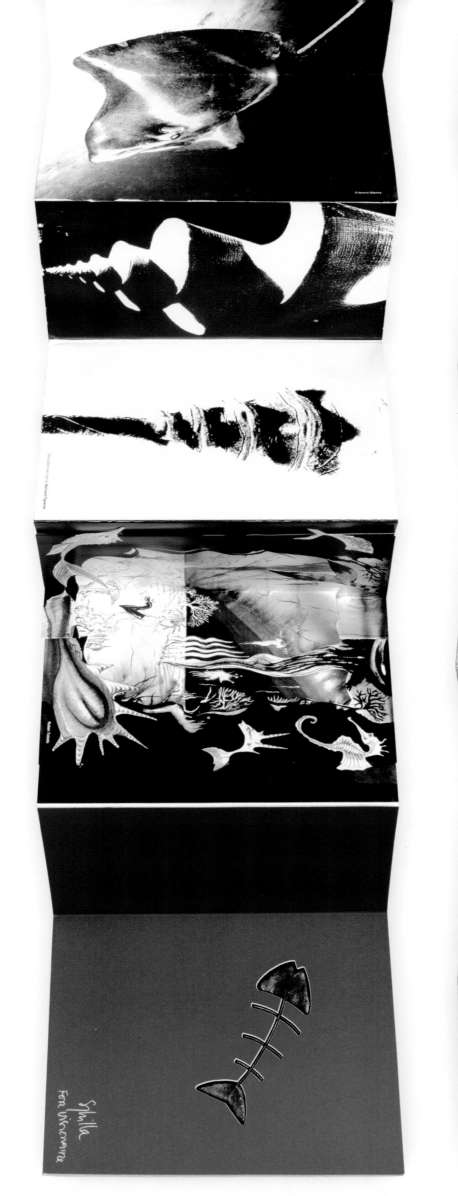

I love the vision of Visionaire. I admire them! It's inspiring, challenging, fun. I couldn't ask for more. As for the sea? It's a deep part of my life. For this issue, I made one brooch. It was a fish bone in rusted iron. Each piece was made by hand and the process of getting just the right amount of rustiness was surreal—but not more surreal than the idea of putting a piece of iron in a magazine! SYBILLA

7 BLACK OCTOBER 1992 With BLACK, Visionaire doubled in size—and also in price. The issue was inspired by the season's all-black Comme des Garçons collection (which Bill Cunningham photographed and we got to print); by Edward Gorey's macabre cartoons (which we also got to print, sometimes as eerie backdrops for the Comme des Garçons dresses); and by artist Antoni Tàpies, who was having a retrospective at the Museum of Modern Art around that time (whose work we did not get permission to print). BLACK was about darkness, the night, shadows, and what you may or may not see when you squint your eyes. A traditional artist's portfolio case, tied with three black ribbons, provided the concept for the packaging. The die-cut letters were based on tears Stephen had made with scrap paper that enabled, once again, different first pages to peek through the cover. Bruce Weber's photograph of a cowboy in the night; François Berthoud's sinister fashion illustrations, and 1,500 original photo collages (yes, 1,500 were made by hand, with no two alike!) by young photographer Kristina Colovic, were among the most cherished contributions to this issue.

cover Mats Gustafson and Stephen Gan

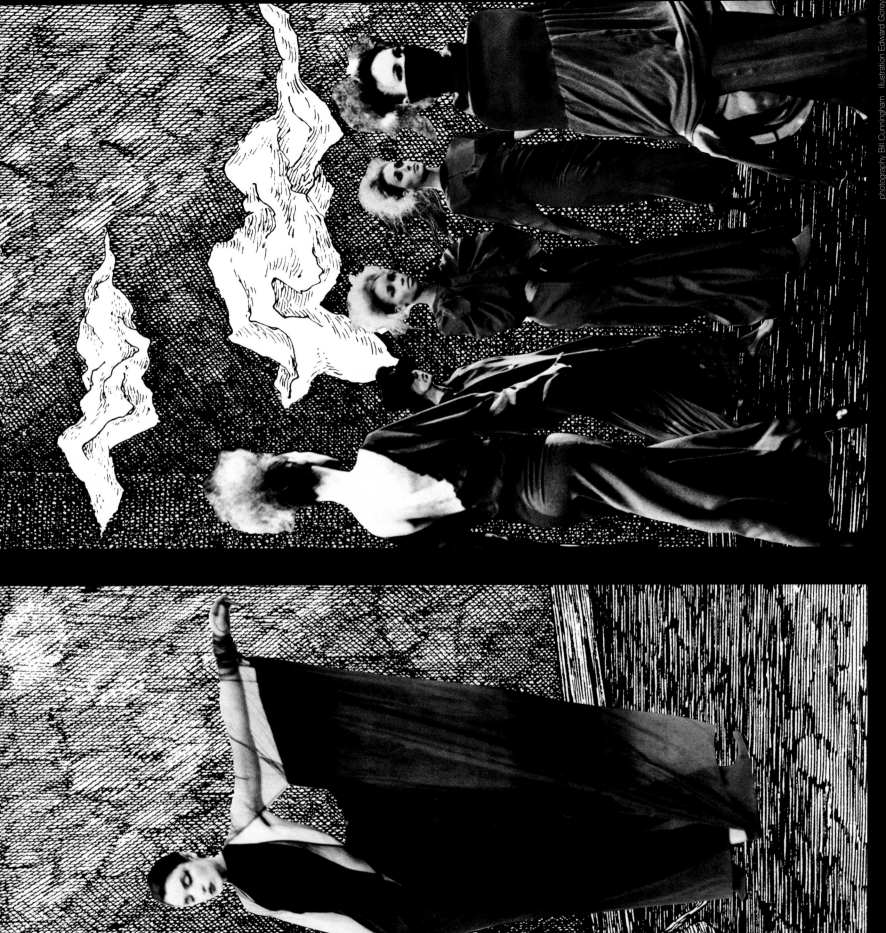

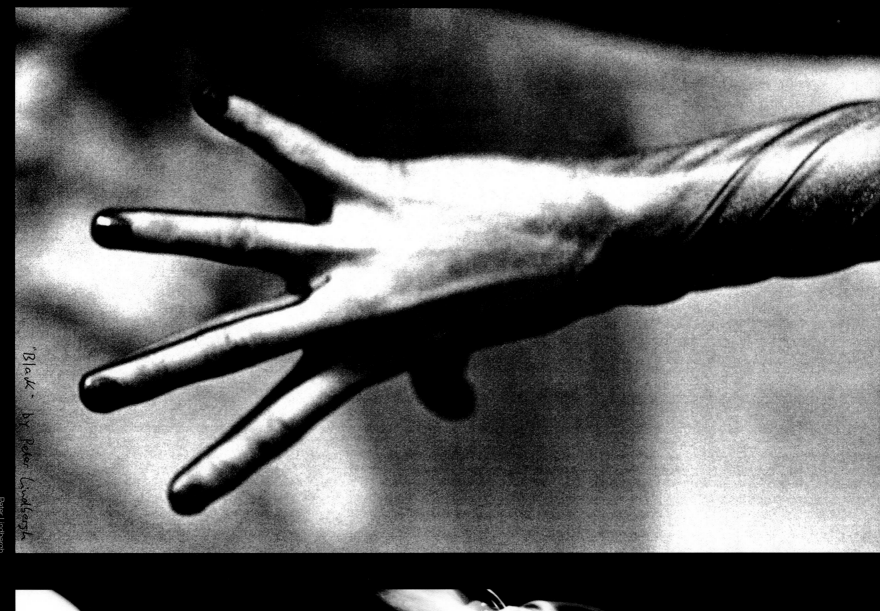

"Black" by Peter Lindbergh

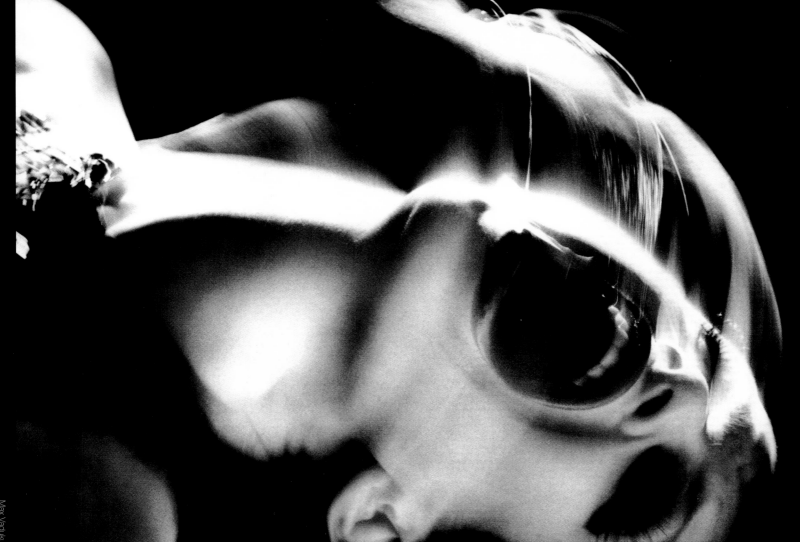

Even when I was a kid, black was my favorite color. Most kids back home in Pennsylvania were into yellow. This was way before the word gothic became part of the suburban vocabulary. Because I drew in charcoal and wore clothes the color of shadows, people thought I sniffed glue. Maybe I was fond of glue, because when I was asked to contribute to the BLACK issue of Visionaire, I remembered clearly the dark hallways of my high school years. Black doesn't have to be black; it's more about the tricks it plays on your mind. I took this image at a 4-H Club fair in Montana. I saw my neighbors' kids proudly riding their cutting horses and showing off their cows. It was a long, hot summer, and I had watched on our small television every Western that John Ford ever made. Even though I wasn't in Monument Valley, the sun falling behind the Crazy Mountains made everyone look like a young John Wayne in a dream. BRUCE WEBER

Bruce Weber

8 THE ORIENT MARCH 1993 This issue came out quite late because we had all spent our Christmas holiday in Thailand getting "inspired." We realize now what a privilege it was to be able to take so much time off in those days! The type on the cover was executed in three different metallic foils, and the case was tied closed using different colored ribbons, so the reader was able to choose the color combination that he liked best. The issue, which opens left to right, in true Eastern manner, explores the splendor of the mythical East (imagine *Madama Butterfly* or *Turandot*), from portraits of Chinese opera singers and Indian maharajas to the burgeoning Orientalist trend in fashion at the time. We took full advantage of the long, narrow panoramic format (one we would repeat in later issues) to provide the perfect showcase for Stephane Sednaoui's breathtaking photographs of India.

cover Jessica Tan Gudnason case Stephen Gan

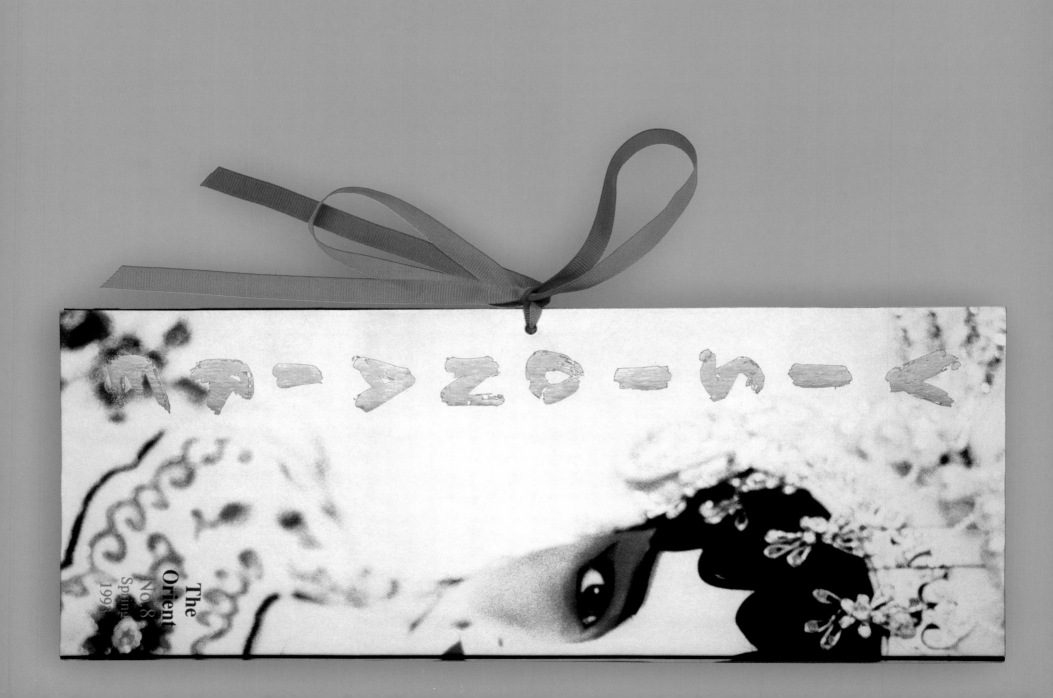

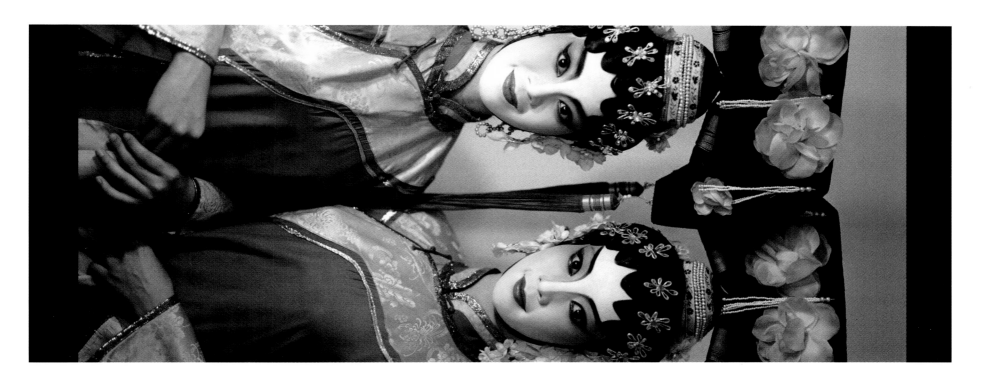

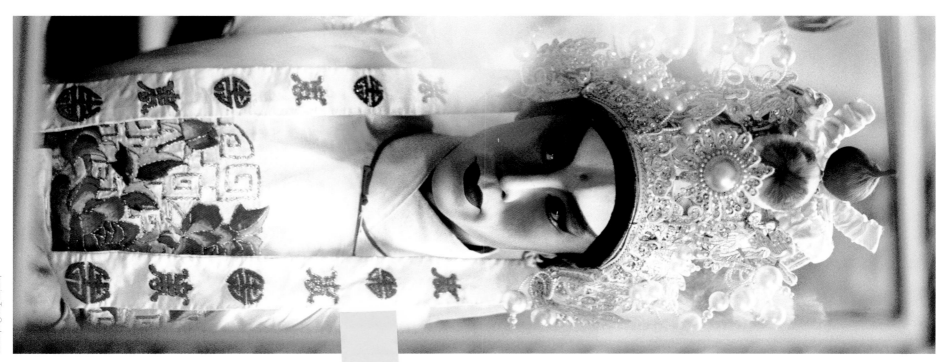

visionaire

no.9 summer 1993

faces

visionaire

no.9 summer 1993

faces

9 FACES JUNE 1993 We envisioned FACES as an album of one hundred portraits. The die-cut cookie-cutter technique we love so much came into full play and enabled Mario Testino, Cecilia Dean, and everyone else in the issue to claim, "My face is on the cover." Inside, Raymond Meier, who is known for stunning still lifes, created a face using a rock, a shell, and a paper clip and

artist Andres Serrano contributed an image from his *Morgue* series. Portraits by Mats Gustafson and Ruben Toledo of women such as Liz Tilberis, Grace Coddington, and Vivienne Westwood remain some of the lasting favorites. Other contributors to this issue included Martin Margiela, Ann Demeulemeester, David Seidner, Stephane Sednaoui, Steven Klein, and Lady Bunny.

case Greg Foley covers from left: Dwight Marshall, Mats Gustafson, John Scarisbrick, Stephen Gan

faces

visionaire no.9 summer 1993

faces

visionaire no.9 summer 1993

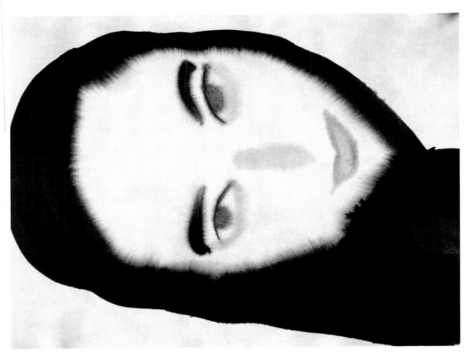

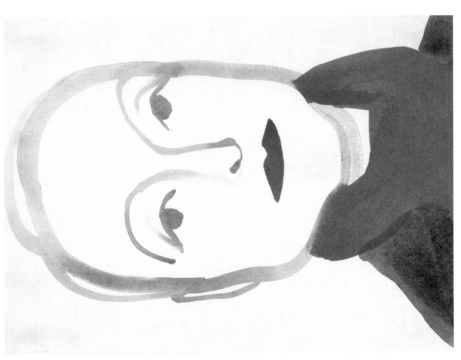

Mats Gustafson top from left: Isabel Toledo, Liz Tilberis, Mika Mizutani bottom from left: Claude Brouet, Bethann Hardison, Grace Coddington

I first started working with Visionaire at issue 2. It was the perfect thing for me. I'm in a lot older than those guys. I'd been through a whole other decade of fashion. To work with younger people on a different kind of magazine gave me a new kind of energy. I had almost had it with fashion. It was great to have a new perspective, a new look at it. Everyone wants to have a forum where the marriage of art and fashion can exist. Most of the time it doesn't work, but Visionaire has created a platform where it can. And that's how I look at the world myself. The theme of this particular issue was FACES. I had been working on a series of portraits at that time, and I had work in progress and work I had completed. What's most fun about Visionaire is that often their theme goes with what you're already working on. Other times the theme provides a challenge to do something new or something that you've always wanted to do. FACES is an endless subject. I had to narrow it down, and I wanted it to relate somewhat to fashion. I made portraits of women I had a personal or professional relationship with. I made them all ageless—it is the freedom of the artist to do this. I wanted them to have a resemblance, but a stylized resemblance. The portrait of Liz Tilberis was the one that I was least happy with. I knew Liz from British Vogue, and at the time she had just started at Harper's Bazaar. When we did this portrait, she had not yet been diagnosed with cancer. It was amazing to me how gracefully and courageously she came out with her struggle with the disease; a dazzling inner beauty came out in her, and this is what's missing in my portrait. I always felt that I'd like to do another one of her with that courageous beauty she expressed. MATS GUSTAFSON

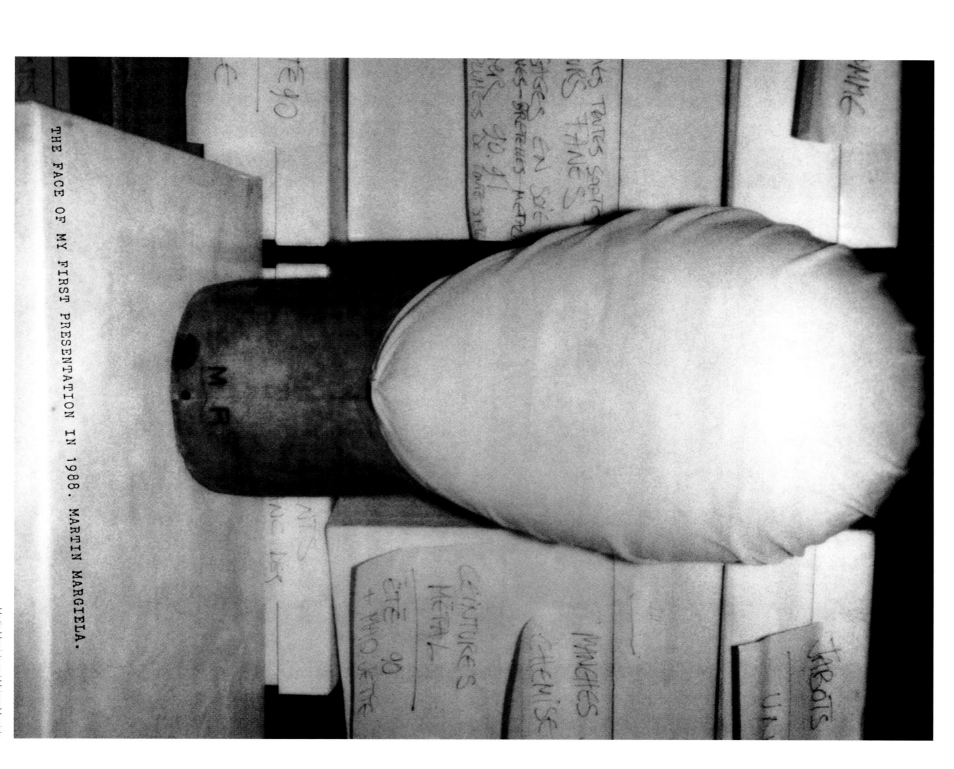

THE FACE OF MY FIRST PRESENTATION IN 1988. MARTIN MARGIELA.

Martin Margiela and Maison Margiela

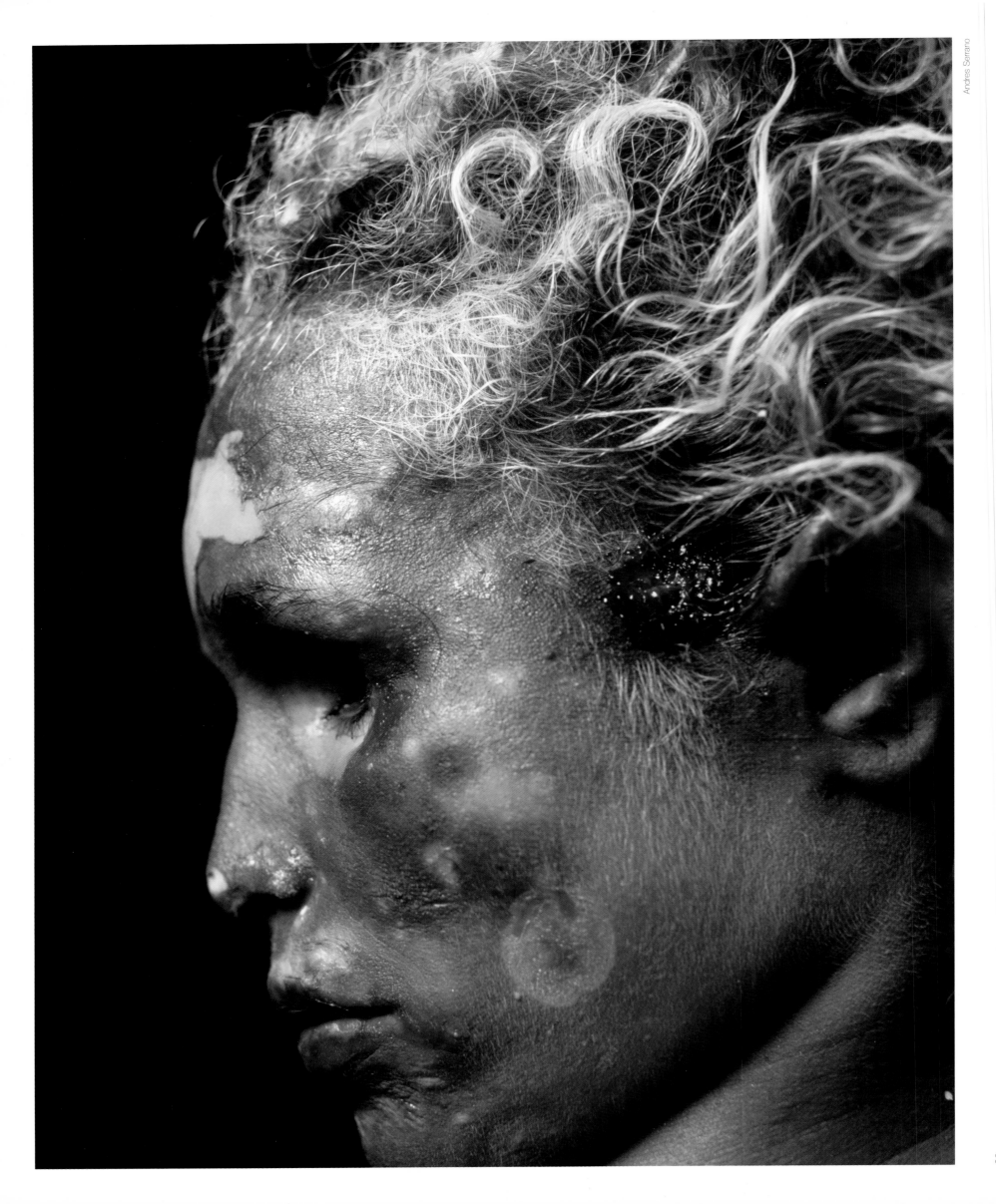

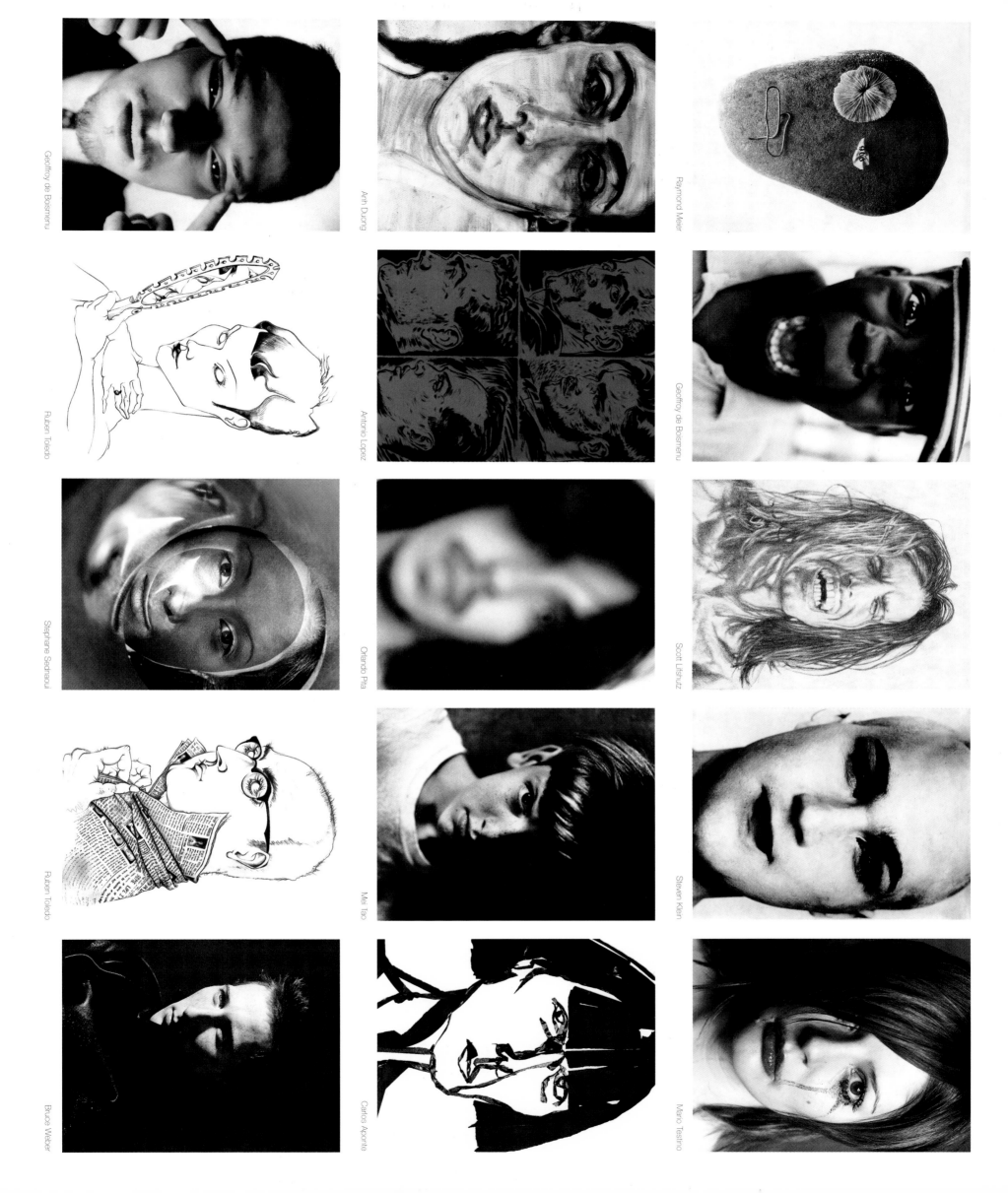

Geoffroy de Boismenu

Anh Duong

Raymond Meier

Ruben Toledo

Antonio Lopez

Geoffroy de Boismenu

Stephane Sednaoui

Orlando Pita

Scott Lifshutz

Ruben Toledo

Mei Tao

Steven Klein

Bruce Weber

Carlos Aponte

Mario Testino

10 THE ALPHABET DECEMBER 1993 Greg Foley, who had been collaborating with us on our cover designs since the day he graduated from Rhode Island School of Design, really went to town with this one. He sliced out every letter he fancied and created one gigantic collage that we then photographed and printed. The concept was exciting: The B from *Harper's Bazaar* and the V from *Vogue* could all appear on our cover, along with many other famous typefaces. In the end it even became a kind of guessing game: "Name that logo." The only drawback was that for months after this cover was made, there was not a magazine, phone book, or cereal box in the house that didn't have a hole cut out of it. The holographic metallic foil stamping also made this one of our most memorable covers. As for the contents, we assigned each of the contributing artists a different letter of the alphabet. For the first time, the directions were very specific, but even so, many artists took the challenge and proceeded as if they had been given carte blanche. The painter Alexis Rockman invented a new animal in P is for Porcupig, and Juan Gatti created a massive three-panel collage, S is for Sex Sea.

cover Greg Foley

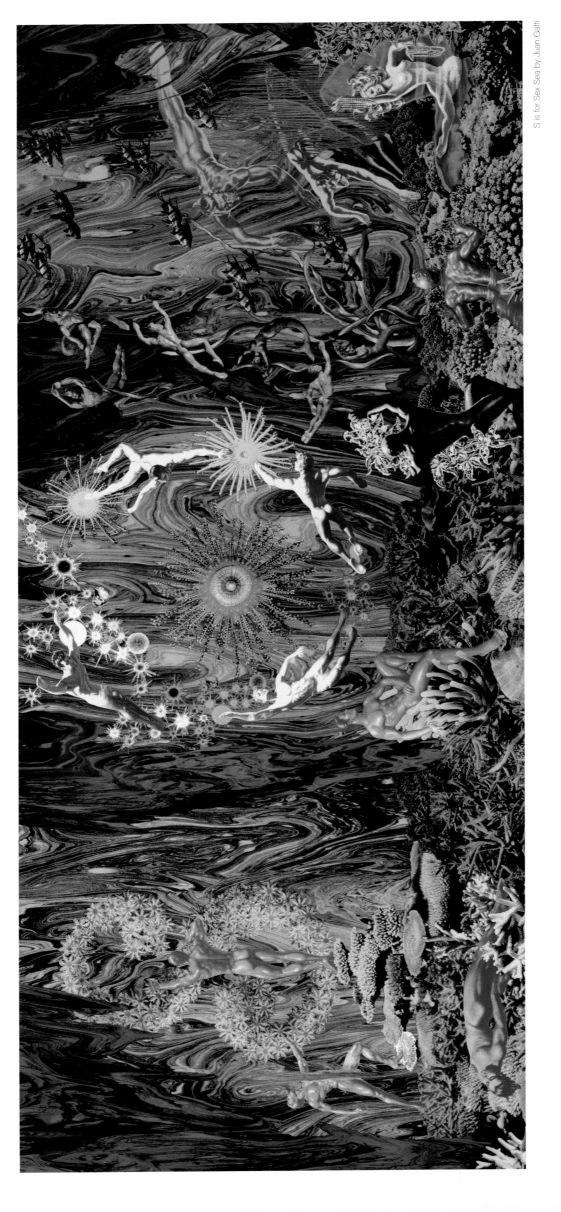

S is for Sex Sea by Juan Gatti

To me, to make Visionaire is to make reality into a utopia or to have accomplished a dream. For THE ALPHABET, I was motivated by the idea of working as a visual DJ, using the medium of collage to remix and sample images. I was given a choice of letters, and I chose S. At the time, I was fascinated by underwater images, and I had the idea of making a kind of musical number: Esther Williams meets Jacques Cousteau. Sex Sea sounded to me like sexy. I found the images from different old magazines and books. When I laser copied them, they veered off into different colors. Then, of course, piece by piece, flower by flower, and little fish by little fish, the collage was cut and glued together by hand. I think it took four people seven or eight days to finish! JUAN GATTI

64

13

13

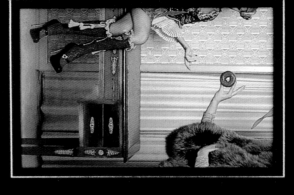

GLUTTONY
貪食
LA GOURMANDISE

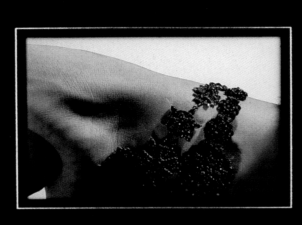

GREED
貪欲
L'AVARICE

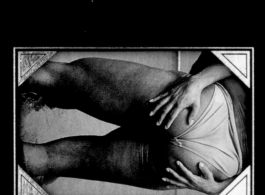

SEVEN DEADLY SINS
七つの大罪
LES SEPT PECHES CAPITAUX

ERDE • FRANK DECARO • RUBEN TOLEDO •

INEZ VAN LAMSWEERDE • JEAN-PHILIPPE DELHOMME • BAI

I thought Lust was a very interesting topic. I made a selection from pictures I had already done. I wanted to do something very funny with the pictures—lustful but ironic. This was one of the early issues, I think. I had known about Visionaire before Stephen and Cecilia contacted me and thought it was a very interesting way to work. I don't publish a lot; a lot of your best images are never really seen. Visionaire doesn't publish ordinary images. They print those odd little pictures that you really like. MARY ELLEN MARK

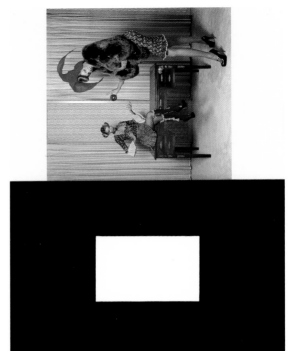

Gluttony by Inez van Lamsweerde and Vinoodh Matadin

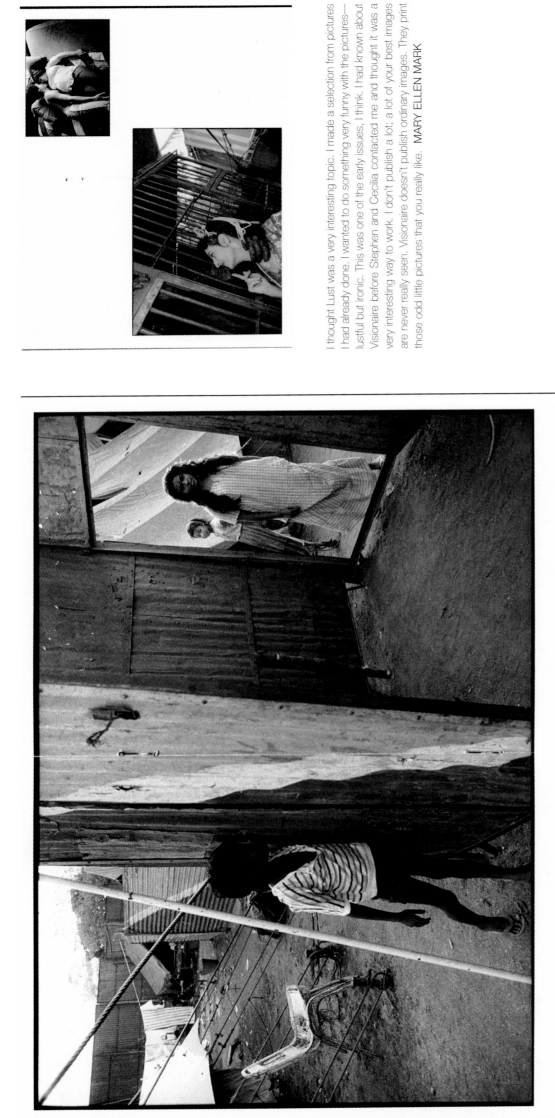

Lust by Mary Ellen Mark

Gluttony by Roxanne Lowit

Greed by Inez van Lamsweerde and Vinoodh Matadin

Envy by Inez van Lamsweerde and Vinoodh Matadin

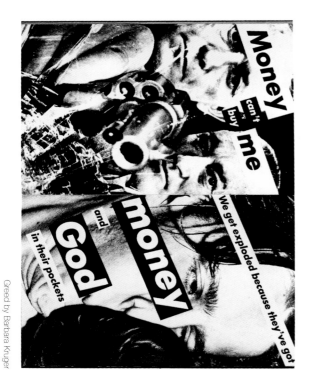

Greed by Barbara Kruger

Sloth by Inez van Lamsweerde and Vinoodh Matadin

Wrath by Mario Sorrenti

14 HYPE! APRIL 1995 New York City newsstands jam-packed with a million titles, all screaming for attention, gave us the idea for the theme. HYPE! was our parody of the media and a spoof on the tabloids. Visionaire had become known as the fashion magazine that didn't carry advertising, but this issue was full of "ads." Funny slogans and tag lines were added to every page. Mario Testino's photo of a Brazilian swim team became a "Drink Milk" campaign. Sixties supermodel Veruschka posed for a make-believe tabloid cover, Helmut Lang sent in an ad for Helmut Lang Industries ("The only company that loves you") photographed by David Sims. There was plenty of editorial content, too. Vogue's editor-at-large, Hamish Bowles, penned an interior-design piece about the "vintage suburban" family room of TV sitcom character Roseanne. Inez van Lamsweerde and Vinoodh Matadin shot a story on New York fashion that featured models computer montaged into New York interiors. We don't know if people got the joke (to this day, some people think that all the ads are real), but we laughed ourselves silly.

cover Inez van Lamsweerde and Vinoodh Matadin graphics Greg Foley

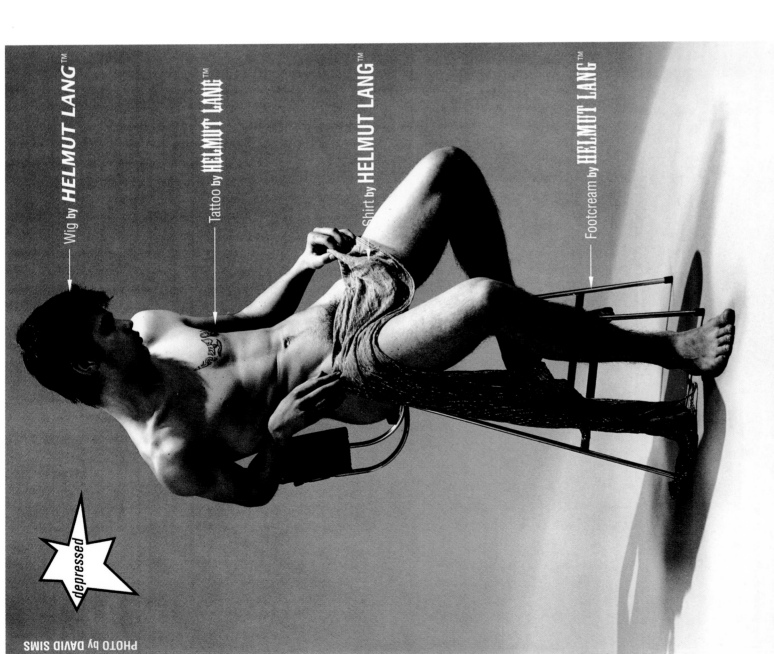

Wig by **HELMUT LANG**™

Tattoo by **HELMUT LANG**™

Shirt by **HELMUT LANG**™

Footcream by **HELMUT LANG**™

depressed

PHOTO by DAVID SIMS

HELMUT LANG INDUSTRIES™. the only COMPANY that LOVES you

HELMUT LANG INDUSTRIES™. the only COMPANY that cares for YOU

I was first introduced to Visionaire several years ago through Helmut Lang. My work for HYPE! was the first thing I did with the team. Helmut had just asked to see some images I had done with Melanie Ward. We were just testing out ideas then. I showed some work to Helmut and he had this idea to create a fragrance ad. I don't know if doing a fragrance was even a twinkle in Helmut's eye at that point, but I thought what he did was very witty. I made the photographs intentionally to look different from pictures I was doing at the time. I mean, I don't do nudes, so that in itself is sort of unusual. It's a hard concept to deal with photographically, especially when the subject is a guy. I think for me it was an opportunity to play at being someone else. I liked the idea of being another kind of photographer. There is a slightly amateurish quality to the photos that makes them look old-fashioned, not like the work of a young British artist. It's a bit of role-playing. Visionaire was the first magazine that would publish work in a dedicated fashion. There is no dogma about it, no commercial mores, and that's why it is especially funny that the shot is a fake ad, which appears in an issue called HYPE! The irony now is that Helmut is finally doing perfume ads, but the fake fragrance ad is nothing like the real ones. It was just a sort of experimentation, having fun with our work. DAVID SIMS

The reclining girl sports a
cheerful outfit by Marc Jacobs
while the reclining girl
shows a sophisticated
sexupiness by Isabel Toledo.
Their shoes are by
Bernard Figueroa and Marc
Jacobs, Respectively.

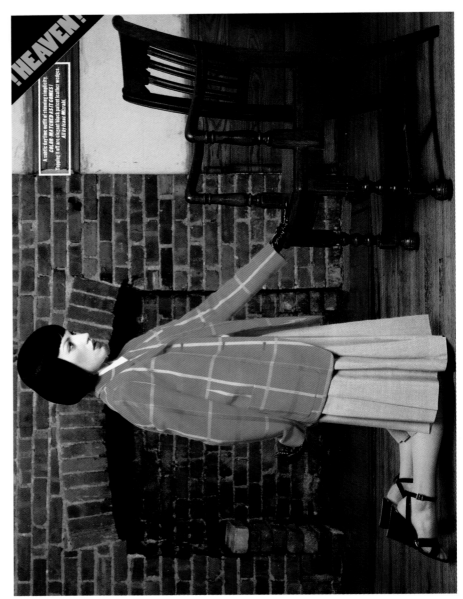

!.HEAVEN.!

A subtle tartan outfit of stunning simplicity
CLAIR BY ROBERT ALTAGEN.!
Topping it off are elegant black patent leather wedges
All by Isaac Mizrahi.

We had dropped our book off at Visionaire in 1993, when we were in New York as artists in residence at P.S.1, but had gotten no response. Then in 1994, after we had our first editorial in *The Face*, Stephen called us when he was in Amsterdam. We met and became friends instantly. He invited us to come to New York and shoot the cover and inside pages for Visionaire's new issue. We stayed with our friend the designer Ronald van der Kemp and turned his loft into a studio for the shoot. The idea was to shoot only American clothes in over-decorated, soap opera–style interiors, since the whole issue would be based on America's hunger for celebrities and their every move. True or false would have to stay undetermined. It's all just hype. The way we worked to achieve this kind of hyperreality was to shoot the backgrounds first separately and later add the studio shot of the girl to the picture on computer. It looked very real and technically perfect, but one could sense that something wasn't right, creating tension and surrealism. We shot all over town in the strangest places to get the right bourgeois, American–style interiors for our backgrounds, from furniture showrooms on Lexington Avenue to the Staff USA building. Then Visionaire set us up to see all the American–designer collections and choose outfits. We did castings for the models and shopped for additional styling items. We then had the girls pose in our "studio," with the light matching the light of the interiors shot earlier. James did the makeup, and Jimmy Paul made the wigs for the girls. Together with our computer operator, Karin Spijker, back in Amsterdam, we then montaged the girls into the background images. We sat Leah down on the bed and put her hand on the wooden chair in the basement. It was probably one of the first series that was really shot specifically for Visionaire, and Stephen, James, and Cecilia made our time in New York very special. We ended up staying in their house/office, sleeping in Stephen's bed, and having endless breakfasts and parties on and off all through 1995. We have worked on many projects together and have proudly contributed to nearly every issue of Visionaire since then. INEZ VAN LAMSWEERDE AND VINOODH MATADIN

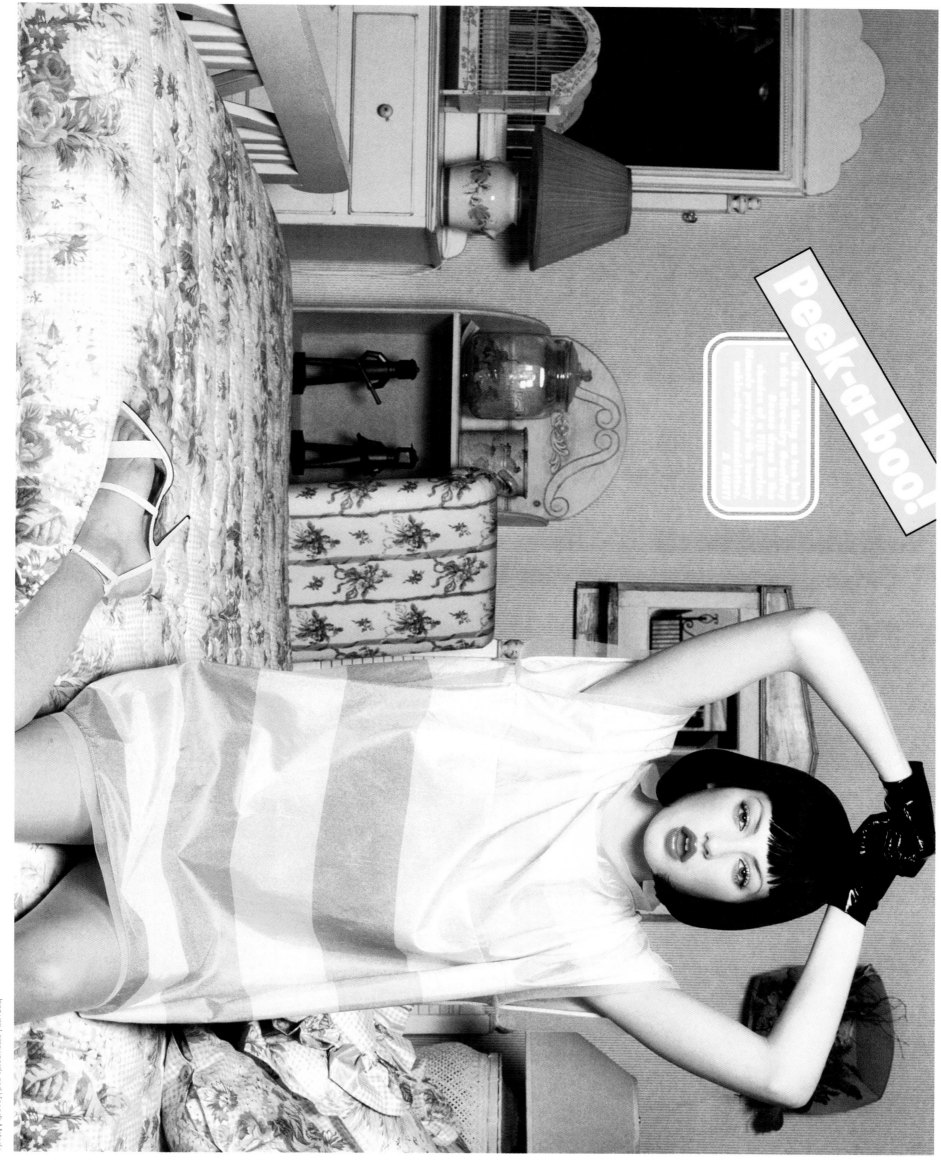

Peek-a-boo!

Inez van Lamsweerde and Vinoodh Matadin

15 CINDERELLA JULY 1995 The theme of this issue was the much-loved—and very fashiony—fairy tale "Cinderella." We imagined we were making a film and asking each of the various directors (contributing artists) to shoot a scene. Raymond Meier portrayed Cinderella's ride to the castle and the magical moment when the glass shoe fits. Mats Gustafson transformed the pumpkin into a Rolls Royce. Bruce Weber cast the sexy prince. Our fairy godmother was played by legendary fashion editor Polly Mellen in one scene and by legendary drag queen DJ Lady Bunny in another. The one constant was the shoe, a vintage Roger Vivier for Christian Dior from the archives of the Metropolitan Museum of Art. It was like a game, in which everyone was doing his part, not knowing who else was participating and not knowing how any of the others' images would turn out. Even Glenn O'Brien, who contributed the text, did not see any of the visuals and was only briefed on various segments of the story. Once all the artwork and Glenn's text arrived, like magic, everything fell into place! It was like watching the shoe fit at the end of the story, right down to the pink-velvet ribbon chosen to go with the dusty-blue flock cover. It had to be FedExed from Switzerland and arrived just at the stroke of midnight!

cover Stephen Gan and Greg Foley

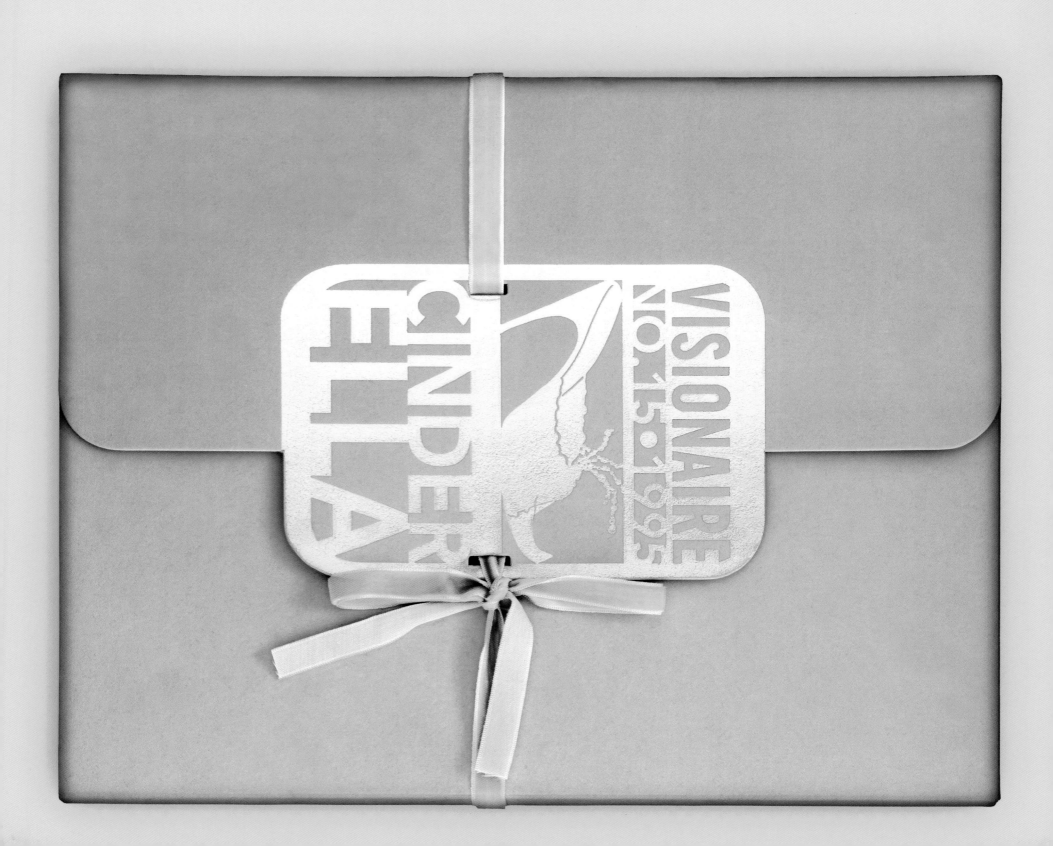

left: illustration Robert Medvedz text Glenn O'Brien right: Steven Meisel

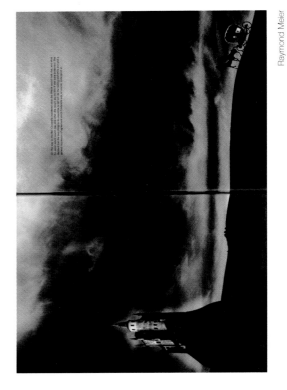

Raymond Meier

nce upon a time there was a girl named Cinderella (nicknamed actually, her real name was Bianca). Cinderella was a Virgo with Scorpio rising. She was a lovely, good girl with a musical voice, a quick mind, an obliging manner, but a fey, pixilated demeanor. Cinderella had a rich dream life and every morning she could recall the exotic and often patently Jungian events of her nocturnal adventures. (Cinderella was, of course, pre-Freud and pre-Jung.)

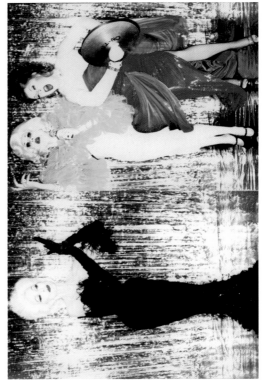

Ellen von Unwerth

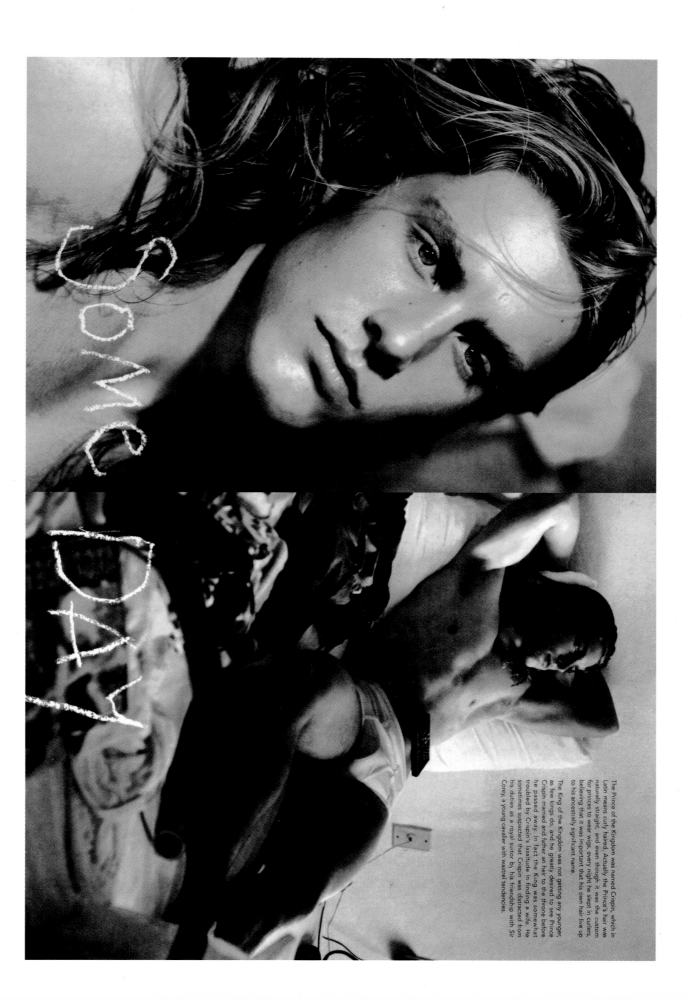

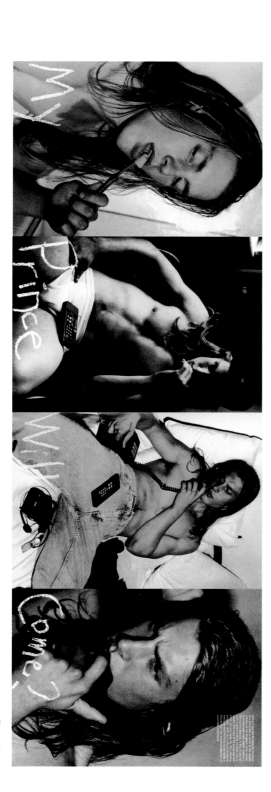

I was part of the Disney generation. I think I was a little kid when "Cinderella" was made into a movie, and the first tragic thing that happened to me was when Dumbo died. And Bambi's mother got shot. Or maybe it was Dumbo's mother that died. It was always the mother that was getting it. "Cinderella" was a story about upward mobility, which is why so many people liked it. I guess the modern Cinderella would be someone like Audrey Hepburn as Holly Golightly. The fairy godmother, whom I think I called Inez, was based on Rosalind Russell in *Auntie Mame*. I knew some of the other people who were contributing to the issue, but I didn't see any of the images until it was finished. It's nice doing things blind. Somehow it all just clicks magically. And I was excited because one of my favorite things, which I got from doing advertising, is putting words with photographs. This was a great group of artists and photographers, so I was happy to work with them. Plus, Cecilia flirted with me. GLENN O'BRIEN

The Prince of the Kingdom was named Crispin, which in Latin means curly haired. Actually the Prince's hair was naturally straight, and even though it was the custom for princes to wear wigs, every night he slept in curlers, believing that it was important that he own hair live up to his ancestrally significant name.

The King of the Kingdom was not getting any younger, as few kings do, and he greatly desired to see Prince Crispin married and father an heir to the throne before he passed away. In fact the King was somewhat troubled by Crispin's lassitude in finding a wife. He sometimes suspected that Crispin was distracted from his duties as a royal suitor by his friendship with Sir Corey, a young cavalier with wastrel tendencies.

sky by Mats Gustafson papercut dress by Ruben Toledo

Mats Gustafson

94

François Berthoud

Inez van Lamsweerde and Vinoodh Matadin

16 CALENDAR DECEMBER 1995 We were intrigued by the idea of doing an issue that was practical, that served an everyday purpose and as a daily source of inspiration. CALENDAR was all that and more. For the case, we came up with a CinemaScope panoramic panel made of Plexiglas, the arched design of a television screen enabling it to stand upright. The issue became a real object that one might come across in the home section of any store. It gave us great pleasure to walk into an office six months or so later and see it on someone's desk, the current week on display. It was difficult, but fun, to assign fifty-two weeks to fifty-two different artists. Of course, all the main holidays went first: a Mario Testino New Year, an Inez van Lamsweerde and Vinoodh Matadin Valentine's Day, a Ruben Toledo Easter, a Marc Jacobs Fourth of July, a Mats Gustafson Thanksgiving, an Ellen von Unwerth Christmas, and a François Berthoud New Year's Eve. The backside of each page featured a Bibliography of Fashion by Richard Martin, who was the curator of the Costume Institute at the Metropolitan Museum of Art.

case Greg Foley

Gold is a very special, historically compelling substance. The pages I made for Visionaire came out of a previous project, *The Magic, Magic Book,* by Ricky Jay, which was published by the Whitney Museum. That kind of magic book is also referred to as a *blow book.* A magician would blow on the book, and a series of images would appear. He'd blow on the book again, and it would be blank. He'd blow a third time, and a different series of images would appear. The images I made are iris bursts. The word iris refers to a centralized force. In classical mythology, it also refers to the goddess of the rainbow. It has this universalized potential. For the magic book, I did the irises in different colors, superimposed but slightly off register. When Visionaire came to me with the proposal, I thought it would be nice to do them in gold. Gold is like white in that it seems to reflect all colors. Gold is a magic color. It has this compelling power and metaphysical dimension to it, so it was interesting and quite fortuitous doing Visionaire so close on the heels of the magic book. The issue was an important meditation on the nature of this substance. I very rarely use gold in my work. I used it on only one other occasion, when I gold leafed images of razor ribbon as part of a large painting I made for the Vienna Secession in 1996. So that goes to show you how respectful I am of the material. It is no accident that gold is such a symbol of sacred power. In GOLD, we handled it in a more playful but also more modern way. PHILIP TAAFFE

Todd Oldham

106

18 FASHION SPECIAL AUGUST 1996 Every issue of Visionaire is, to some degree, about fashion, but Issue 18, was the first all-out Fashion Special. Forty-four artists, photographers, and image-makers were asked to give their personal interpretation of clothing selected from the collections of forty-five of the world's most innovative and influential fashion designers. Highlights of the issue included Nan Goldin's collaboration with Helmut Lang, Jurgen Teller shooting Hussein Chalayan, Terry Richardson's take on John Bartlett, and Craig McDean's nine-page life-size foldout featuring Comme des Garçons. But the real surprise was the packaging: a deluxe monogrammed portfolio designed and produced specially for Visionaire by Louis Vuitton. People went wild. Some couldn't believe that the case was real. By the time the launch party was thrown at Mr. Chow in New York City some three weeks after the issue appeared, all 2,500 copies had sold out. It is among the most rare and sought-after back issues. Needless to say, we wish we had done a limited-edition run of ten thousand.

case Louis Vuitton

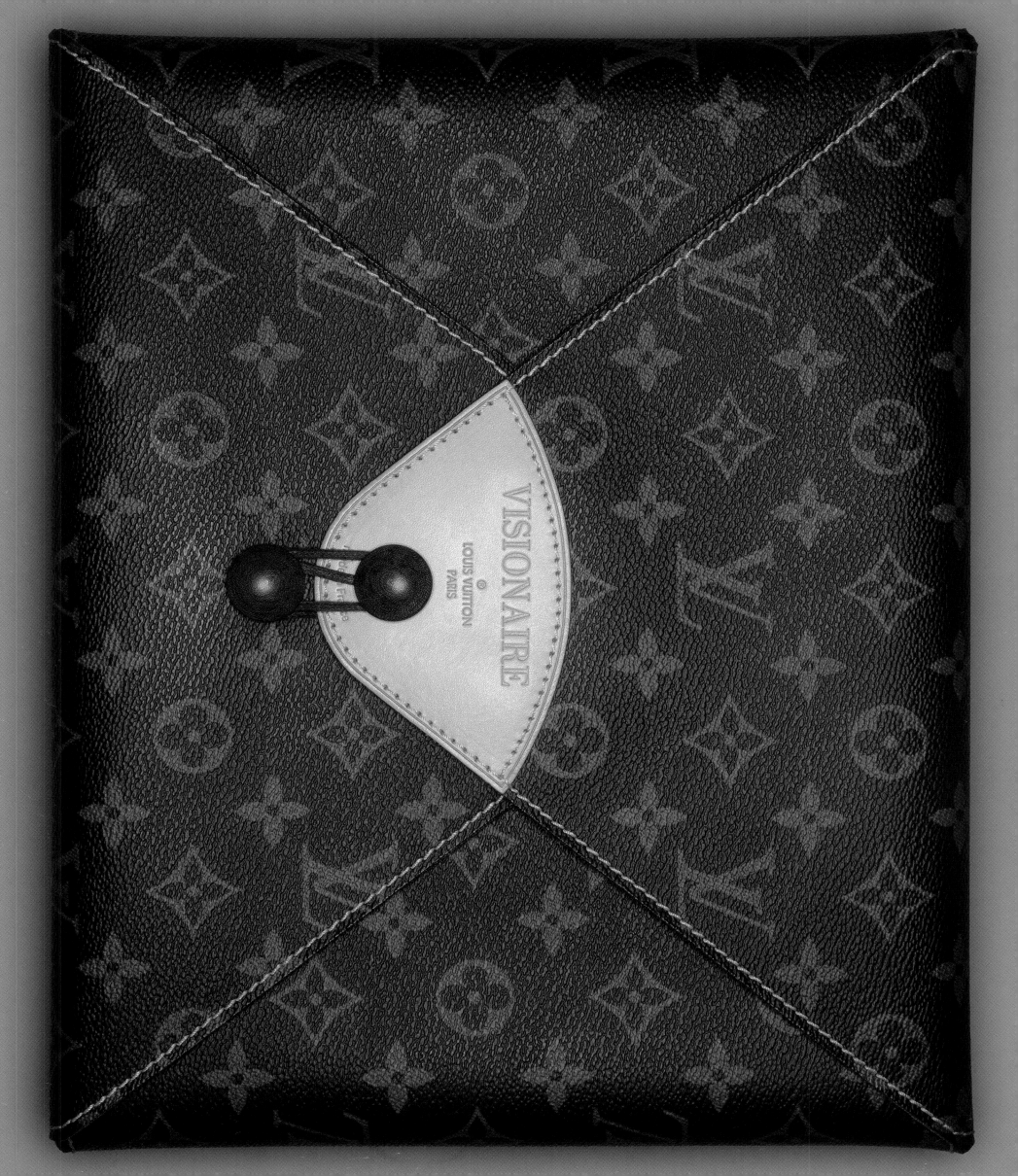

Daryl K by Inez van Lamsweerde and Vinoodh Matadin

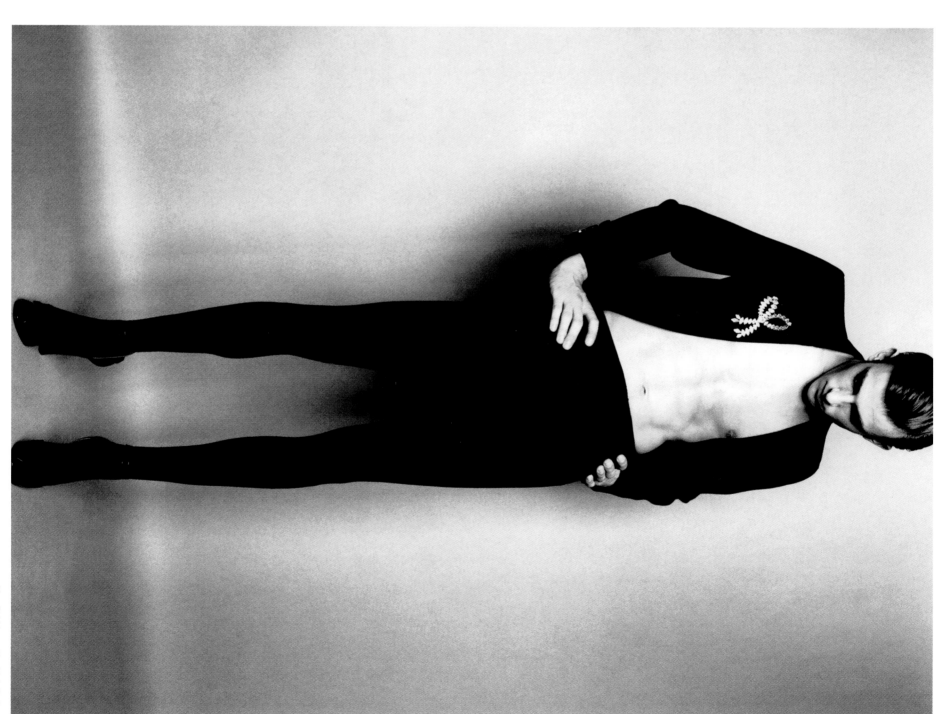

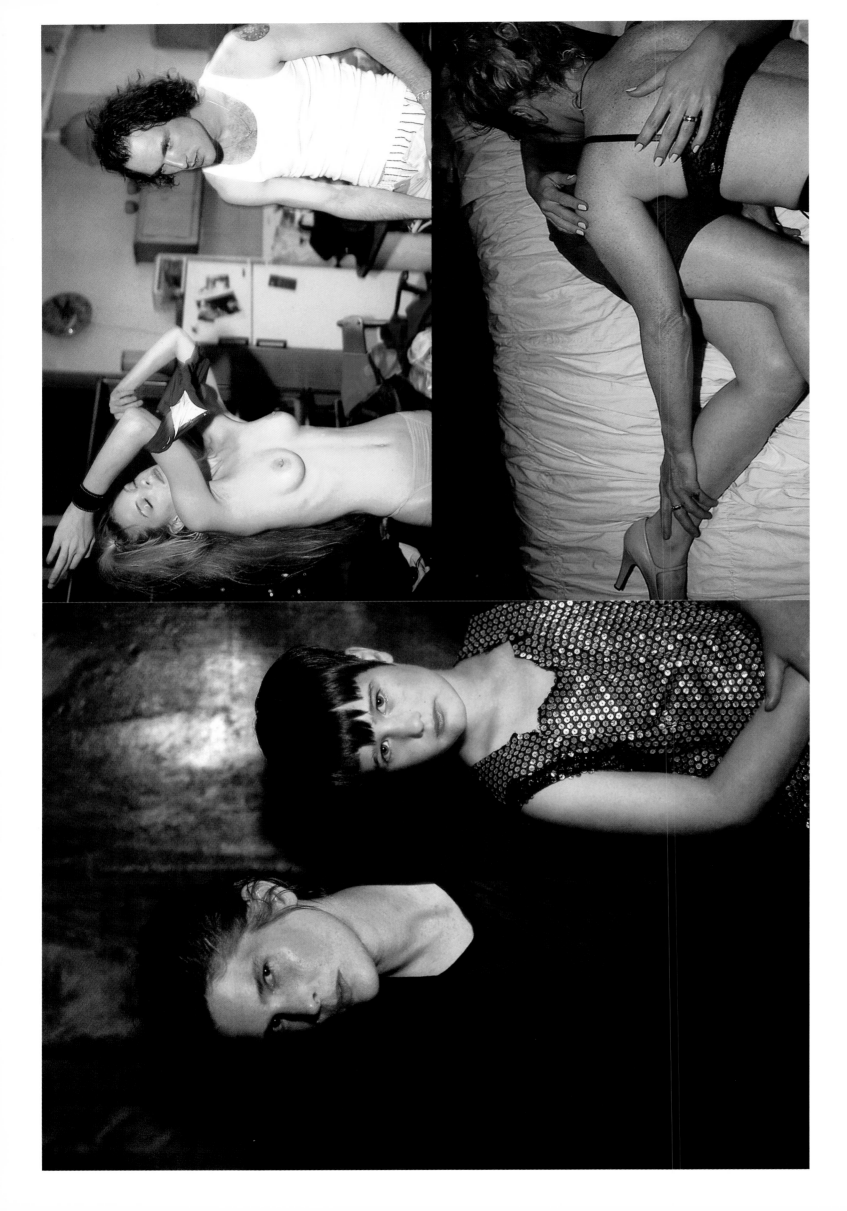

FASHION SPECIAL presented the opportunity to work with Helmut Lang, whom I've long admired. In the creative process, I used only my friends, my lover, and James King, a young model who had become my friend. I also invited one of the top models of the eighties, Lesley Weiner (and her daughter), out of retirement. She happened to be a favorite of Helmut. As always, I had no specific ideas in mind, and we spent two days in a beautiful apartment on Cleveland Place and on a roof. The other place was in my home. I wanted to show people from seventeen to fifty-three, to show all body types and all three genders, to break the fashion rules of youth and anorexia. We had a lot of fun. I had complete freedom in choosing the models, the clothes, and the locations. Helmut was very fierce in our collaboration and in our editing of the work. He wanted to highlight the aesthetic qualities of my work. In the end, I think his edit was good, and the front cover was especially brilliant. NAN GOLDIN

112

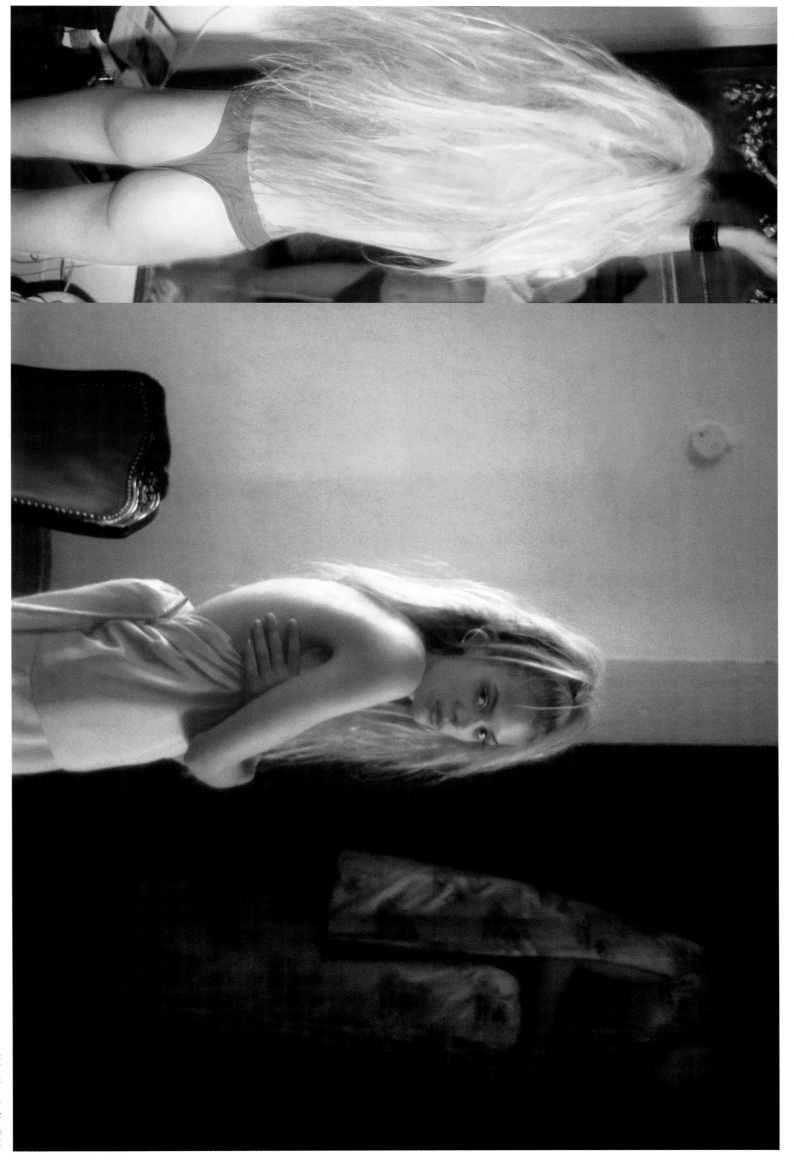

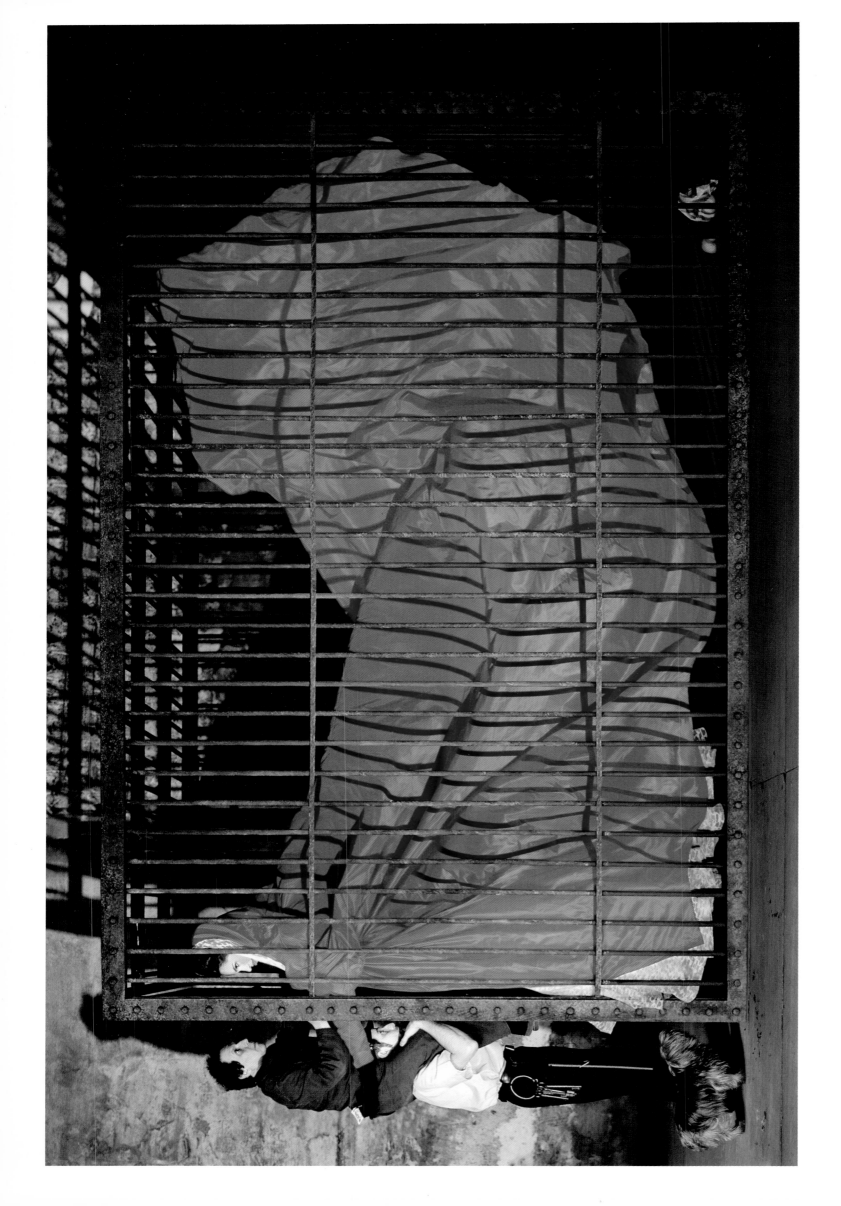

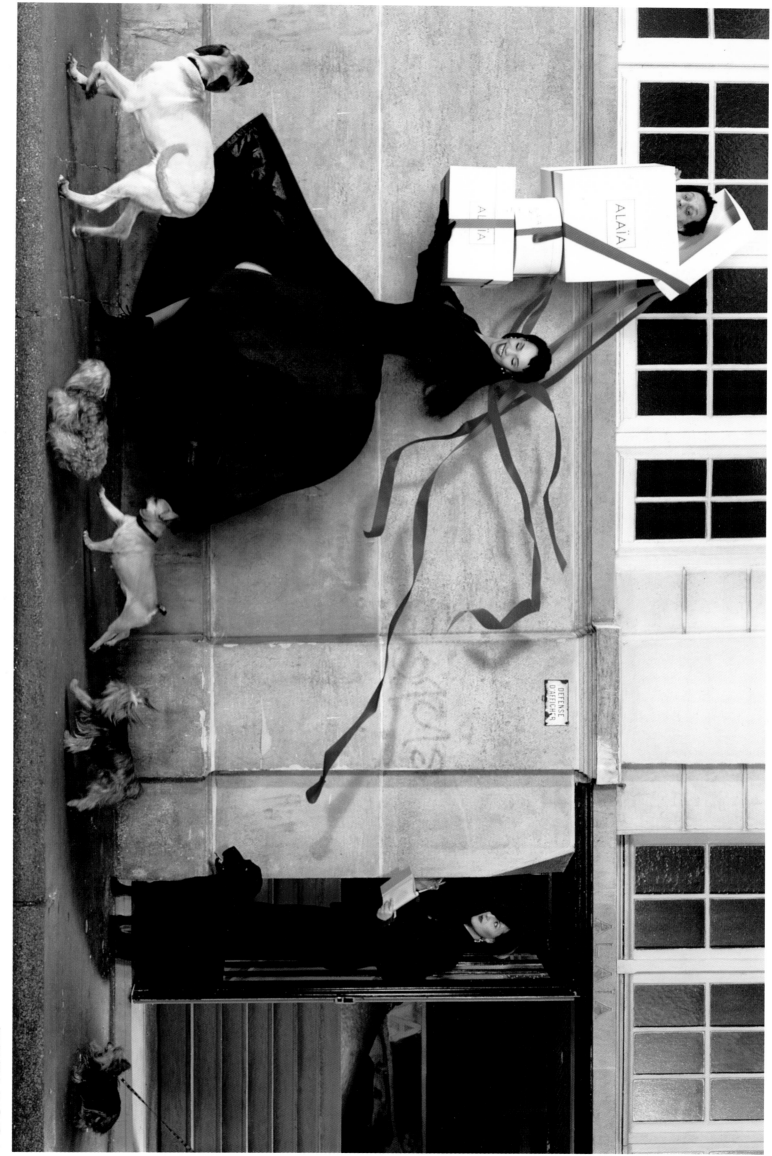

We had been working on the Jil Sander ad campaign with photographer Craig McDean, when Visionaire asked Craig to contribute to their FASHION SPECIAL. Craig wanted to use art directors for his work, so he asked us if we wanted a hand in it. We did. At the time, we were obsessed with hyperreal pictures and were using hyperreal images of model Guinevere in the Jil Sander campaign. Visionaire gave the format: an issue the size and shape of a regular magazine that would fit in a bag by Louis Vuitton. We liked the idea and thought, Wouldn't it be great to fit a whole woman in a bag? So we came up with the plan to put an entire body on a nine-page foldout. Nine pages are roughly the size of a human being, and thus we divided the model into nine frames and shot it that way. But we also wanted a divided body, a looser aspect to the body, to create a tension with the hyperreal aspect. We shot in London, and we used a piece of string next to the camera to mark how much of the body we had photographed—you see, we shot it in quite a loose way. And we decided to put a grid on the backside of the foldout to emphasize the technical, rigid aspect to the loose approach on the front. The most interesting part of the project was the collaboration between us as art directors and Craig as photographer. It's an essential way of working today, because you can't expect one person to make a photograph alone anymore. It requires a big team of people, and it's necessary to have a dialogue among all of them. It avoids cheating on the image or a disappointment in the results. It is so important to set the rules between ourselves and the photographer before we begin. Eighty to ninety percent of our work is actually done at the shoot, but each new project requires new rules. For this photo, the rules were a hyperrealistic woman set in nine pages. I still think the image is strong, and even though our work has changed a great deal, it has the same kind of spirit underneath. But we continue to try new things, to have a challenge with each new work. It isn't good to repeat a recipe, and there must be some recipe. I don't feel like the white page is a creative factor for us. It's important to have some sort of question, any question, but also to have something to answer. M/M, PARIS

Comme des Garçons by Craig McDean and M/M, Paris

FASHION SPECIAL was the second time I collaborated with M/M, Paris for Visionaire. We had the idea to shoot a girl in true-life scale. Since film doesn't come that large, we shot every part of her body in 8 x 10 and put it together like a foldout to achieve actual life size. I had a choice among four designers. I chose Comme des Garçons. CRAIG MCDEAN

19 BEAUTY NOVEMBER 1996 Beauty really was in the eye of the beholder, starting with the cover itself. The packaging—a mirrored mylar case featuring a limited-edition Visionaire lipstick, mascara, and lipgloss, made especially for the issue by our sponsor, Prescriptives—was a topic of endless debate. Everyone had a different point of view. Some on our editorial team thought that by putting makeup on the cover, we would be sending the wrong message: "To be beautiful, you need this." Others argued that cosmetics symbolized contemporary beauty and loved the idea of walking into a bookstore and seeing actual products floating on the cover of a book. Still others reasoned that seeing your reflection on the mirrored mylar cover, the message was simply: "This is beauty staring you in the face!" Oddly enough, the commercial implications of putting our sponsor's product right on the cover never came up in our discussions. In fact, contrary to what one might think, it was our idea to feature their products prominently on the cover, not theirs. More visions of beauty were played out in the pages of the issue: Contributors included makeup artists and hairstylists, such as Serge Lutens, Kevyn Aucoin, François Nars, Dick Page, Topolino, Danilo, and our very own James Kaliardos, who transformed Cecilia Dean into three different races.

case Stephen Gan and Greg Foley

VISIONAIRE N° 19 BEAUTY

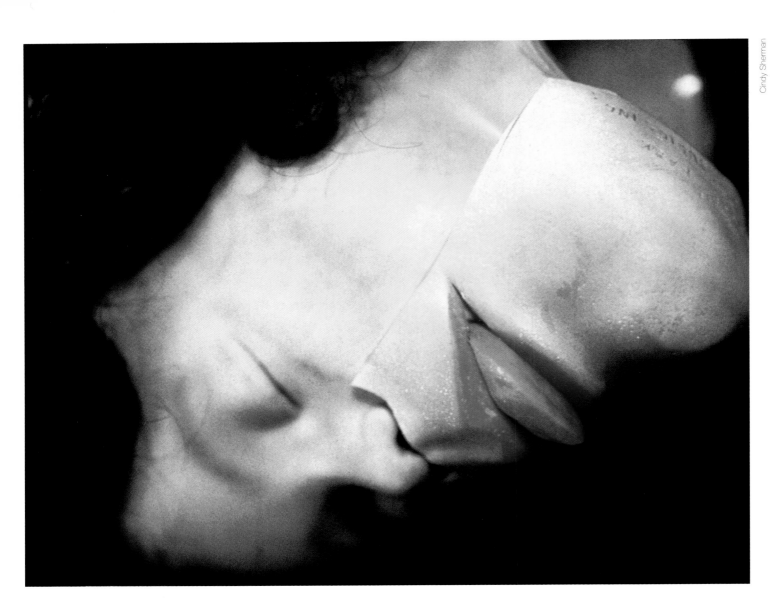

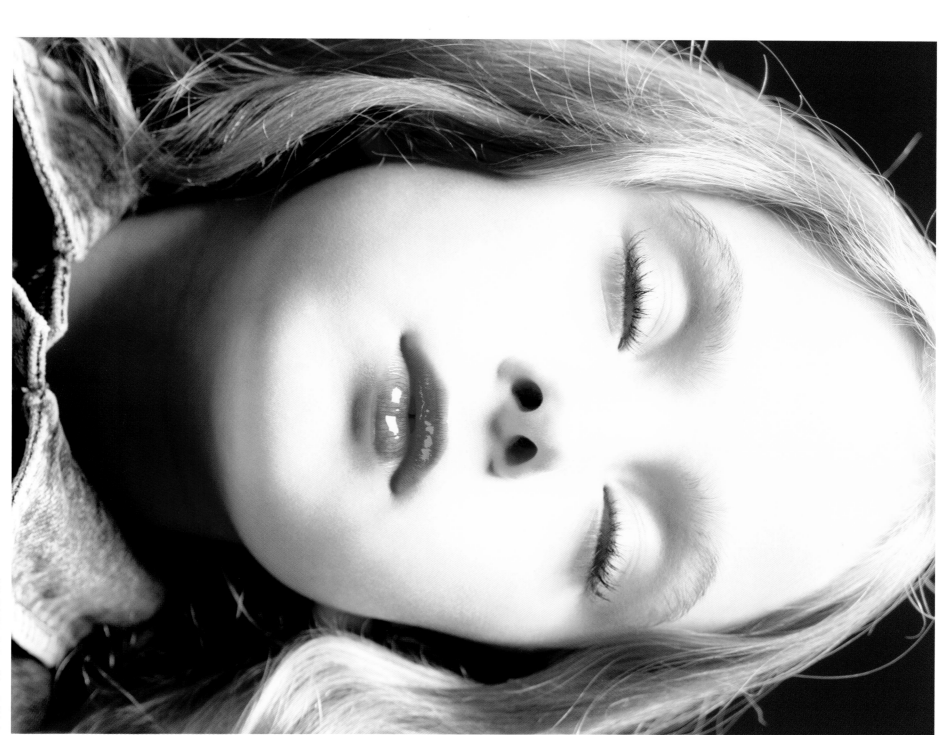

I think I was very literal about the theme of the issue, BEAUTY. I'm a makeup artist, but I wasn't really thinking about makeup but simply what was engaging me at the time—the women I liked and the way they looked at the time. One of the portraits is of a friend of mine, Alicia. She was about to go on a three-month trip and had shaved her head. It was interesting to see her looking so different and for a purely practical reason. I love Jackie's face, the actual physicality of it. Hooded eyes are sort of an obsession of mine. And then there is the photo of Annie Morton, who is a model. We didn't do any makeup or hair. I just shot it in her apartment. It was the first time anything I had photographed had been published, and it was a conscious decision on my part not to do makeup for my own images, though I did do the makeup for Bruce [Weber's] contribution to the issue. The weird thing with makeup artists is that they always want to know what everyone else is doing. To see where they would personally go all gathered together is very interesting as a visual cross-reference. A lot of people really chased themselves to push their ideas as far as they could. To me, the issue pretty much sums up the idea of the eye of the beholder. DICK PAGE

James Kallardos

Terry Richardson

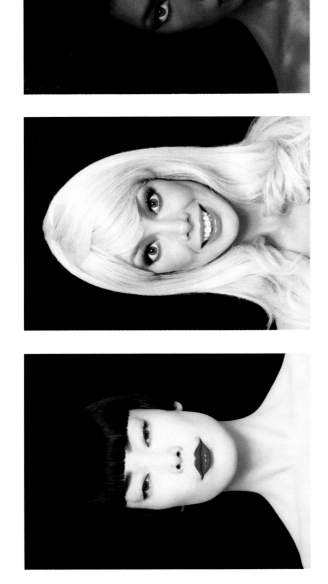

Dick Page

If Gerard Depardieu had met Simone Signoret and they fell in love and had a baby it would've looked *Just* → like Piers

Bruce Weber

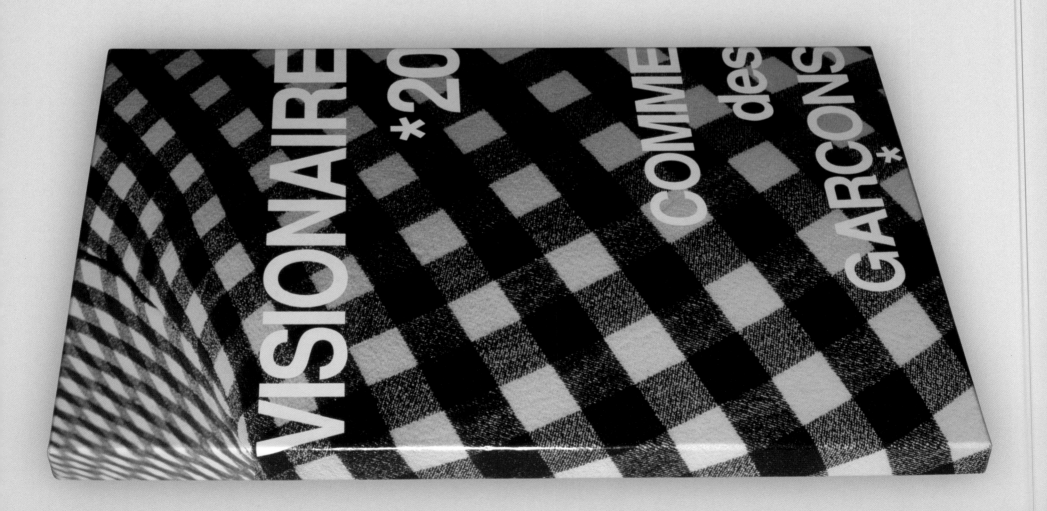

20 COMME DES GARÇONS FEBRUARY 1997 Rei Kawakubo and Comme des Garçons had always been an inspiration to us, so it seemed only appropriate that with this issue, Rei became our very first guest editor. To strike up our "dialogue" with her, we conceived the issue as a "visual interview." From the beginning, she expressed a desire to see really strong fashion photography, and opened up her archives and chose her favorite pieces for select photographers to reinterpret. It was exciting for us to see what a young photographer like Mario Sorrenti, then twenty-six, would do with fashion that dated as far back as 1982 (when he was only eleven years old). Philip-Lorca diCorcia, contributing for the first time, took a Comme des Garçons dress to the bustling streets of Hong Kong, and at Rei's request, Nick Knight mixed Comme des Garçons with Alexander McQueen and created what turned out to be one of the most reproduced Visionaire images ever. The issue, by a stroke of good luck, coincided with the designer's notorious "bump" collection that season. A real dress pattern, printed on muslin, came packaged in the issue. It was an immense success, selling out all 2,800 copies more quickly than we had ever imagined.

cover Greg Foley photography Masayuki Hayashi

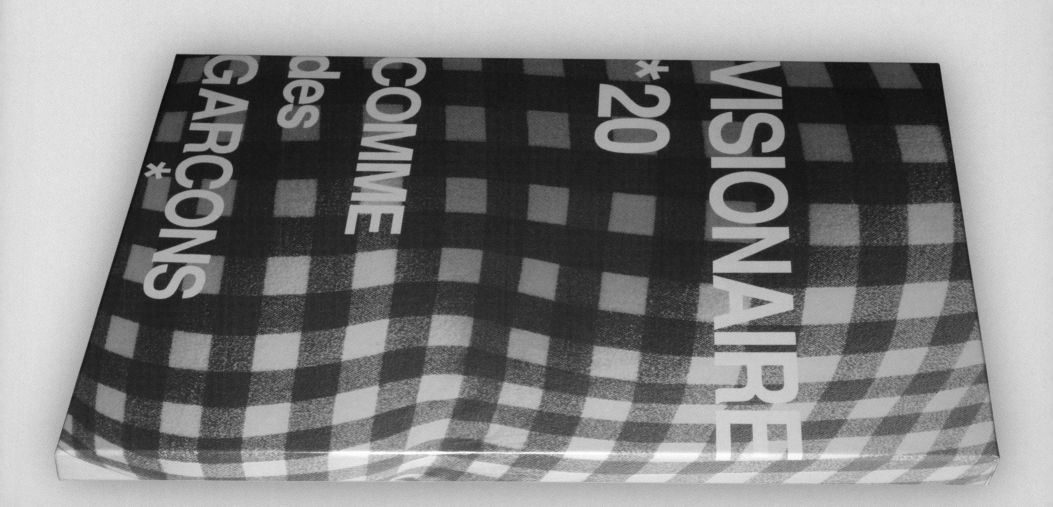

What do you make of this?

Six $\frac{1}{4}$

I was inspired to work with Visionaire because they were also trying to do something new. I had worked with many of the contributors to the issue before and respected their work. Also, I thought they would enjoy doing it. Instinctively, I chose some pieces I thought were strong, and Visionaire let the stylists choose what they wanted. I thought it was a good idea to include a pattern in the issue. People don't always realize how exciting and intricate a pattern can look. We also included a booklet in the issue, Six 1/4, which was a quarter of the size of the magazine I used to do called Six. We did Six to express the sense of values of Comme des Garçons through another medium and to explore creation through a magazine. Art and fashion are not the same thing. One you wear, one you look at. Ultimately, I am a clothing designer, but sometimes art can help express in another way the sense of value inherent in the clothes. REI KAWAKUBO

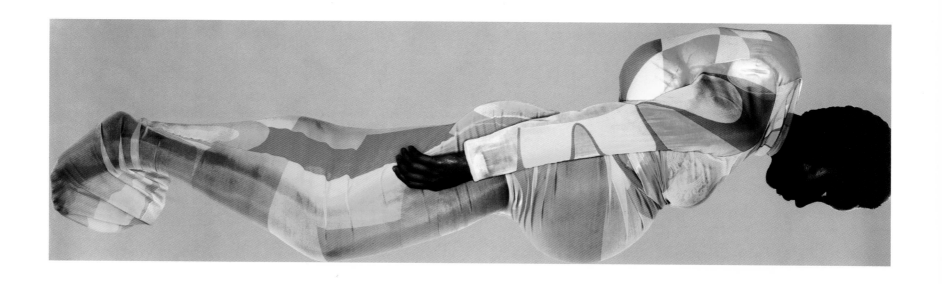

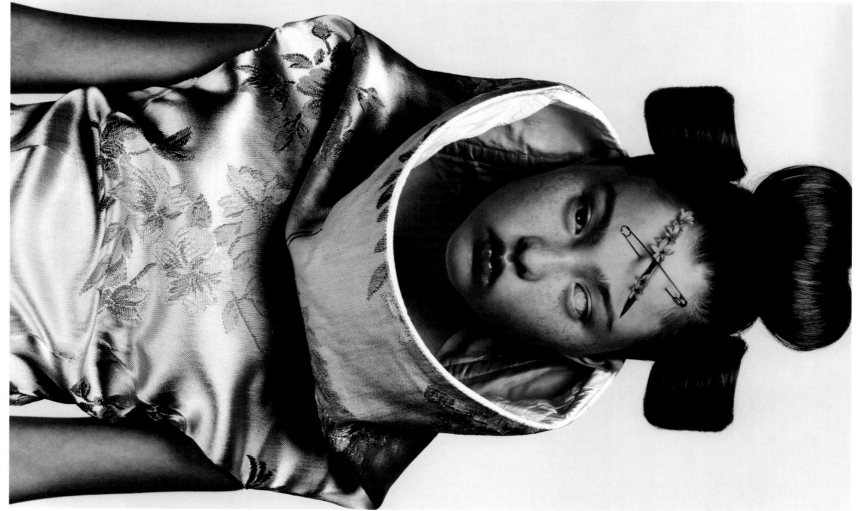

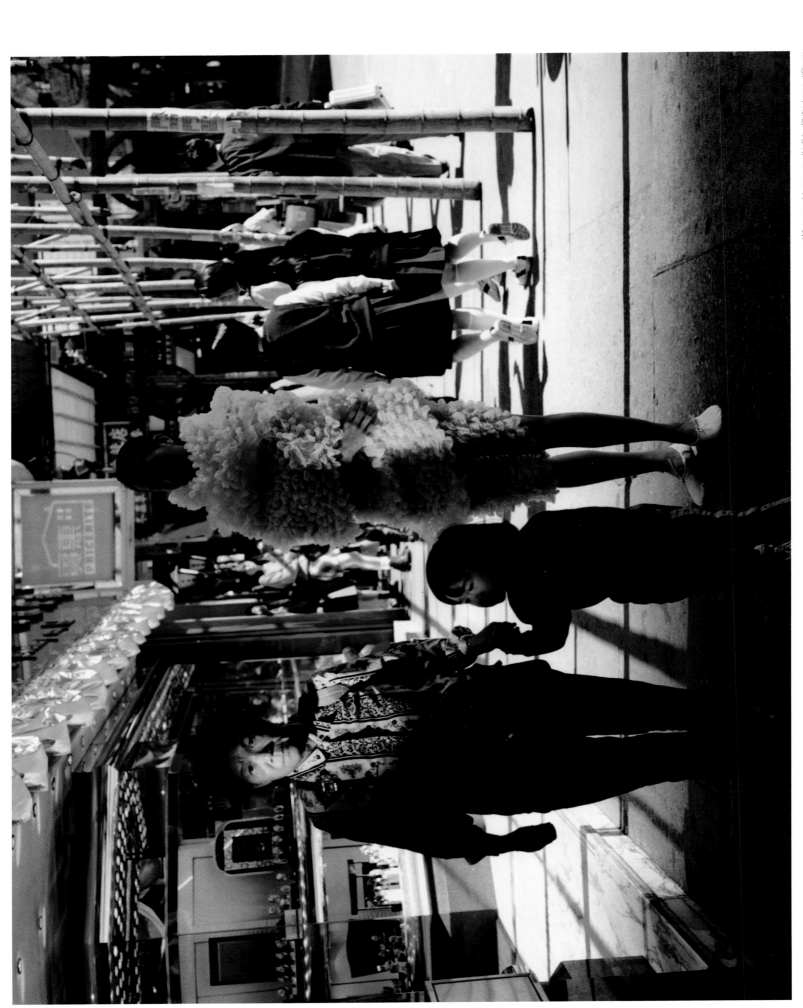

Where would you wear this? by Phillip-Lorca diCorcia

At that particular time I wasn't doing any fashion photography. Basically, the way it was set up, they just shipped the dress and said, "Shoot it." Not that most people give me a lot of restrictions, but with Visionaire I could not have had fewer restrictions. This made it very intriguing. I was on assignment in Macau and went over to Hong Kong to do my own work and to do this picture. I was working on a series of pictures titled *Streetwork* that involved a technique like the one I ultimately used in that Comme des Garçons picture. It's not a real

person but a model I cast through a modeling agency. I didn't have anyone to do hair or makeup. I just said to her, "Show up and bring your own shoes." Rather than playing on the futuristic aspect—the dress looks like a huge mound of bubble wrap—I decided to downplay it, and put her in the middle of the street. With fashion I have a hard time distinguishing between art and commerce and Rei Kawakubo is one of the resident geniuses of the form. Still, for me, to work on the creation of the image, to enhance the self-image of a designer as cutting

edge or artistic is a commercial endeavor. No matter how minute and indirect, I am promoting Comme des Garçons. After I did this picture, whenever people would ask me to do work that was similar to the personal work I was doing at the time, I'd refuse. It's an easy technique to churn out editorial or ad work that way, and I didn't want to exploit my personal work, I didn't want to to eat my own tail. I hadn't really formulated this rule yet, but for Visionaire I basically broke it. I don't think I've ever done that for anyone else. PHILLIP-LORCA DiCORCIA

Does size matter?

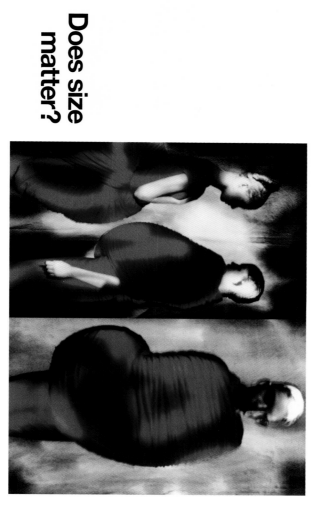

Paolo Roversi

Do you ever look back?

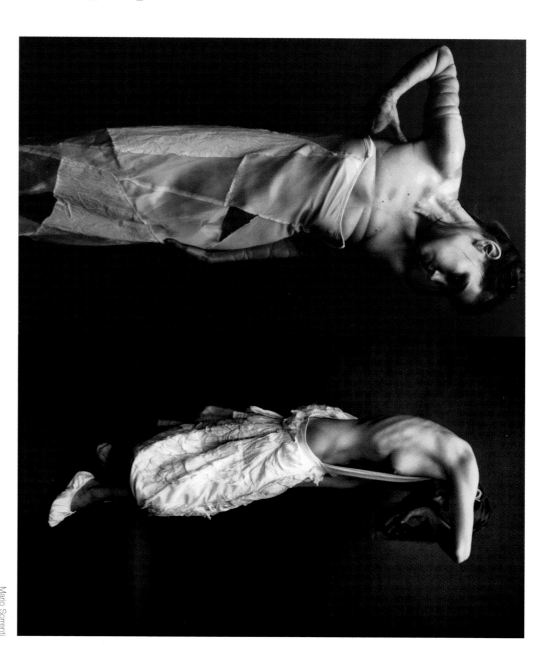

Mario Sorrenti

Is fashion deep?

Craig McDean and M/M, Paris

21 DECK OF CARDS / THE DIAMOND ISSUE APRIL 1997 This issue provided two rare opportunities, among the many others that accompany the making of each issue of Visionaire. First, we were able to hand over entire series of images (in this case, suits) to individual art directors. Fabien Baron conceived the House of Hearts as a meditation on motion with dancer Ushio Amagatsu of Sankai Juku. M/M, Paris realized the House of Spades in a variety of Parisian butcher shops. Lee Swillingham and Stuart Spalding portrayed the House of Clubs in—where else?—nightclubs. And Visionaire worked with thirteen artists to build the House of Diamonds. Mario Testino shot John Galliano as the King while Inez van Lamsweerde and Vinoodh Matadin photographed Iman as the Queen, dressed, fittingly, in Alexander McQueen. A Bruce Weber boy toy was the Jack. The second opportunity was the incorporation of diamonds, courtesy of the Diamond Information Center, DeBeers and H. Stern, into each picture, which required the highly insured shipping of millions of dollars worth of jewels to all parts of the globe. The 3,000 issues were packaged in individual jewelry boxes, each with its own lock and key, and offered a real diamond for one lucky subscriber. Our launch party took place at The "21" Club in New York, a former speakeasy that we transformed into a faux casino complete with card tables. Another lucky winner walked away from the evening with a diamond necklace.

case Greg Foley and H. Stern

Visionaire

21

VISIONAIRE
The Emperor's New Clothes BY KARL LAGERFELD
23

23 THE EMPEROR'S NEW CLOTHES DECEMBER 1997 This was our nude issue. Setting fashion aside but keeping style intact, fashion designer Karl Lagerfeld picked up his camera for Visionaire and photographed fifty of the world's most beautiful people. Over the course of nine months, ensconced in his private Paris studio, he captured men and women as they shed their clothes to reveal their true physiques—and their true selves. Subjects included supermodels Amber Valletta, Linda Evangelista, and Karen Elson; actors Rupert Everett, Julie Delpy, and Demi Moore; industrial designer Marc Newson; and New York City Ballet's principle dancer Nikolaj Hubbe. Presented in a custom-designed, blond-wood painter's box, the rich, sepia-toned prints were packaged like bon bons, with chocolate-colored flock and ribbon.

cover Greg Foley

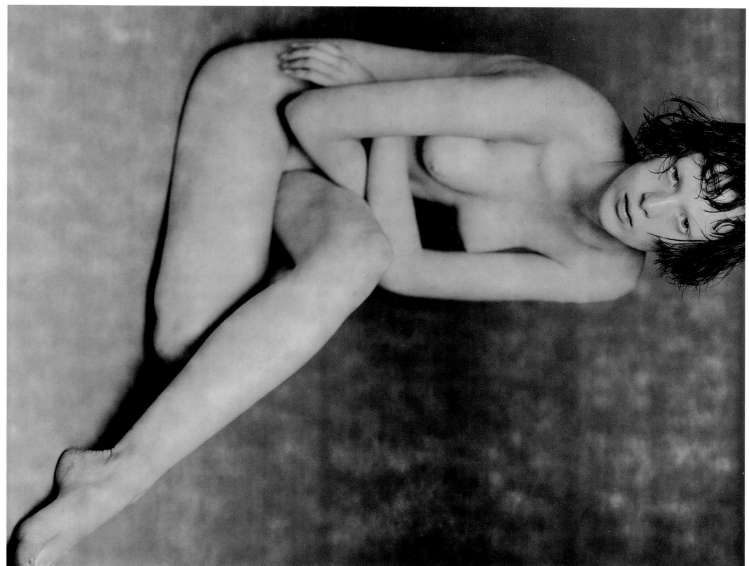

Karen Elson

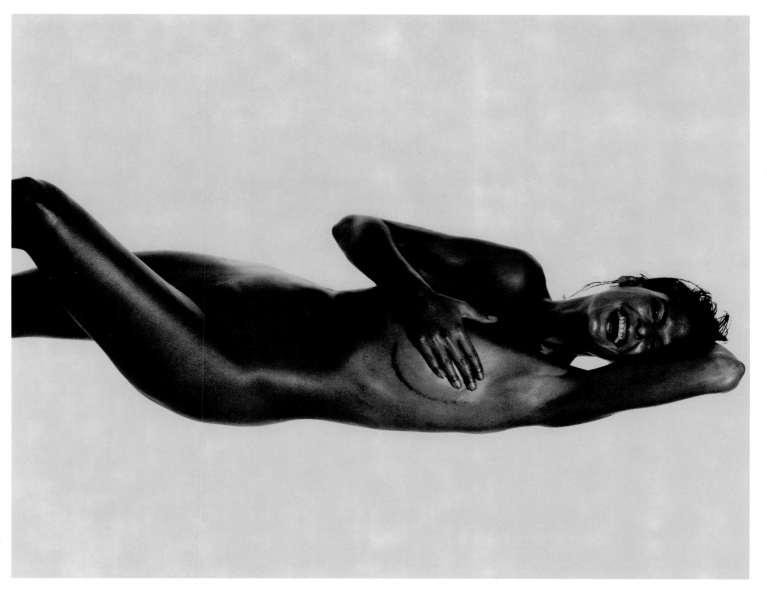

Linda Evangelista

24 LIGHT MAY 1998 Visionaire teamed up with fashion luminary Tom Ford and Gucci on an issue devoted to the theme LIGHT. This was our most ambitious project to date in terms of content and production. There was a conscious effort on the parts of both Visionaire and Ford to steer clear of fashion and to focus on what we considered to be fine-art images. LIGHT introduced a new cast of contributors to the Visionaire fold: artists such as Sam Taylor-Wood, Andreas Gursky, and Christopher Bucklow; art director Peter Saville; animator Hayao Miyazaki; and architect Toyo Ito. Then there was the issue itself. That winter found us doing everything from sourcing the state-of-the-art, paper-thin filament that would literally light up the issue (a couple people in our office were nearly electrocuted in the process!), to negotiating the price for 33,000 batteries. The end result: twenty-four large-format transparencies self-contained in a super-sleek, fully-functional light box—the first battery-operated publication! Only 3,300 copies were made.

case Greg Foley and Doug Lloyd

VISIONAIRE 24 LIGHT

TOM FORD FOR GUCCI

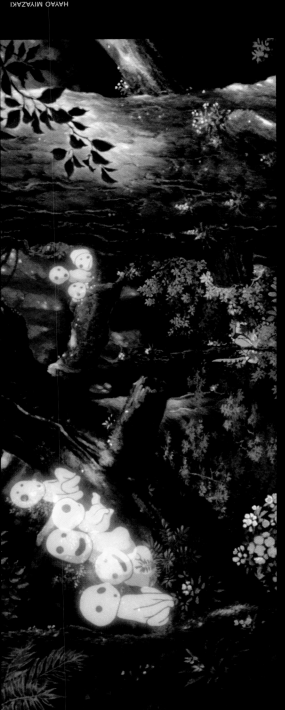

In a world where most magazines and editorial publications have to pander to a mass market, Visionaire really allows complete creative freedom. We wanted to do something that was modern and techno-logically advanced, and at the same time optimistic. There is nothing more optimistic than light, and in a certain sense, it's the opposite of what has been happening in fashion over the past decade, which has been very dark, very black, very somber. Some of the artists' work I personally own, some of them I knew, some of them I didn't know, but they were all artists whose work I respected. My favorite images are the photograph of Erin by Luis Sanchis, which is a very beautiful nude, and the image from Jane and Louise Wilson. It's about light, but they took the idea further. The project was packaged in a Gucci look. It's my favorite color, black, and it's in one of my favorite materials, Plexiglas. The look of it was very much in line with what we were doing at Gucci at the time. The contents are also what I thought was happening in fashion. I felt the retro look was over, and we were all striving to move into the future and create something new and original. That said, we chose not to make it an issue rooted in fashion, because fashion is not only about clothes, it's really about everything around you. There is a look or feel or spirit that runs through all areas of culture. I think people who are visually interested in the world are the people who would have been interested in this issue. TOM FORD

HIROMIX
VISIONAIRE 24

LEE JENKINS
VISIONAIRE 24

SAM TAYLOR-WOOD
VISIONAIRE 24

VISIONAIRE 25

25 VISIONARY JULY 1998 When we hit the landmark
number 25, we seized the opportunity to make an
anniversary issue of greatest hits: brand-new work by
some of our all-time favorite visionaries issued in an op
art-inspired case the size of a standard twelve-inch
album cover. In keeping with the greatest hits theme,
musician Towa Tei produced the VISIONARY soundtrack
CD to accompany our picture album featuring contributing
teams Mario Testino and Carine Roitfeld; Karl Lagerfeld
and Yohji Yamamoto; Isabel and Ruben Toledo and
choreographer Twyla Tharp. David Bowie curated a
special section featuring artists Tony Oursler, Tracey Emin,
Gavin Turk, and Beth B. And eight young designers
envisioned their work in a section called New Visions.
case Greg Foley

VISIONAIRE 25

VISIONARY

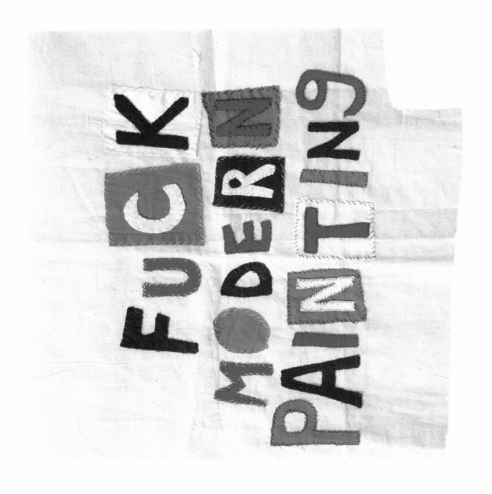

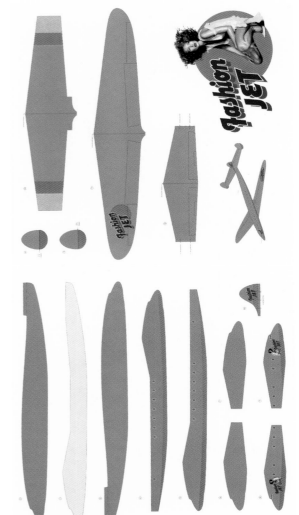

curated by David Bowie from left: Gavin Turk, Tracey Emin

Craig McDean

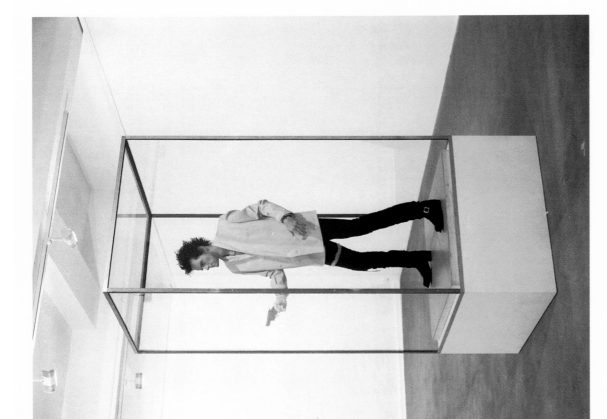

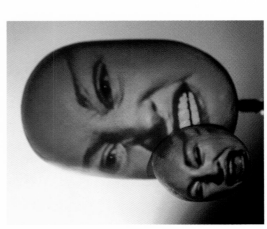

curated by David Bowie from left: Tony Oursler, Beth B

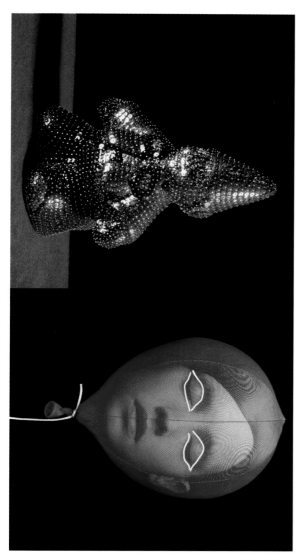

Viktor & Rolf by Inez van Lamsweerde and Vinoodh Matadin

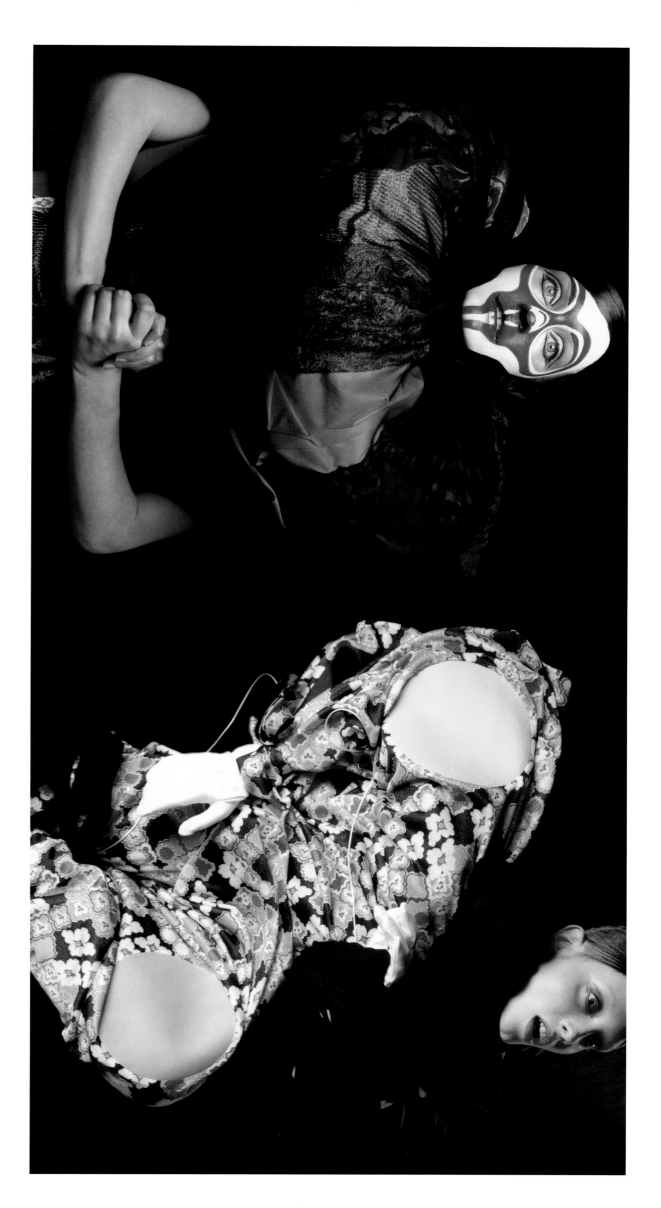

Jeremy Scott by Sean Ellis

Philip-Lorca diCorcia

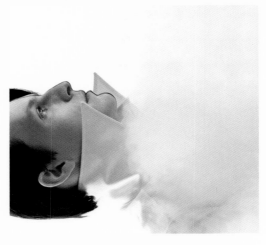

from left: Véronique Leroy by Inez van Lamsweerde and Vinoodh Matadin, Véronique Branquinho by Bert Houbrechts

Philip Treacy by Marcus Tomlinson

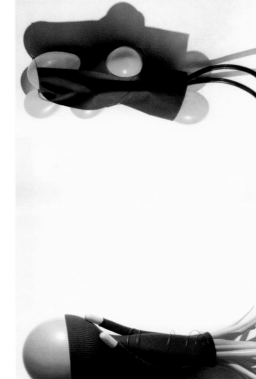

Junya Watanabe by Mario Sorrenti and Jane How

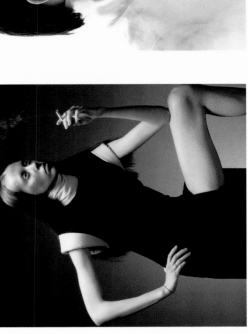

from left: Nicolas Ghesquière for Balenciaga by Inez van Lamsweerde and Vinoodh Matadin, Raf Simons by Bert Houbrechts

160

When Visionaire first contacted me, I was not familiar with their work and had actually never heard of them. Nicholas Callaway, my friend and the publisher of my first book *Eiko by Eiko*, told me that there were a lot of talented and enthusiatic young people doing some very interesting experimental work at Visionaire, and that my work would be a good fit for the publication. When I went to visit the Visionaire offices for the first time, I was very impressed that indeed, as Callaway had said, it was an environment filled with lots of young, creative energy. I felt we could collaborate well. As I spoke with the Visionaire staff, it became clear that they were very impressed by and most interested in the graphic design and advertising work represented in my book. However, at the time, I was deeply engrossed in designing costumes for a very innovative production of Wagner's *Ring Cycle* in Amsterdam. I threw that idea on the table, suspecting that they'd be surprised at the direction my career had taken. I knew it would jar with the image people had of me as being strictly a graphic

designer and advertising director, and I always love to upset the tendency to categorize and pigeonhole. Also, I felt that Visionaire focused a bit too narrowly on the worlds of fashion and photography while ignoring other important aspects of culture. Some may have seen the inclusion of my opera work as not in keeping with the established spirit of Visionaire. I don't know whether it was welcomed as a good change, or simply prompted the question, "What's this doing in Visionaire?" But no matter what medium or world I am creating in, I always relish the idea of being the outsider and always seek to stand out from the visual vocabulary around me. It seems that Visionaire's mission has always been to present the limitless and wonderful array of creative vision around us, and I hope they continue to push the boundaries of what that vision includes. In a world where fashion seems to rule all, I encourage Visionaire to continue to look beyond mere trends and to seek out what is truly innovative and inspiring using the widest definition of culture possible. EIKO ISHIOKA

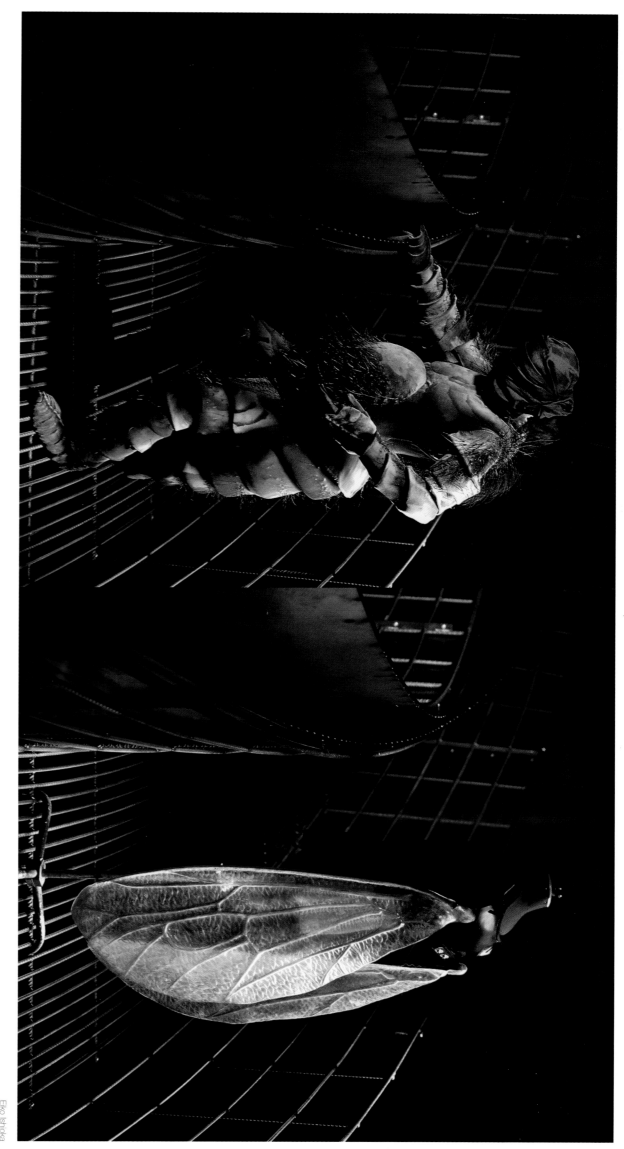

Eiko Ishioka

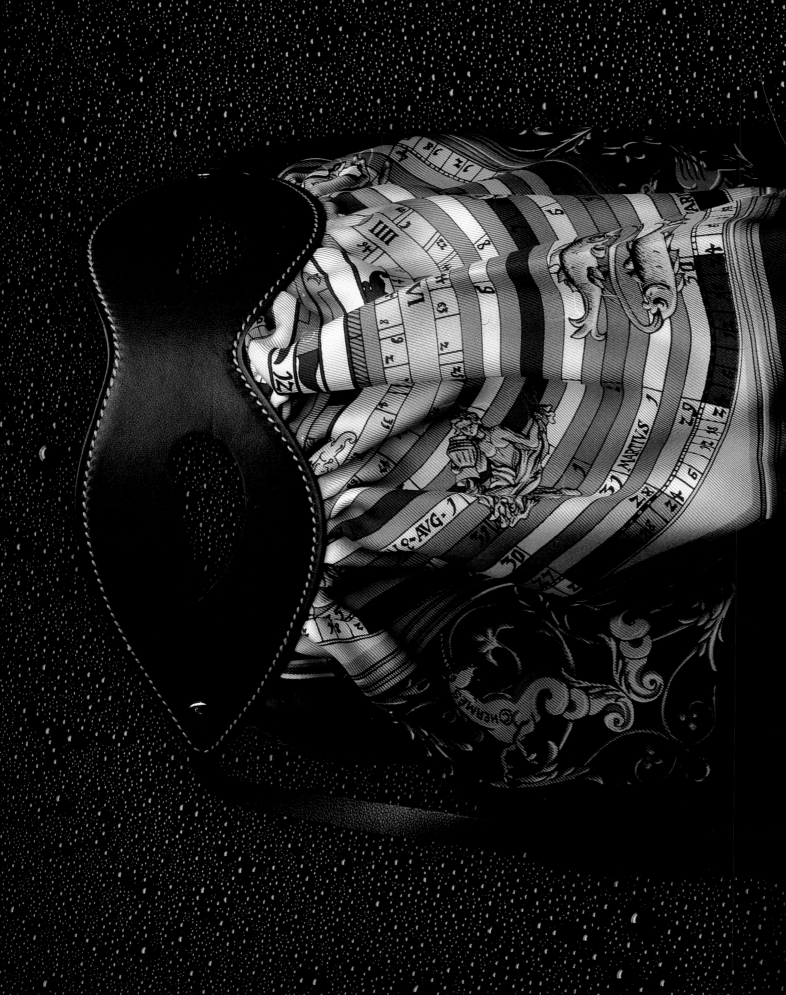

26 FANTASY NOVEMBER 1998 Fantasy is the subtext of every issue of Visionaire, but with this issue we pushed the boundaries to the fantastical. A round box housed round, unbound artwork. Each of the cover elements— photographed by Inez van Lamsweerde and Vinoodh Matadin—was produced exclusively for FANTASY. The dress was designed by Nicolas Ghesquière for Balenciaga. Viktor & Rolf made the banner, and Jeremy Scott created the gold porcelain doll's head and hands. It was the first issue in which we published work by Jeff Wall, Gregory Crewdson, Marcus Piggott and Mert Alas, and Tyen. More contributions came from Steven Klein, Tony Oursler, and Tim Burton, and there was a special section curated by Isabella Blow featuring, among others, David LaChapelle, Mariko Mori, and Tim Noble and Sue Webster. Each issue included an Hermès mask that many wore to the masquerade ball launch party.

mask Hermès cover Inez van Lamsweerde and Vinoodh Matadin case Greg Foley

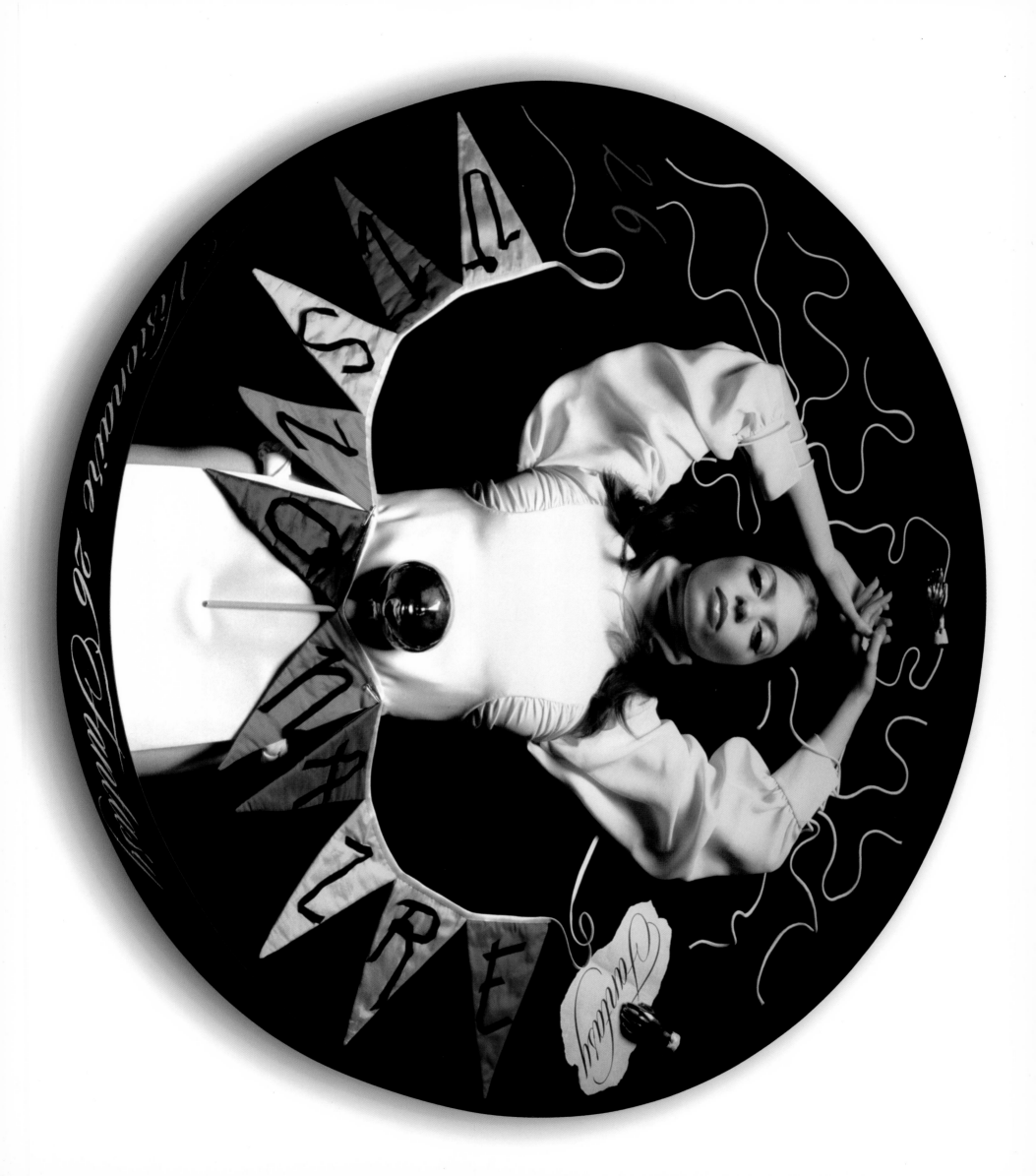

David LaChapelle

Elliott Puckett

David Byrne

Piotr Uklanski

Jack Pierson

Tim Burton

Mariko Mori

Tony Oursler

Tyen

Tim Noble and Sue Webster

Jeff Wall

Miwa Yanagi

164

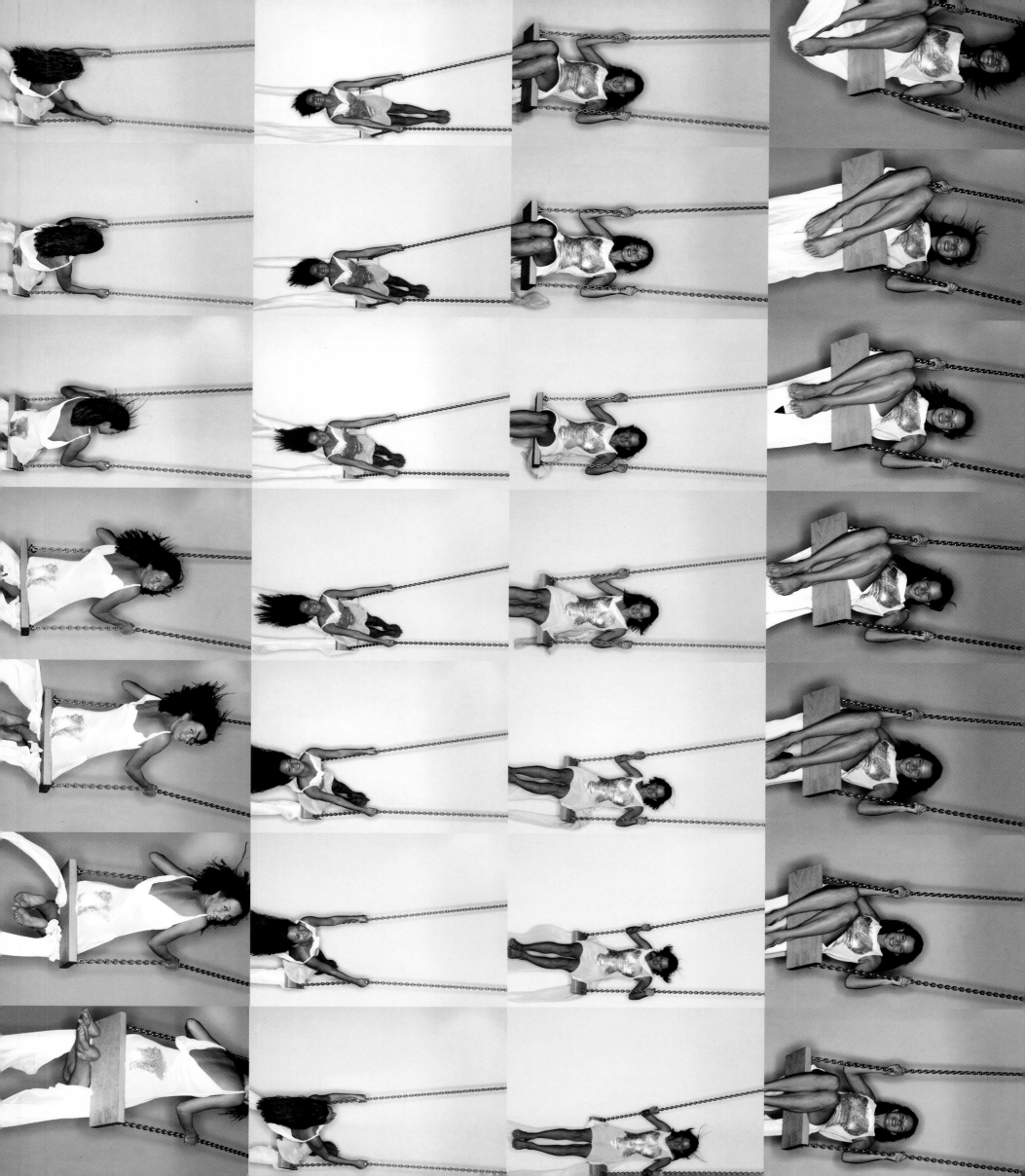

MATT ALAS &
MARCUS PIGGOTT

TONY BURSLER

HUSSEIN CHALAYAN

FABIEN BARON
ROSS BLECKNER
FRANCOIS BERTHOUD
VICTORIA BARTLETT

WK EDDY DESPLANQUES

TONY PAYNE
THIERRY PEREZ

SEAN ELLIS
KATY ENGLAND

PETER SAVILLE
JEREMY SCOTT

ALEX GONZÁLEZ

MARIO SORRENTINO
MARCUS TOMLINSON
KARL TEMPLER

NICK KNIGHT
STEVEN KLEIN

CHRIS LEVINE

STEVEN MEISEL
ALEXANDER MCQUEEN
MARTIN MARGIELA
RAUL MARTINEZ
MARCUS MAM
J. ABBOTT MILLER &
PAUL CARLOS

I remember Visionaire used to be sold outside the tents at the Paris collections. I don't remember who was selling it, but it was some very nice young kid. That's how I first encountered it. Working with Visionaire, you always get a brief—the issue is about love or erotica or the sea. And sometimes you think, "Well, I've got nothing to say about that." Sometimes when you've got that kind of freedom, you end up with a lot of non-commitment. Other times I guess that's the challenge. This issue was about movement, and they had this lenticular cel they were working with, I thought about different things, things decaying or changing color, movement over a long period of time. In the end I wanted to do something light and childlike, a little bit delicate, and not too loaded with meaning. I don't know how it is in America, but there were these things you get in a box of frosty puffs, an image of a kid kicking a ball or something. This is what this image reminds me of; it's just very playful and nice. Kate in fact was on the swing for six hours—that's when you find out what a great model she is. Kate is brilliant. She had to hold the same position throughout an entire cycle of the swing, and I would come in and take the shot at just the right moment. It was really hard work—for her. My part was easy. I just pointed the camera at the pretty girl and pushed the button. NICK KNIGHT

The MOVEMENT cover is, for me, the most resolved piece of work I have contributed to Visionaire. Nick [Knight] and I decided to work together on the project and to use this remarkable lenticular material that Visionaire proposed. The medium itself was amazing, so we didn't need complexity of content—all we needed was a simple idea to best use the material. We thought initially about movement across the frame but then realized the potential of depth. Perhaps someone coming from afar and then back again? One of my favorite photographs of Nick's features a swing. I suggested that he might try that again, but this time in motion —with Kate doing the swinging. The concept was agreed.

Technically, we could have shot it with a movie camera, but Nick being Nick wanted it large format. So we did it the hard way and used the 8 x 10 camera! There were station marks like the gates of a slalom course. As Kate passed by, the camera would go off and we ended up with one frame from each passage. We then repeated the process from behind for the back cover. However, over the course of an hour the swing moved from side to side, so when we put the frames together, they were off register. We gave the whole problem to Martin Orpen, who was going to prepare the film for printing. Martin aligned Kate so that it appeared to be one continuous and convincing trajectory. Nick chose the exact shots for

each stage, with the hair flying this way or that, or Kate laughing. In cinema it's called stop-frame animation. You move an arm just a tiny bit and then another tiny bit, then a day later, a puppet has simply waved. Meanwhile, in the studio, Howard [Wakefield], along with Paul Hetherington and Paul Barnes, was working out the graphic animation for the typography. We found that *Visionaire* and 27*Movement* have the same number of characters and realized that we could morph one into the other. When the V became a 2, the hybrids in between were really interesting. Each letter had to be drawn in the direction you would write it, so that the transitions would look convincing. PETER SAVILLE

Fabien Baron

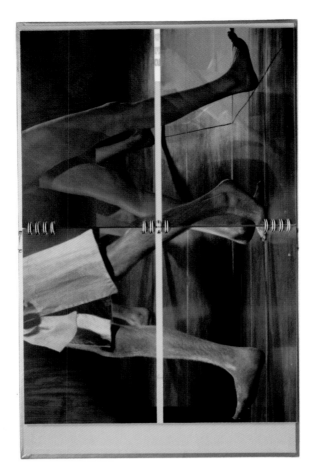

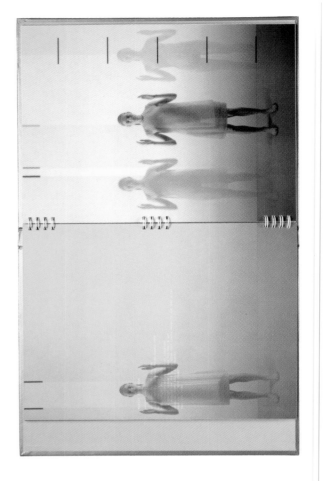

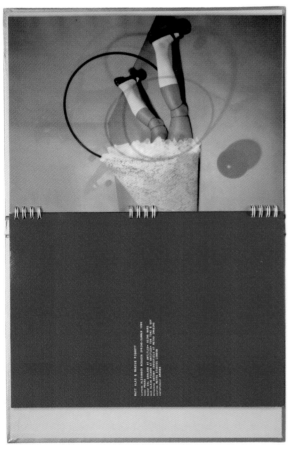

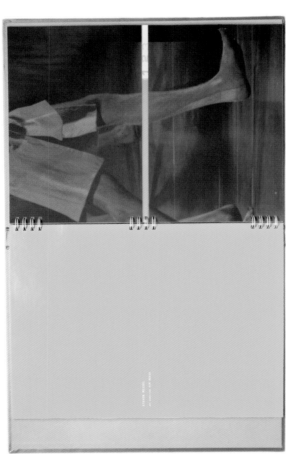

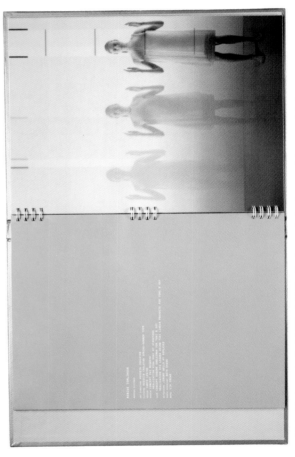

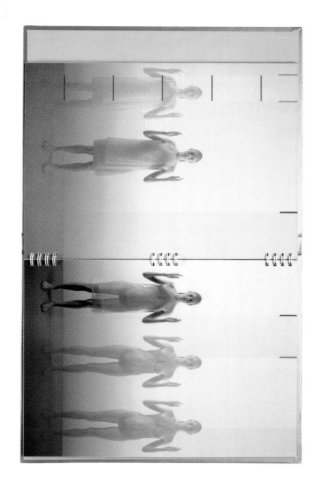

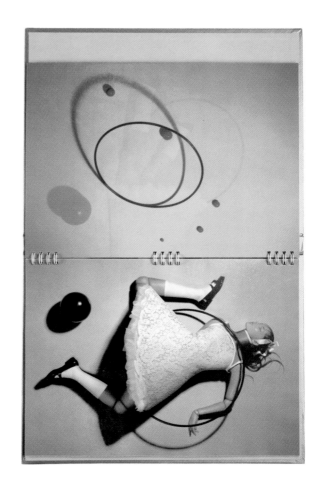

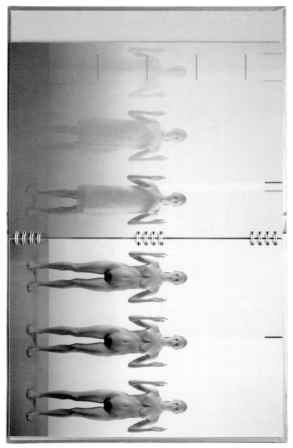

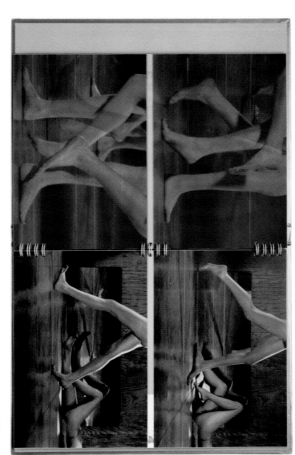

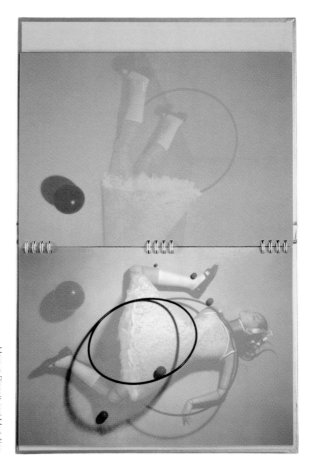

28 THE BIBLE AUGUST 1999 Our millennium issue: "the greatest story ever told" retold in images by modern-day artists and photographers. The intent was to make an issue that was visually provocative but not blasphemous or gratuitously shocking. We worked closely with Dr. Royal Rhodes, professor of religion at Kenyon College, who helped us excerpt passages from the King James Bible. Mario Testino photographed Adam and Eve (dressed in Martine Sitbon and poised to prune with Hermès hedge clippers); Wolfgang Tillmans contributed the Crucifixion; Andreas Gursky's image of a rave became the Exodus; Mary Ellen Mark envisioned a modern day Mary and Joseph; and Steven Meisel imagined the Apocalypse in a series of eerily foreboding fashion images inspired by the painter Odd Nerdrum. As if tackling the Old and New Testaments wasn't already enough, Visionaire collaborated with industrial designer Philippe Starck to create special packaging for the issue. His concept? A molded-plastic "energy sphere." The case was a major undertaking as well as a technical challenge, and there were times when it looked like it would take a miracle to get it produced. But several months after conception, THE BIBLE appeared in all of its glory. 6,000 copies were made.

cover Greg Foley case Philippe Starck

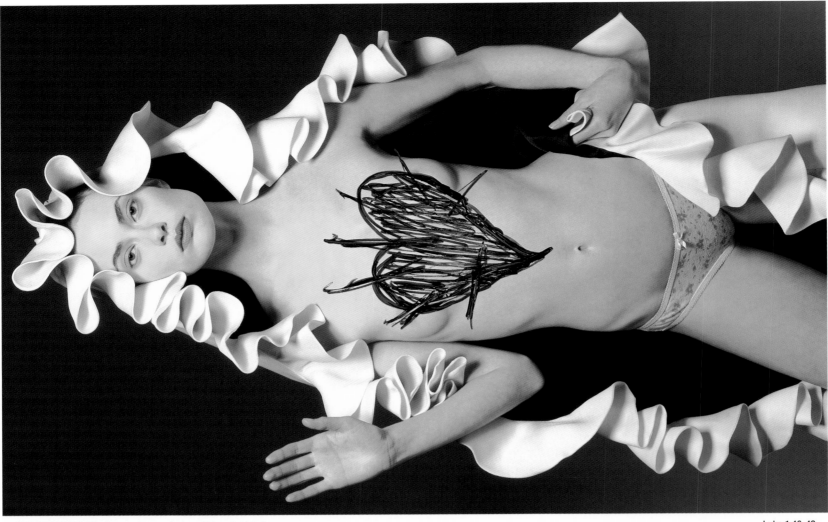

THE VIRGIN MARY by Inez van Lamsweerde and Vinoodh Matadin

Silk gazar veil Viktor & Rolf Haute Couture Makeup James Kaliardos Hair Danilo Lighting Joddokus Driessen Image manipulation Karin Spyker Model Shalom Harlow

And Mary said, My soul doth magnify the Lord, and my spirit hath rejoiced in God my Saviour. For he hath regarded the low estate of his handmaiden: for, behold, from henceforth all generations shall call me blessed. For he that is mighty hath done to me great things; and holy is his name.

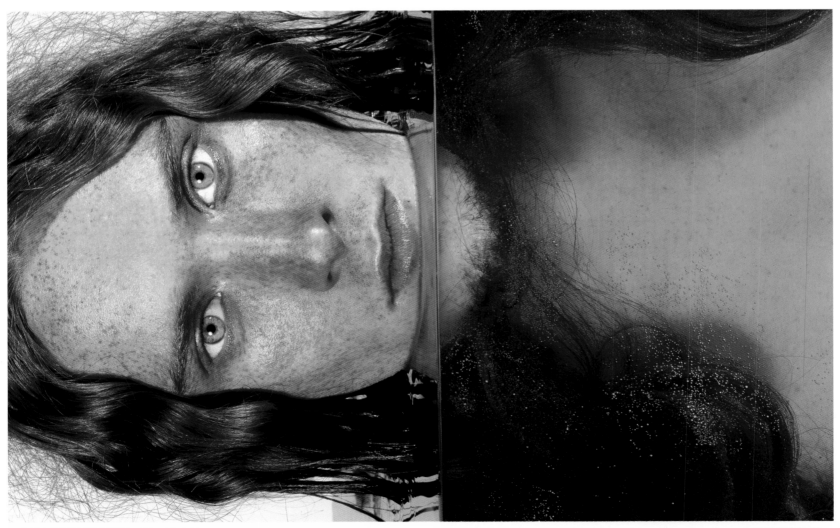

THE BAPTISM OF JESUS by Richard Burbridge

Hair Jimmy Paul Model Kevin

Luke 3:16, 21-22

John answered I indeed baptize you with water; but one mightier than I cometh, the latchet of whose shoes I am not worthy to unloose: he shall baptize you with the Holy Ghost and with fire. Now when all the people were baptized, it came to pass, that Jesus also being baptized, and praying, the heaven was opened, and the Holy Ghost descended in a bodily shape like a dove upon him, and a voice came from heaven, which said, Thou art my beloved Son; in thee I am well pleased.

THE EXODUS by Andreas Gursky

May Day II, 1998. Courtesy Victoria Miro Gallery, London

Exodus 13:18, 21-22

But God led the people about, through the way of the wilderness of the Red sea: and the children of Israel went up harnessed out of the land of Egypt. And the LORD went before them by day in a pillar of a cloud, to lead them the way; and by night in a pillar of fire, to give them light; to go by day and by night; he took not away the pillar of the cloud by day, nor the pillar of fire by night, from before the people.

It is always exciting to find my work in a themed group exhibition or in the context of someone's personal collection, so naturally, it inspired me to contribute a photograph to a completely unknown context with the directive "the Exodus from the Bible." For me, the title was very inspiring because I am interested in the visualization of collective myths and desires. The Bible is, of course, a useful source for this kind of connection. Even if most of the time my work draws upon the phenomena of everyday reality, you can see in it the historical visual reference. Those pictures that are saved in our collective memory help us to give a psychological dimension to a profane copy of reality. While going through the Visionaire BIBLE and looking at images like *The Baptism of Jesus* by Richard Burbridge or *The Last Supper* by Sam Taylor-Wood, I experienced such a feeling of déjà vu. As for my own work, the Hong Kong Shanghai Bank symbolizes the modern Tower of Babel; the general assembly symbolizes the board managers in a shareholders meeting, that is, the Last Supper. As for my *May Day* photos, they are not meant as glorifications of techno culture, even though I love techno and house music. On the contrary, I would say that my personal interest in this culture is not at all a prerequisite for a purposeful photo. Instead, I use these situations to visualize common human desires. ANDREAS GURSKY

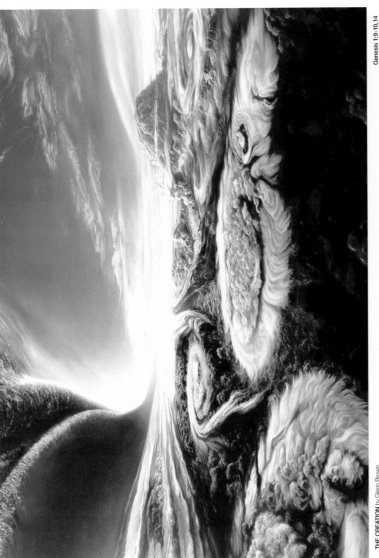

THE CREATION by Glenn Brown

Genesis 1:9-10,14

And God said, Let the waters under the heaven be gathered together unto one place, and let the dry land appear: and it was so. And God called the dry land Earth; and the gathering together of the waters called he Seas: and God saw that it was good. And God said, Let there be lights in the firmament of the heaven to divide the day from the night; and let them be for signs, and for seasons, and for days, and years.

NOAH'S ARK by Frank Gehry

Genesis 6:13-16

And God said unto Noah, The end of all flesh is come before me; for the earth is filled with violence through them; and, behold, I will destroy them with the earth. Make thee an ark of gopher wood, rooms shalt thou make in the ark, and shalt pitch it within and without with pitch. And this is the fashion which thou shalt make it of: The length of the ark shall be three hundred cubits, the breadth of it fifty cubits, and the height of it thirty cubits. A window shalt thou make to the ark, and in a cubit shalt thou finish it above; and the door of the ark shalt thou set in the side thereof; with lower, second, and third stories shalt thou make it.

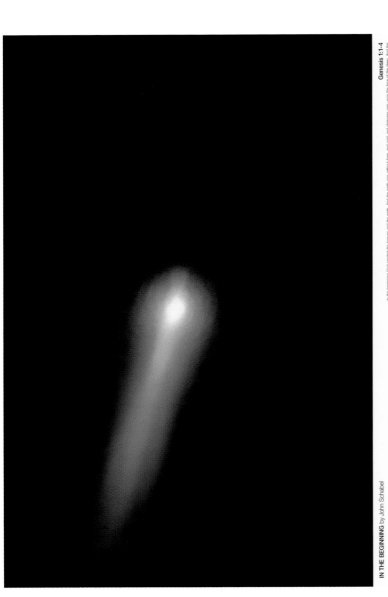

IN THE BEGINNING by John Schabel

Genesis 1:1-4

In the beginning God created the heaven and the earth. And the earth was without form, and void; and darkness was upon the face of the deep. And the Spirit of God moved upon the face of the waters. And God said, Let there be light: and there was light. And God saw the light, that it was good: and God divided the light from the darkness.

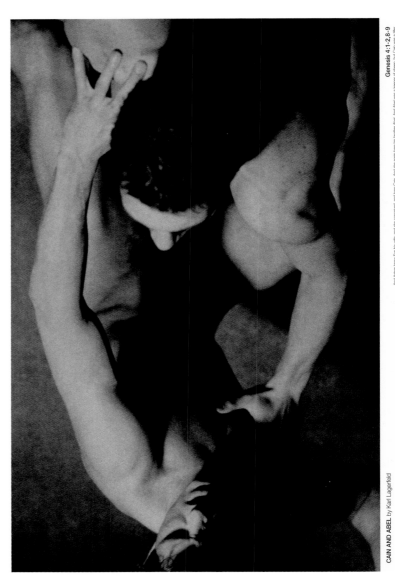

CAIN AND ABEL by Karl Lagerfeld

Genesis 4:1-2,8-9

And Adam knew Eve his wife; and she conceived, and bare Cain. And she again bare his brother Abel. And Abel was a keeper of sheep, but Cain was a tiller of the ground. And Cain talked with Abel his brother: and it came to pass, when they were in the field, that Cain rose up against Abel his brother, and slew him. And the LORD said unto Cain, Where is Abel thy brother? And he said, I know not: Am I my brother's keeper?

178

THE GARDEN OF EDEN by Me Company

Genesis 2:8-9,15,18

And the LORD God planted a garden eastward in Eden; and there he put the man whom he had formed. And out of the ground made the LORD God to grow every tree that is pleasant to the sight, and good for food; the tree of life also in the midst of the garden, and the tree of knowledge of good and evil. And the LORD God took the man, and put him into the garden of Eden to dress it and to keep it. And the LORD God said, It is not good that the man should be alone; I will make him an help meet for him.

ADAM AND EVE by Mario Testino

Genesis 3:7-9

And the eyes of them both were opened, and they knew that they were naked; and they sewed fig leaves together, and made themselves aprons. And they heard the voice of the LORD God walking in the garden in the cool of the day: and Adam and his wife hid themselves from the presence of the LORD God amongst the trees of the garden. And the LORD God called unto Adam, and said unto him, Where art thou?

DAVID AND GOLIATH by Enrique Badulescu

1 Samuel 17:45,50-51

Then said David to Goliath, Thou comest to me with a sword, and with a spear, and with a shield: but I come to thee in the name of the LORD of hosts, the God of the armies of Israel, whom thou hast defied. So David prevailed over the Philistine with a sling and with a stone, and smote the Philistine, and slew him; but there was no sword in the hand of David. Therefore David ran, and stood upon the Philistine, and took his sword, and drew it out of the sheath thereof, and slew him, and cut off his head therewith.

THE ANNUNCIATION by Gregory Crewdson

Luke 1:26,30-31,34

And the angel Gabriel was sent from God unto a city of Galilee, named Nazareth, to a virgin espoused to a man whose name was Joseph, of the house of David; and the virgin's name was Mary. And the angel said unto her, Fear not, Mary: for thou hast found favour with God. And, behold, thou shalt conceive in thy womb, and bring forth a son, and shalt call his name JESUS. Then said Mary unto the angel, How shall this be, seeing I know not a man?

A CHILD IS BORN by Christopher Bucklow

Jon Bloom, 1994 edition still. Courtesy Paul Kasmin, New York and Interim Art, New York/Yancey Richardson Gallery, San Francisco.

The people that walked in darkness have seen a great light: they that dwell in the land of the shadow of death, upon them hath the light shined. For unto us a child is born, unto us a son is given: and the government shall be upon his shoulder: and his name shall be called Wonderful, Counsellor, The mighty God, The everlasting Father, The Prince of Peace.

Isaiah 9:2,6

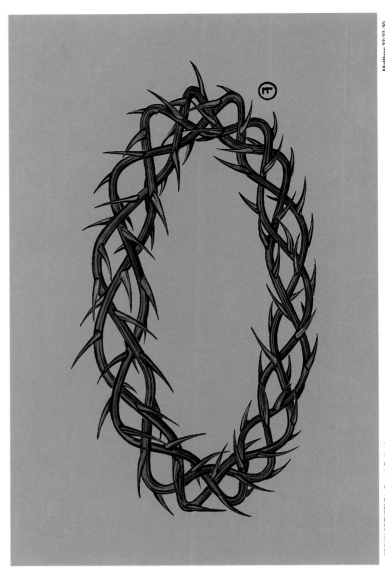

CROWN OF THORNS by François Berthoud

Then the soldiers of the governor took Jesus into the common hall, and gathered unto him the whole band of soldiers. And they stripped him, and put on him a scarlet robe. And when they had platted a crown of thorns, they put it upon his head, and a reed in his right hand: and they bowed the knee before him, and mocked him, saying, Hail, King of the Jews! And they spit upon him, and took the reed, and smote him on the head.

Matthew 27:27-30

NO ROOM AT THE INN by Mary Ellen Mark

And Joseph also went up from Galilee, out of the city of Nazareth, into Judaea, unto the city of David, which is called Bethlehem; to be taxed with Mary his espoused wife, being great with child. And so it was, that, while they were there, the days were accomplished that she should be delivered. And she brought forth her firstborn son, and wrapped him in swaddling clothes, and laid him in a manger; because there was no room for them in the inn.

Luke 2:4-7

I never work with companies or magazines. I work with humans. I was one of the best people destined for this project of THE BIBLE as I am a militant antibeliever. Like all integral antibelievers, I am fascinated by The Bible. My idea was to create mystery and immateriality in a modern way. PHILIPPE STARCK

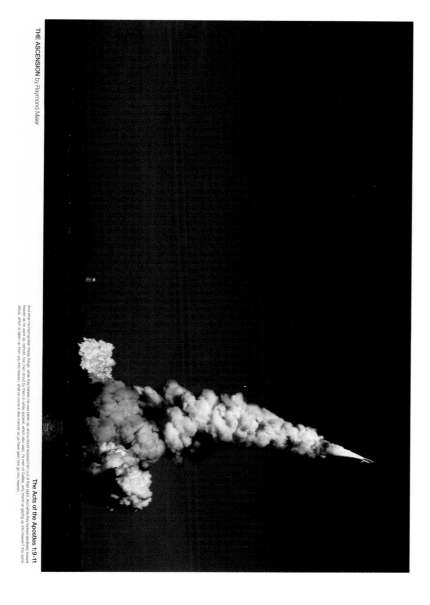

THE ASCENSION by Raymond Meier

The Acts of the Apostles 1:9-11

MOTHER AND CHILD by Jean-Paul Goude

Luke 2:40

THE APOCALYPSE by Steven Meisel Art direction Paul Martinez · Styling Brana Wolf · Makeup Pat McGrath · Hair Garren · Set design Mary Howard · Inspiration Odd Nerdrum

Revelation 1:10-11,17-18

I was in the Spirit on the Lord's day, and heard behind me a great voice, as of a trumpet, saying, I am Alpha and Omega, the first and the last: and, What thou seest, write in a book. And when I saw him, I fell at his feet as dead. And he laid his right hand upon me, saying unto me, Fear not; I am the first and the last: I am he that liveth, and was dead; and, behold, I am alive for evermore, Amen; and have the keys of hell and of death.

JESUS WALKS ON WATER by Mats Gustafson

Mark 6:48-51

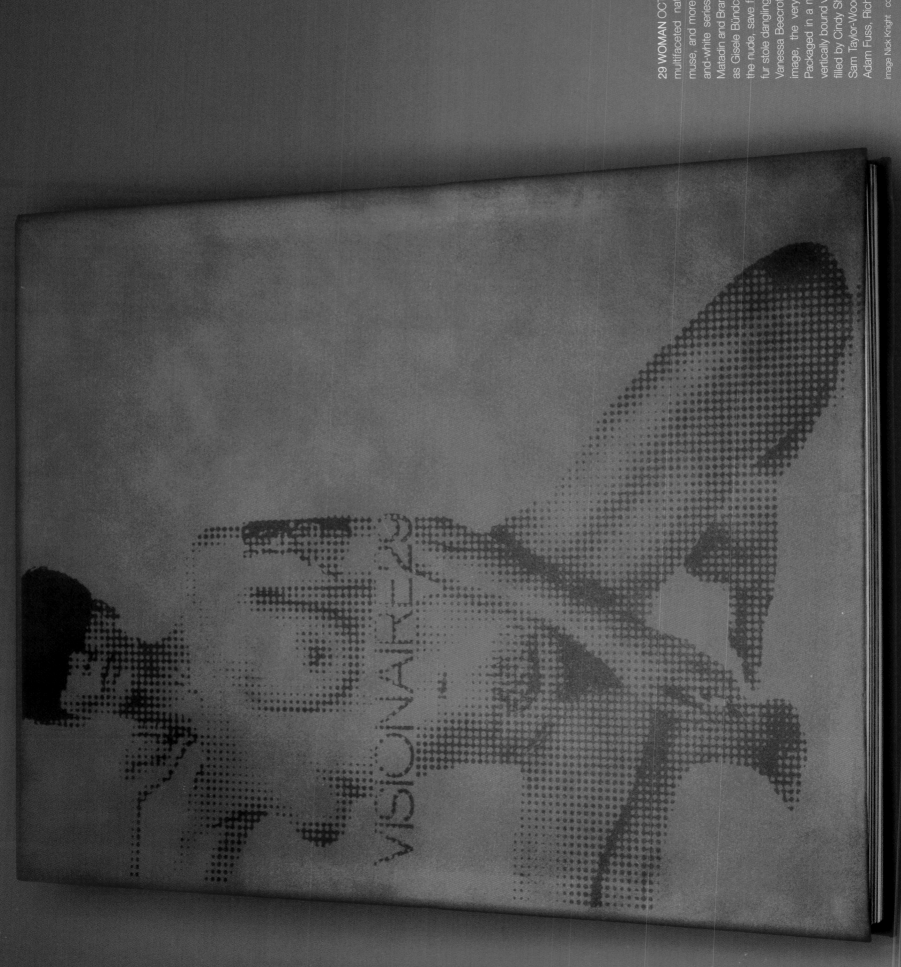

29 WOMAN OCTOBER 1999 In this issue we explored the multifaceted nature of woman—as model, Madonna, muse, and more. Highlights included the eight-part black-and-white series by Inez van Lamsweerde and Vinoodh Matadin and Brana Wolf, which featured such supermodels as Gisele Bündchen, Maggie Rizer, and Frankie Rayder in the nude, save for a Louis Vuitton cape draped here or a fur stole dangling there; Nobuyoshi Araki's photograph of a Vanessa Beecroft performance; and Nick Knight's life-size image, the very feminine, naked *Natasha (née David)*. Packaged in a multiplaned, mirrored case, the issue is a vertically bound volume of red ultrasuede whose pages are filled by Cindy Sherman, Nan Goldin, Beth B, Kara Walker, Sam Taylor-Wood, Sarah Moon, Jane and Louise Wilson, Adam Fuss, Richard Phillips, David Bowie, and others.

image Nick Knight cover and case Greg Foley

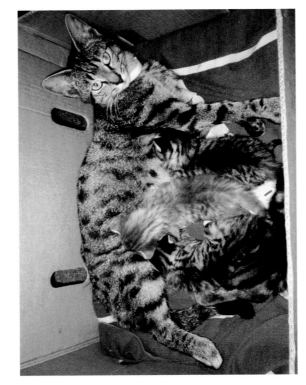

Terry Richardson

I first met Stephen, James, and Cecilia in the men's room of a club in the 1990s, and I've been a contributor for several issues. When they called me up for WOMAN, I had this image of a mother cat circling in my brain. I shot the actual photo when I was in Dublin, on location with Polly Mellen for *Allure*. We were scouting a lot of different locations, and there was this cardboard box with a cat and her kittens at one of the houses, and I took their picture. That's how I photograph—just what comes across my life, like a diary. Later, I remembered this photo for WOMAN. I have always thought that cats, and particularly female cats, are quite feminine. The strongest image of motherhood is the female cat with a fresh litter. There is something so beautiful about little kittens struggling for milk. A lot of humans don't breast-feed, but cats do. Humans turn their backs on their children, but cats don't. There are a lot of neglected children in the world, but the beauty of a female cat is that she always provides for as many kittens as she has, no matter how big the litter. Female cats taking care of their babies... I don't know, maybe I was a cat in another lifetime. TERRY RICHARDSON

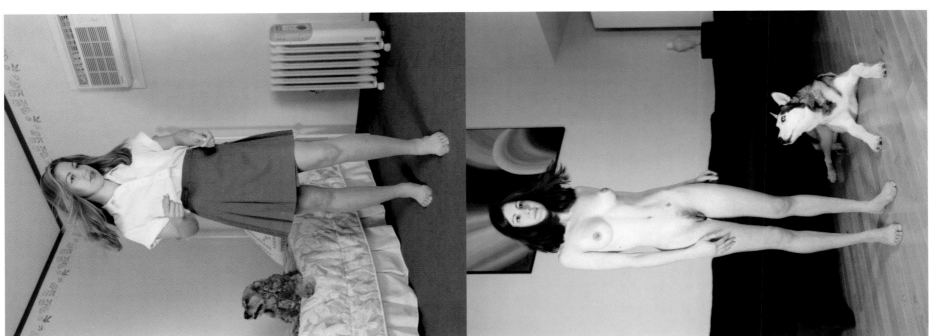

Katy Grannan

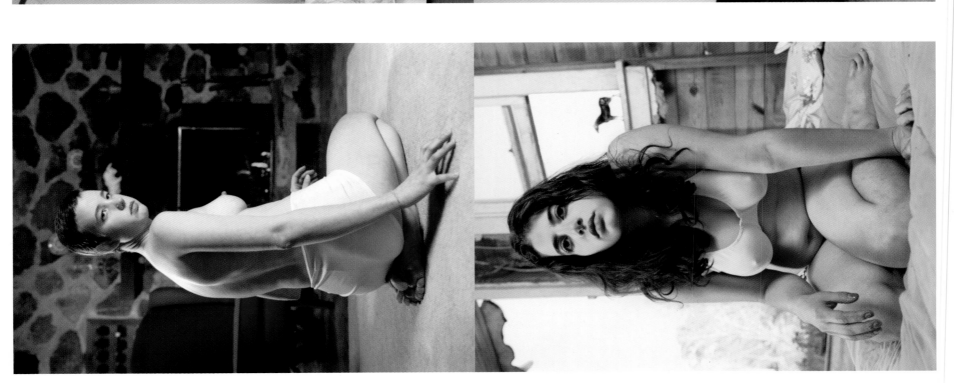

TRACEY MOFFATT

GUY LIMONE

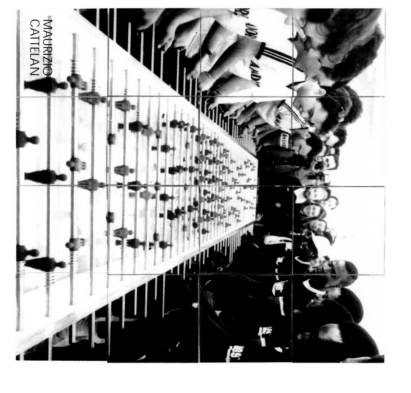

MAURIZIO CATTELAN

YOSHITOMO NARA

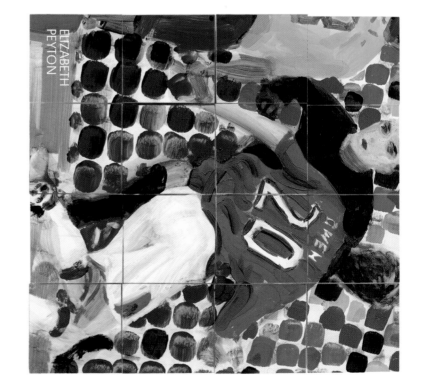

ELIZABETH PEYTON

RAYMOND MEIER

Hornusen is a game people play in the mountains near Bern. I was always fascinated by it but had never actually seen it played, so I had a real personal interest to go and do this picture. I was on vacation in Switzerland, so I did a little research to find out where it was being played. I had a fantastic time. All of the officials were thrilled that I was going to photograph the tournament. It's a very low-key game, and it doesn't get a lot of exposure. I guess you could compare it to polo in the United States. It is the polo of simple people, and it is mostly farmer kids who play it. Hornusen, as you can imagine, is quite dangerous. A small ball, about the size of a golf ball, is pitched at great speed, and players throw these paddles, which are like the boards they use for cooking pizzas, into the air to try and intercept it. It's really amazing. I had this picture in my mind with all of the paddles flying in the air—which is almost exactly how it turned out. RAYMOND MEIER

VISIONAIRE 31 BLUE

31 BLUE FEBRUARY 2000 With BLUE we fulfilled two dreams: to make an issue of large-format, poster-size images and to sew the issue into a custom-made garment, in this case, a limited-edition Levi's turn-of-the-century One-Pocket Sack Coat. With Levi's as the sponsor and blue as the theme, much of the artwork focused on Americana. Inez van Lamsweerde and Vinoodh Matadin photographed Shalom in an American-flag T-shirt. Richard Phillips overlaid a 1970s-style smiley face on a detailed drawing of a sneering girl. Marcus Piggott and Mert Alas treated us to an iconic close-up of Kate Moss wearing a Levi's collar piece reconstrued to read "eLvi's." Gus Van Sant shot a blue-eyed albino couple from his upcoming film project, and Justine Kurland provided her dystopic view of suburbia. More contributions came from Fabien Baron, Greg Foley and Orfi, David Armstrong, Nan Goldin, Terry Richardson, and Gary Hume.

case Levi's cover Justine Kurland

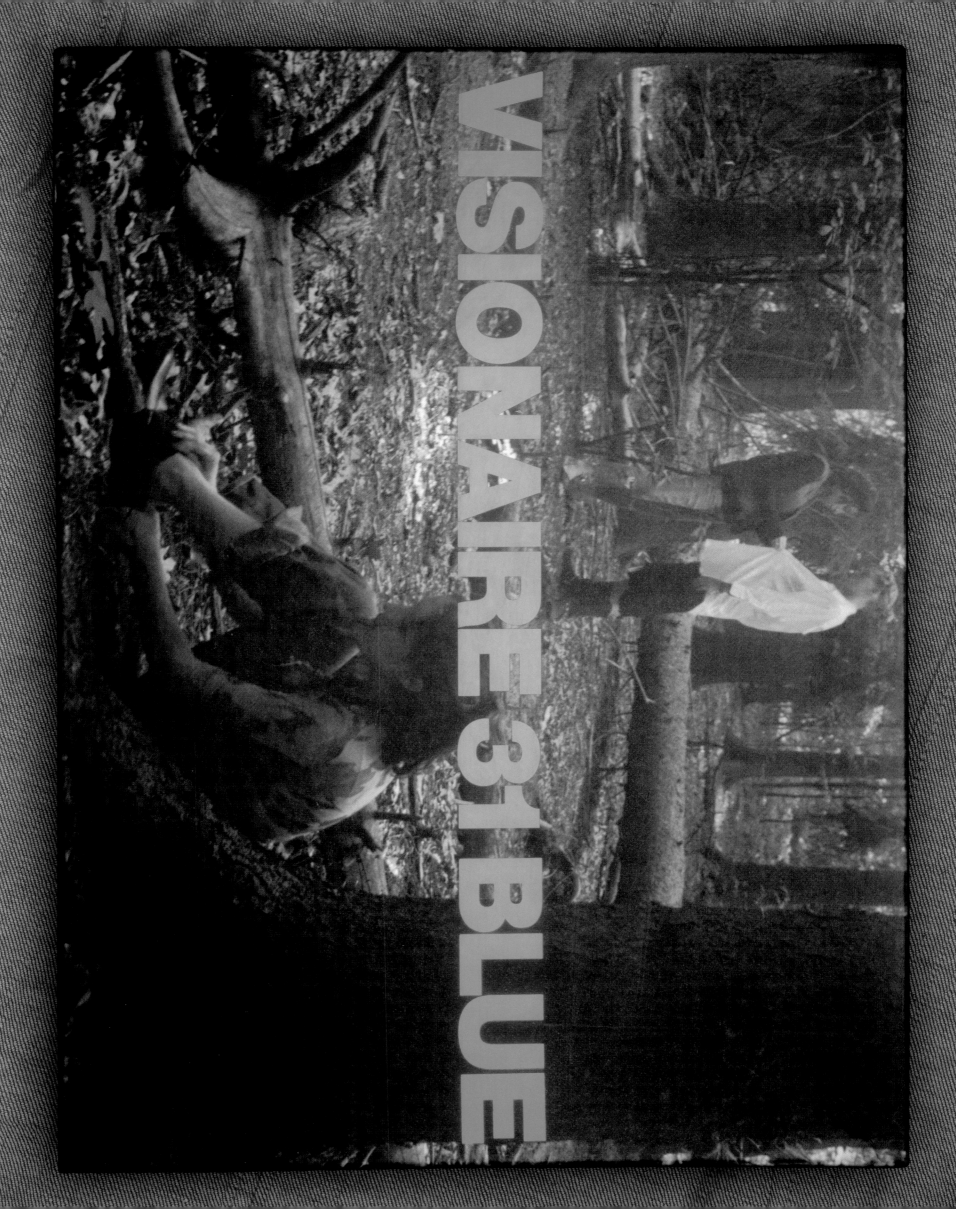

The foundation of my artwork emerged as a radical presentation of fashion-based imagery and large-scale oil painting. I was motivated to contribute to Visionaire because of the leading position it had taken in merging diverse artistic practices in completely unique contexts. BLUE was an opportunity to introduce my work in the poster format, which was the first way I experienced art growing up in the '70s.

The piece I contributed was a charcoal and chalk drawing made in preparation for the seven by five foot painting *Untitled (Smiley)* 2000. The image was inspired by a '70s porn-magazine cover I found in Germany. When discussing the project with Visionaire, we agreed that this drawing had excellent poster potential. The connection to the concept of BLUE happened when we collaborated on shifting the "smiley" from its traditional yellow to a Visionaire blue, the result being the warping of the impact of the image into a unique experience that exists solely in the issue. In the end, I was very pleased with the outcome of the issue, not only because of the fine collection of posters on the abstract subject but also because of the completely uncompromised realization of the object. The radical act of sewing the issue into a custom coat caused an emergency in my mind. RICHARD PHILLIPS

Richard Phillips

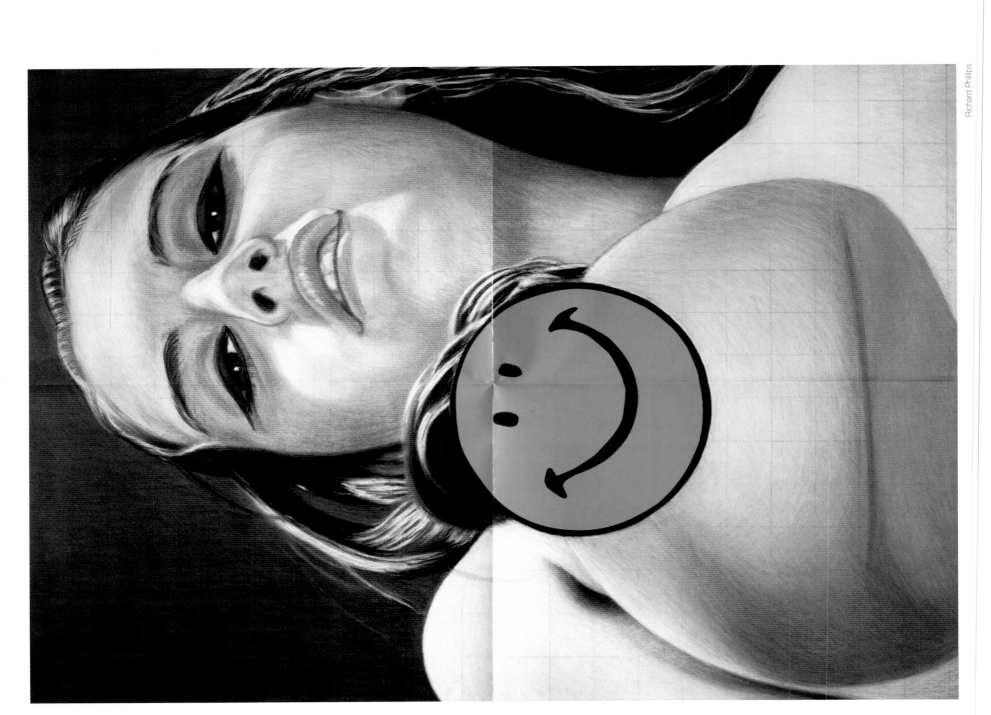

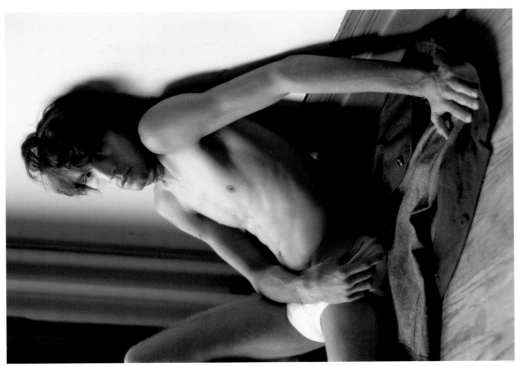

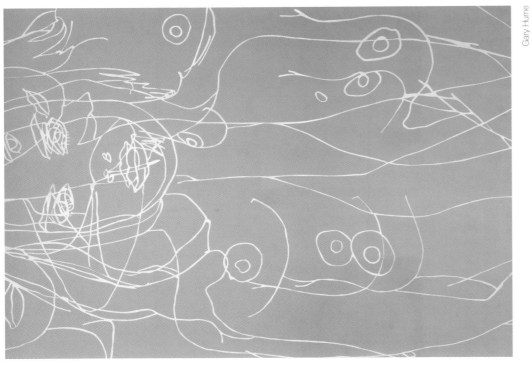

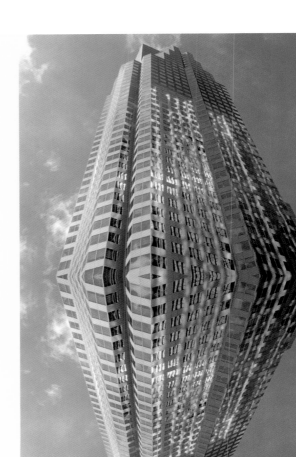

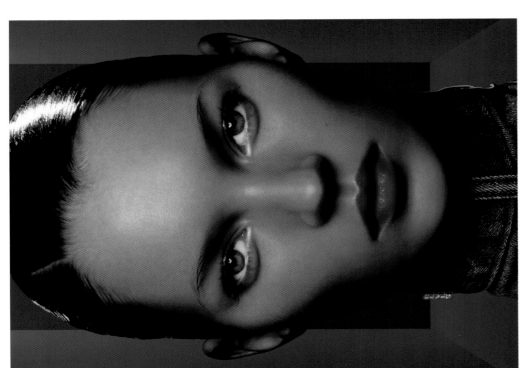

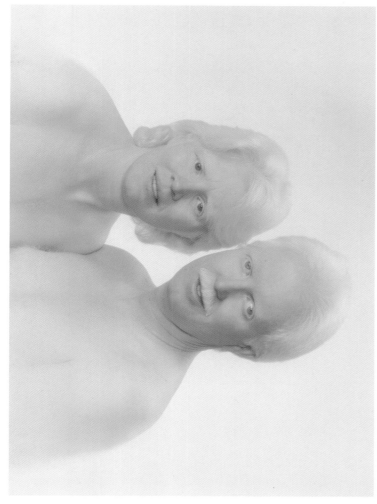

Gus Van Sant

Wolfgang Tillmans

Sharon Ellis

Mario Testino

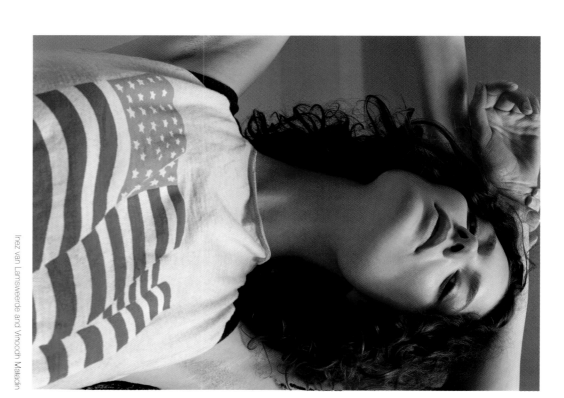

Inez van Lamsweerde and Vinoodh Matadin

32 WHERE? MAY 2000 Stephen met Jean-Louis Dumas, the president of Hermès, in Moscow one snowy winter night. Jean-Louis carries around a little sketchbook wherever he goes and uses it to record all of his various travel experiences. Years later, the idea for this Hermès travel pouch—designed by Jean-Louis himself—came up. We were traveling a lot at the time and were amused by the idea of a collection of imaginary, faraway places and the silly postcards that say things like "Greetings from Mars." Contributors included Andreas Gursky, Mary Ellen Mark, Wolfgang Tillmans, Bruce Weber, Lauren Greenfield, Peter Lindbergh, and Jeff Burton. The postcards were made individual not only by the singular vision of each contributing artist but also by the original graphic treatment on the reverse side of each of the fifty-five silver-edged images. They also proved to be excellent party invitations. We sent boxes of them to friends in such far-flung places as Tokyo, Bangkok, Paris, and Brooklyn, which they then mailed back to us with the requisite postage stamps, and the inevitable wear and tear of shipping and handling.

leather case Jean-Louis Dumas cover Greg Foley

VISIONAIRE 32

WHERE?

HERMÈS
PARIS

VISIONAIRE 32

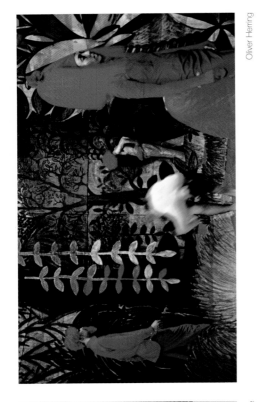

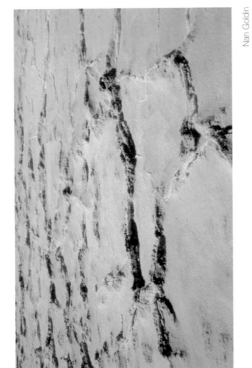

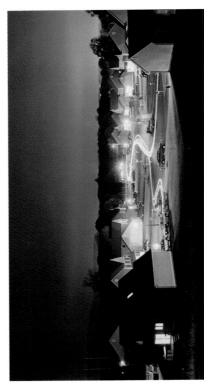

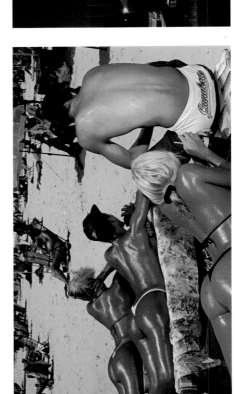

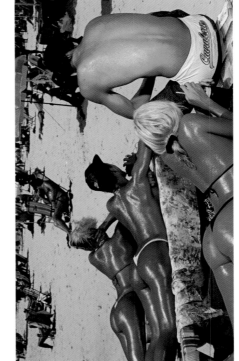

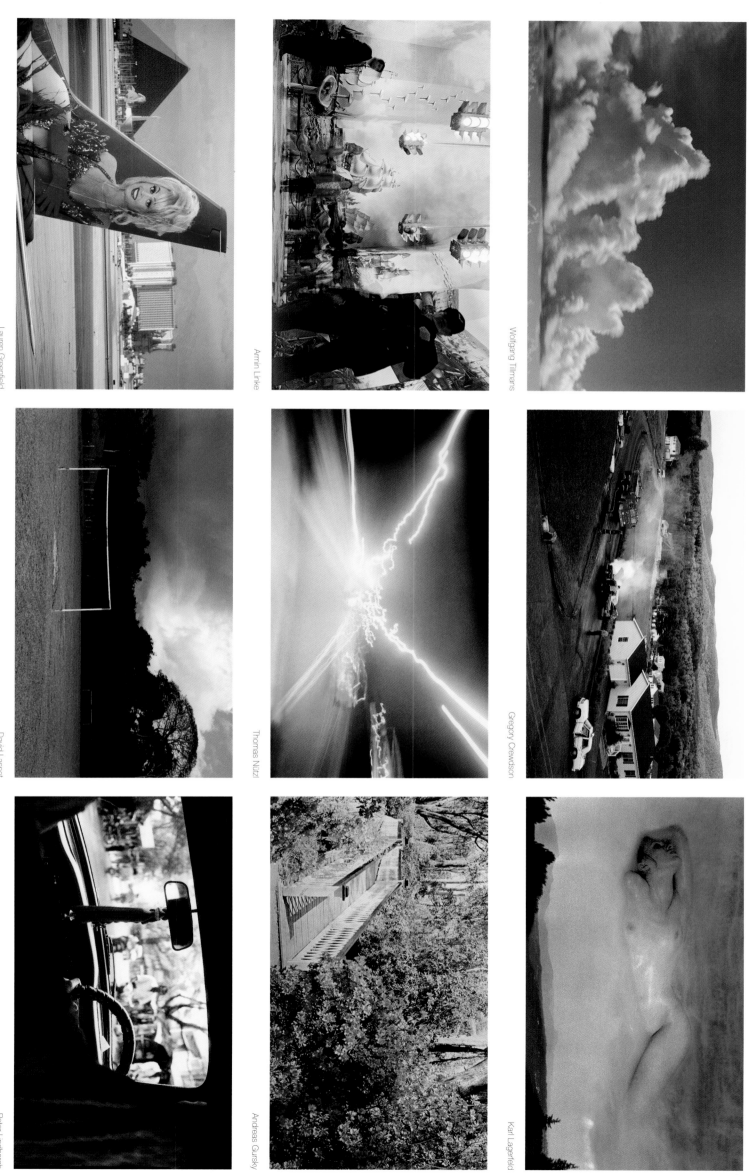

Lauren Greenfield

Armin Linke

Wolfgang Tillmans

David Lasret

Thomas Nützl

Gregory Crewdson

Peter Lindbergh

Andreas Gursky

Karl Lagerfeld

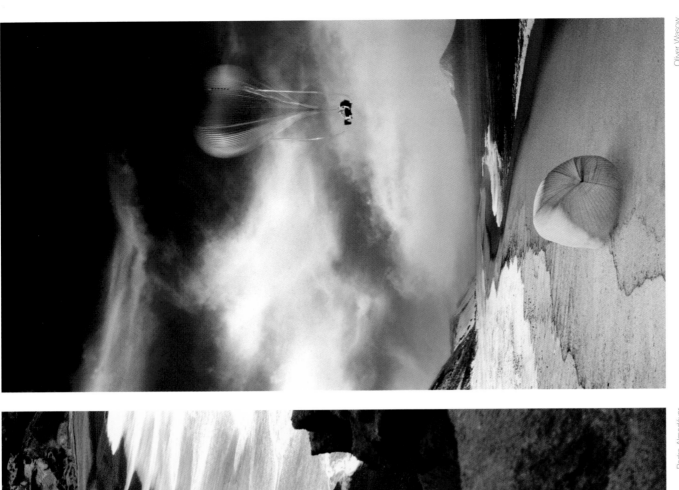

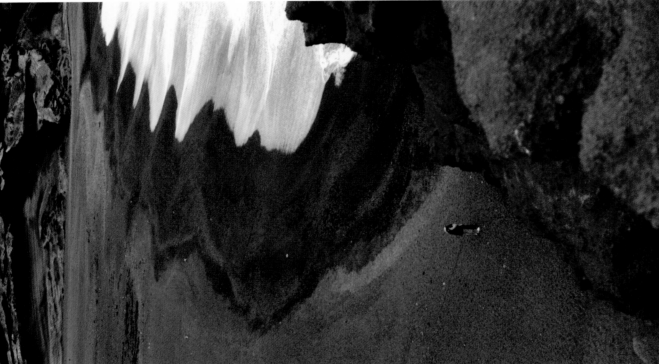

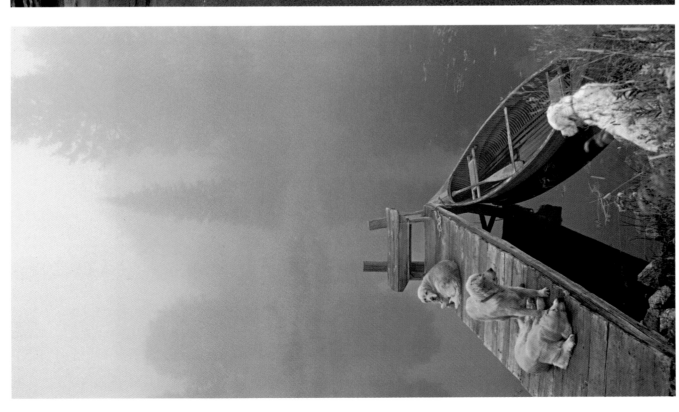

I was particularly attracted to WHERE? because I think of my photographs as travel photos, pictures of places I've been or would like to go, things I've seen or would like to see. I've collected postcards for years and am fascinated by the idea of how we document the experience of going to other places. The postcards I made for Visionaire were photographs I took while traveling, though they have been somewhat digitally altered after the fact. Their titles—the names of cities, countries, beaches, etc.—are based not on where the photographs were actually taken but on where they look as though they might have been taken. They're about states

of mind as much as states of place. The thematic nature of Visionaire's projects intrigues me, as does their focus on packaging and the creation of unique and beautiful objects. I like too that Visionaire draws from a wide range of artists, not just fashion photographers but fine-art photographers, painters, and filmmakers as well. It seems that as artists gain access to new technologies and the limits to self-publishing and self-distribution start to erode, the already fuzzy lines between fine and commercial art are blurring even further. In this respect, the people at Visionaire are definitely ahead of the curve. OLIVER WASOW

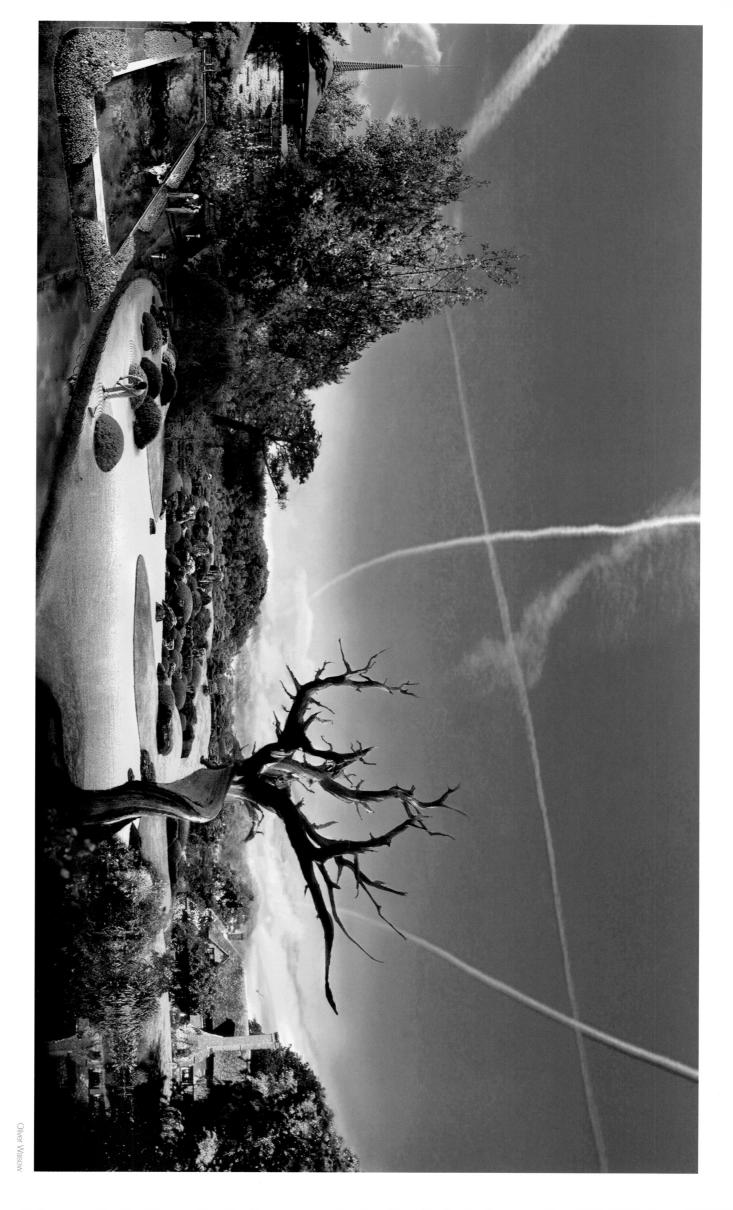

Oliver Wasow

33 TOUCH OCTOBER 2000 Artist and longtime Visionaire contributor François Berthoud outdid himself when he interpreted twenty of our favorite new looks from the fall/winter 2000–2001 collections, which were all about excess and sensory overload. Elements such as pop-ups and cutouts represented a journey back to our roots, but whereas in the past we could only afford to use one or two of these techniques in an entire issue, this time each page received multiple treatments. Flocking, foil stamping, sculpt-embossing, and honeycomb extension gave the feeling in print of fur over metallic lace over sequins over a dress with leather appliqués over patterned stockings. Our collaborator Fendi's tactile ready-to-wear collection that season was a key source of inspiration. The unbound illustrations were wrapped in a wearable pony-skin *cache-col* and housed in a brushed-gold metal box. Highlights include designs by John Galliano, Alexander McQueen, Viktor & Rolf, Junya Watanabe, and Helmut Lang.

case Greg Foley and Fendi

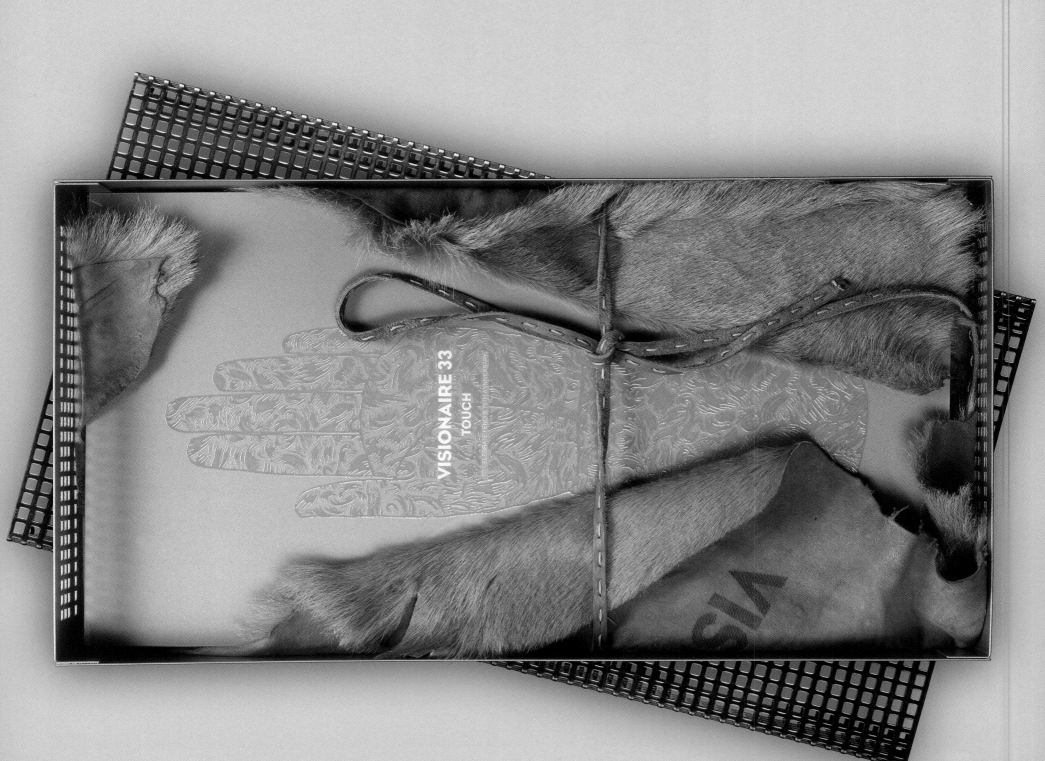

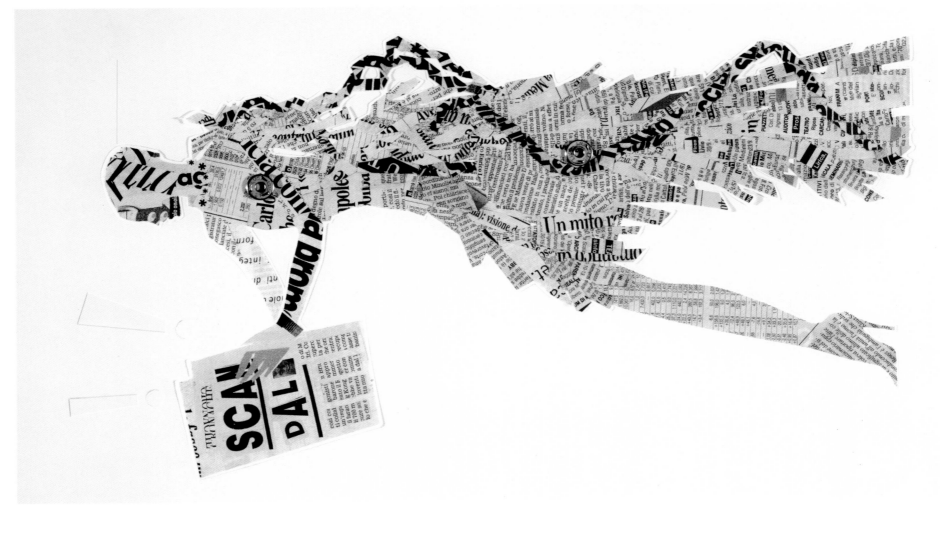

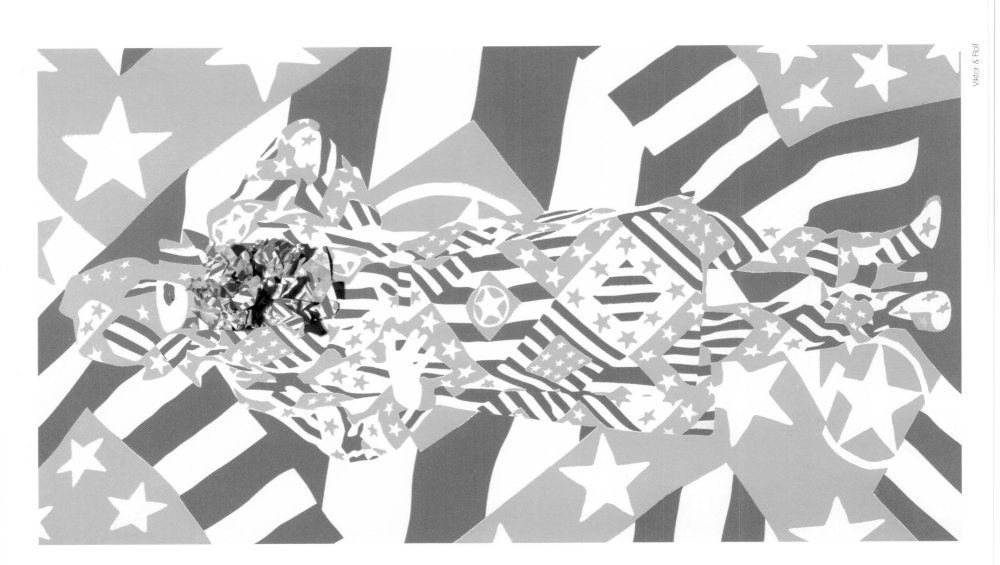

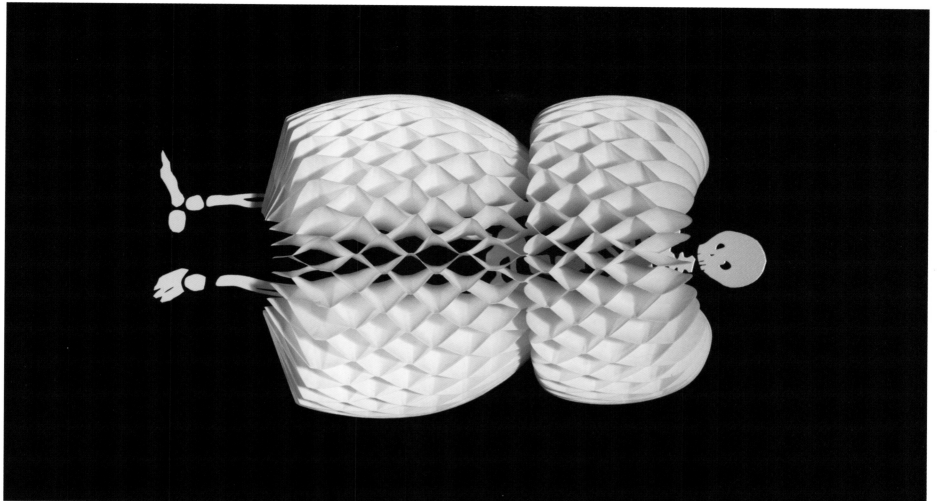

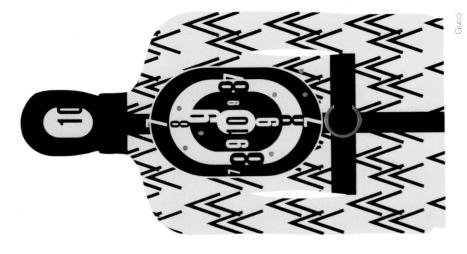

What I like most about Visionaire is the spirit of complete freedom, of doing things out of passion alone, and especially the idea of doing something completely independent but with a lot of fun around it. TOUCH represented the peak of our collaboration. Each time we've worked together, we've tried to push the limits of print—which is part of the overall Visionaire concept but also very specific to our collaborations. With art and illustration as opposed to photography, we've had more opportunities to really experiment. In TOUCH, every plate was completely different, created using a different technique. I was thrilled because we really did it all the way through. It's very extreme. But this is what makes Visionaire Visionaire. There is the structure, the organization, and the means to realize things, and more importantly, the time and the people to make them happen. For an artist to be put into a situation like that, to be able to best express himself, there is nothing better. FRANÇOIS BERTHOUD

Fendi

Helmut Lang

Alexander McQueen

Fendi

Chanel

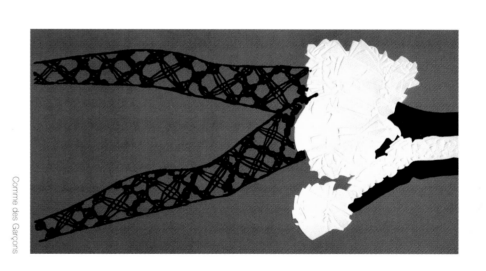

Comme des Garçons

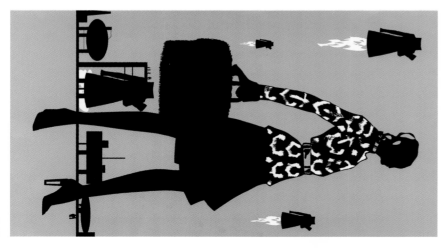

Fendi

Fendi

34 PARIS JANUARY 2001 Curated by Hedi Slimane, the design director of Dior Homme, PARIS was in many ways a reaction to our tendency toward the baroque—one that we had just fully indulged in the previous issue, TOUCH. For PARIS, leading architects, artists, and designers portrayed the City of Light as the City of Tomorrow, with clean, spare lines and a strict white, gray, and black color palette. The issue was a testament to Hedi's reductionist aesthetic and an exploration of a burgeoning new movement: art that has its base in architecture. To this end, architect Greg Lynn designed a lacquered gray monolith with an interior topography engineered to hold the bound book as though suspended in space. Contributors included architects Neil Denari, Andreas Angelidakis, and Dominique Perrault; video artist Chris Cunningham; artists Thomas Demand, Elisabeth Ballet, James Casebere, and Craig Kalpakjian; graphic designers H5 and John Maeda; and the French band Air.

case Greg Lynn

VISIONAIRE 34 PARIS DIOR HOMME

VISIONAIRE 34 PARIS DIOR HOMME

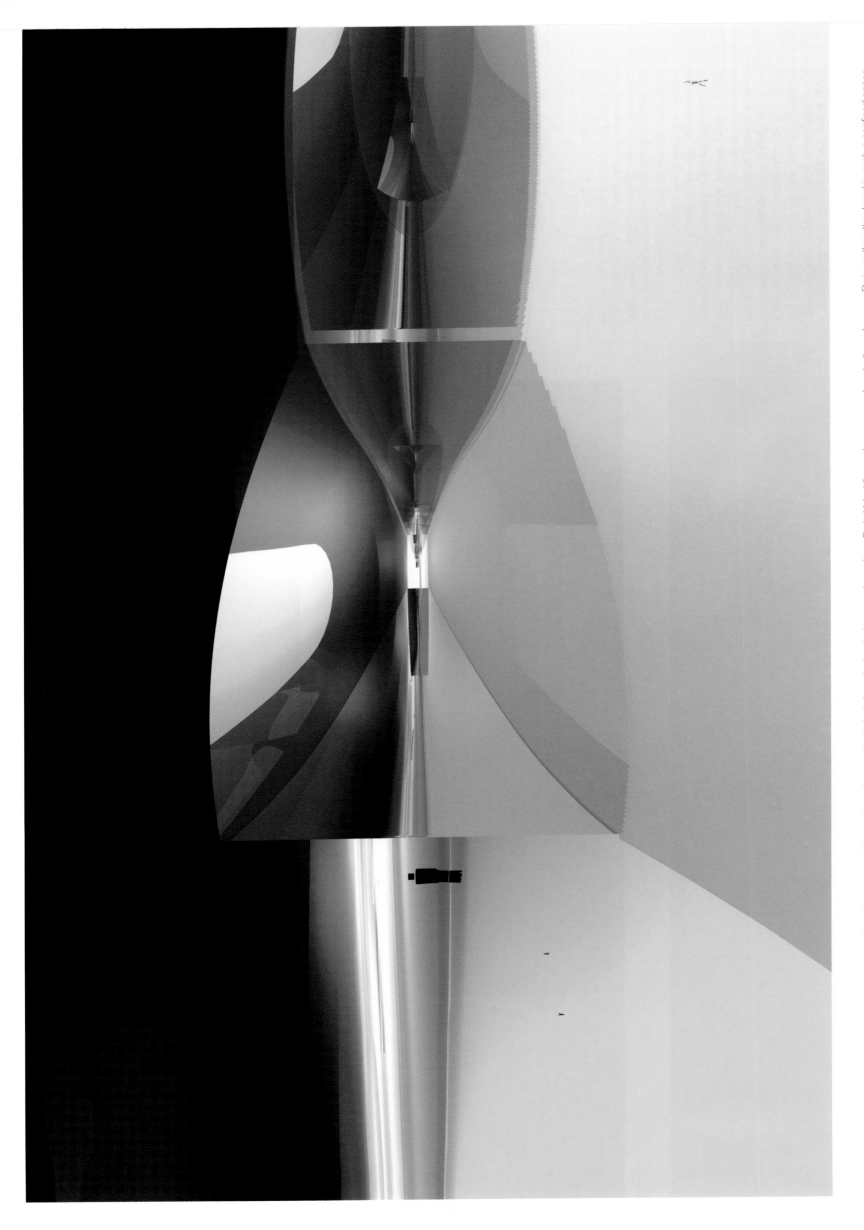

I had wanted to do an issue about Paris for quite some time. It was something that Stephen and I had spoken about a lot. When I joined Dior it was very natural to transpose a certain idea of Paris to a new generation as the idea of Paris is a key issue for me at Dior. For me, the PARIS issue came with the process of creating Dior Homme. I had a new house, a new studio, this new idea—the issue is a piece of a whole. There were a few people whose work I am fond of and knew I wanted to include from the beginning, people such as Craig Kalpakjian and Thomas Demand. There is a very specific aesthetic I am interested in and the idea was to build a new Paris using architecture as a main support. I didn't want any fashion in the issue. Neither are there any signs of human life. This is in part because I was already creating fashion and a character for Dior. I was pursuing a single idea and people may find it dry—basically it's lines and graphics and free

space, almost ethereal space. Paris on the other hand is such a confined space, almost reclusive. But it was always really very clear to me. It was also very obvious that I would do this issue with Visionaire. PARIS is a very particular perspective, different from the issues they had done in the past. It was interesting to bring it in a new direction, to open things up to new people. At the end of the day, it is about collaboration, opening the space for Visionaire and for me. HEDI SLIMANE

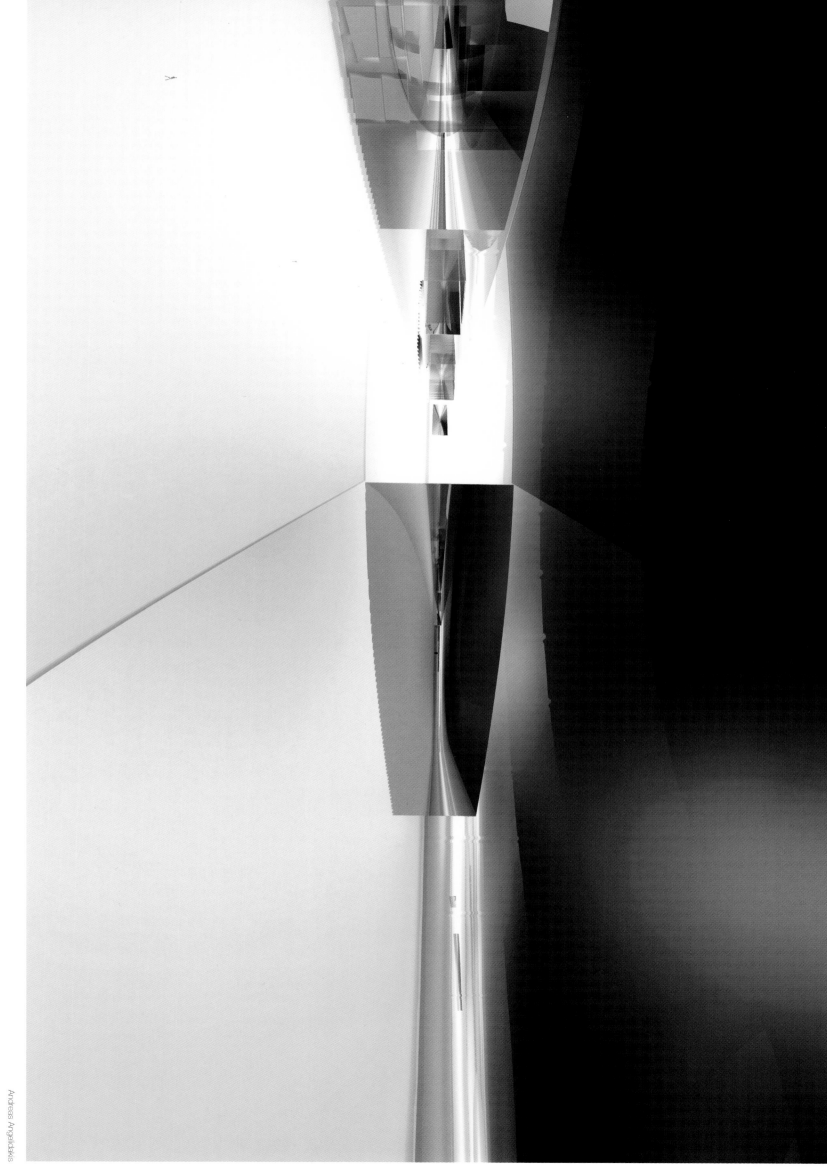

35 MAN MAY 2001 Having done an issue on woman, we decided the time had come to do one on man. Mario Testino, in his second run as guest editor, conceptualized the ultimate men's magazine complete with past icons and new heroes, advertisements from the 1970s, photographs made by famous women of their men, and man as seen by contemporary artists. Neville Wakefield edited an all-vellum section of video stills, Will McBride contributed a section called Manliness, and Mario Testino did Man at Work. More than one hundred contributors participated, including photographers Richard Avedon, Nick Knight, Mario Sorrenti; filmmakers Larry Clark, and Sofia Coppola; gallerist Sadie Coles; music-video director Hype Williams; artist Sarah Lucas; and models Cindy Crawford, Gisele Bündchen, and Claudia Schiffer.

cover Mario Testino case Greg Foley

VISION AIRE 35 MAN

MARIO TESTINO

ED VAN DER ELSKEN ›
UNTITLED (NED, 1928
COURTESY THE NETHERLANDS PHOTO ARCHIVES
AND ANNET GELINK GALLERY, AMSTERDAM

MOTOCROSS, LONDON ‹
WEDDING, DUBLIN ›

TIM HAILAND ‹
UNTITLED (NED, 1997
COURTESY THE ARTIST AND CRG GALLERY, NEW YORK

MARIO TESTINO ›
ANATOMY STUDY 2, 2000

PETER VAN STRAATEN ‹
COURTESY ROB MALASCH / SERIEUZE ZAKEN, AMSTERDAM

SARAH LUCAS ›
HAPPY FAMILIES, 1999 (DETAIL) COURTESY SADIE COLES HQ, LONDON

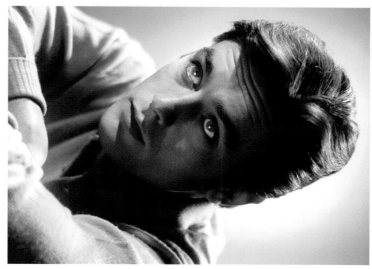

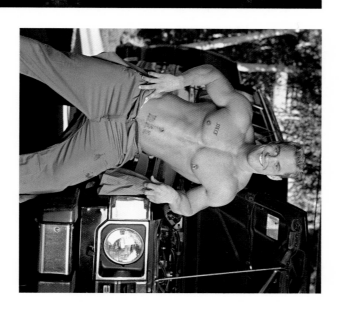

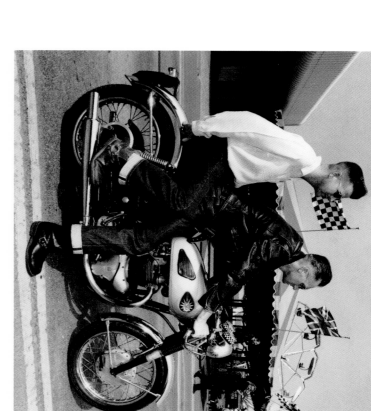

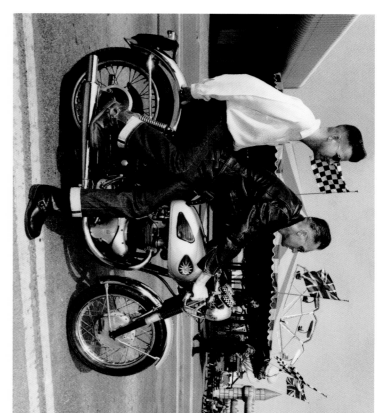

MICHAEL HOWELLS, HERBERT BOYCE, 1999, PHOTO BY HELEN SOLOMON, DAVID DOWTON, MARCELLO MASTROIANNI, 2000

DANIEL KRAMER, BOB DYLAN WITH CIGARETTE IN HARMONICA HOLDER, TOWN HALL, PHILADELPHIA, PA., 1964, COURTESY TORCH GALLERY, AMSTERDAM

JEFF BURTON, CAESAR, 1999, COURTESY CASEY KAPLAN GALLERY, NEW YORK

I had been pretty immersed in my work over the previous ten years so I didn't know much about Visionaire. Sadie Coles, my gallerist in London, called and said it was the coolest magazine on the planet, so that really piqued my interest. I checked it out in a bookstore; most of the issues were wrapped in plastic and cost $150 or more. The first issue I contributed to was WOMAN, then WHERE?, and finally this one, MAN, which was sort of right up my alley. Most of the work I've done has been about selling man to men who fetishize men. This particular image was a box cover for a feature adult film, a portrait of a friend of mine, Caesar, working on a car—classic homoerotic manliness. It pulled out another body of my work people weren't really aware of; straightforward portraiture based on selling someone as a sex object. It's also just a pretty picture. Most of my work is in porn shops, and this was an opportunity to see it in a completely different context. I thought it would be an interesting addition to the work of the fine artists, fashion photographers, and other contributors to the issue. The hierarchy is normally so rigid, with fine art at the top, fashion a bit lower than that, and porn even a bit lower than that. I wanted to break through and introduce those genres to one another. I like the idea of rupturing expectations and blurring the boundaries between art and porn, high and low, rare and popular. JEFF BURTON

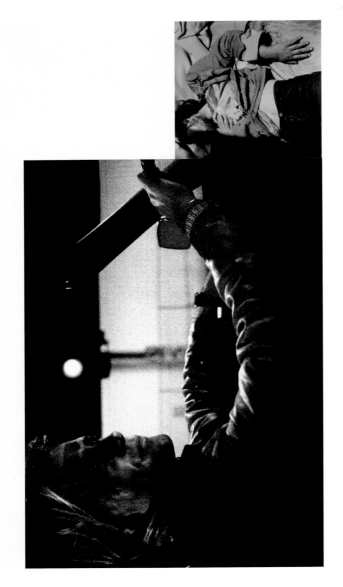

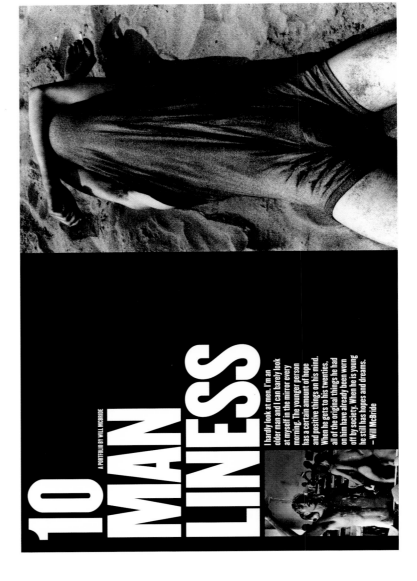

THOMAS NÜTZL‹
SUNSET BLVD. 4:00 AM
MILES ALDRIDGE›

10 MANLINESS

A PORTFOLIO BY WILL MCBRIDE

I hardly look at men. I'm an older man and I can barely look at myself in the mirror every morning. The younger person has a certain amount of hope and positive things on his mind. When he gets to his twenties, all of the original things he had on him have already been worn off by society. When he is young he still has hopes and dreams.
– Will McBride

EMMANUELLE ALT‹
PHOTO BY KARL LAGERFELD›
MARCELO KRASILCIC,
ISIDORO KRASILCIC

Public Notice

Police notice

Illegally parked vehicles
including ☒ will be removed

Recovery will cost at leas

TRAVELER, HEATHROW, LONDON‹
TIAGO RAPOSO, LISBON,

Mario Testino

11 MAN AT WORK

MARIO TESTINO
STYLING CARINE ROITFELD
MAKEUP TOM PECHEUX
HAIR MARC LOPEZ
PHOTOGRAPHY ASSISTANTS TOBIAS RATZ
AND MICHAEL BEAUPLET
STYLIST ASSISTANTS JACE WINTER
ALEXI LUBOMIRSKI, CHNCELO CLAUDIO
AND JULIA VON BOEHM

DANIEL KLAJMIC
AND ISABELLA BLOW ‹
TOP
CLOTHING ALEXANDER HERCHOVITCH
MAKEUP AND HAIR CELSO KAMURA
THANKS TO MAURICIO IANES
AND PABLO MARTINEZ
MODELS DOUGLAS AND DANIEL MOTELI

CARMEN FREUDENTHAL
AND ELLE VERHAGEN ‹
CLOTHING VERONIQUE BRANQUINHO,
VERONIQUE LEROY, MARTIN MARGIELA
VIVIENNE WESTWOOD, RAF SIMONS,
MAKEUP PET HAIR LIEKE
MODELS PETRA, LIES, LUCS, WINNIE, ROBERT,
EUGENE, ELS, GLOBE, TYNEKA AND RONALD

Chris Levine

PEDRO CLAUDIO ‹
SOLVE SUNDSBØ ‹
(UNTITLED (WATERBOY))
STYLING SIMON ROBINS
MAKEUP PETROS PETROHILOS
HAIR PETER GRAY
IMAGE MANIPULATION MARK BOYLE
AND GLENN GRESFORD AT METRO IMAGING
LOCATION BIG SKY STUDIO
MODEL GEORGE CLEMENTS

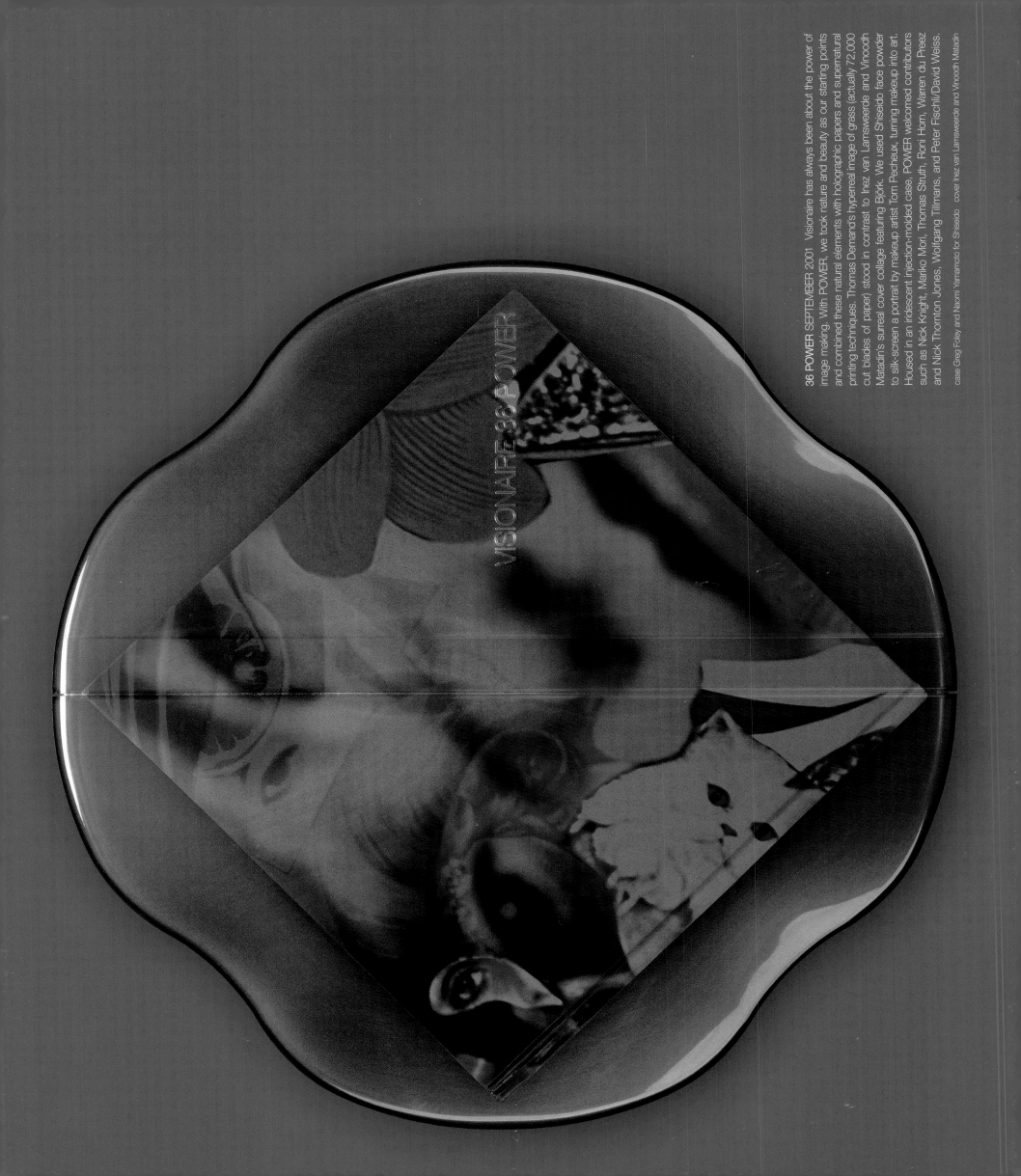

VISIONAIRE 36 POWER

36 POWER SEPTEMBER 2001 Visionaire has always been about the power of image making. With POWER, we took nature and beauty as our starting points and combined these natural elements with holographic papers and supernatural printing techniques. Thomas Demand's hyperreal image of grass (actually 72,000 cut blades of paper) stood in contrast to Inez van Lamsweerde and Vinoodh Matadin's surreal cover collage featuring Björk. We used Shiseido face powder to silk-screen a portrait by makeup artist Tom Pecheux, turning makeup into art. Housed in an iridescent injection-molded case, POWER welcomed contributors such as Nick Knight, Mariko Mori, Thomas Struth, Roni Horn, Warren du Preez and Nick Thornton Jones, Wolfgang Tillmans, and Peter Fischli/David Weiss.

case Greg Foley and Naomi Yamamoto for Shiseido cover Inez van Lamsweerde and Vinoodh Matadin

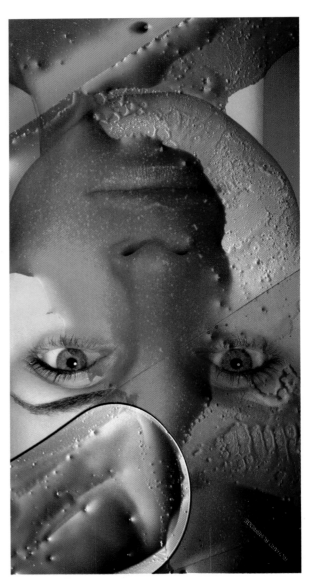

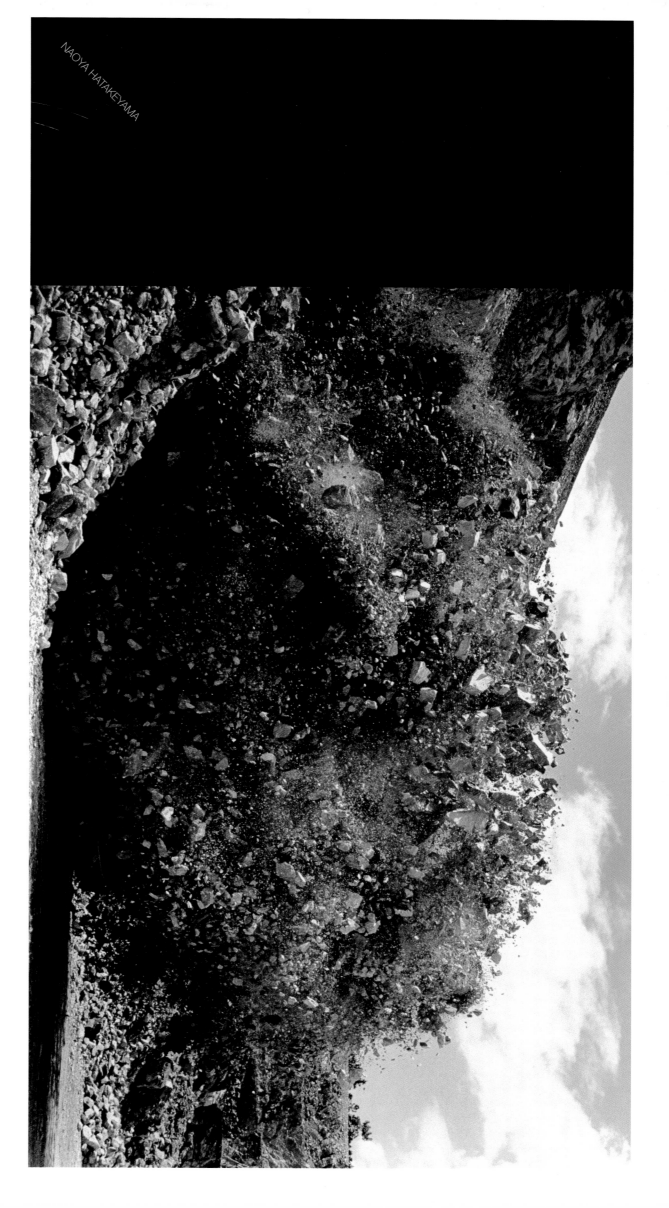

NAOYA HATAKEYAMA

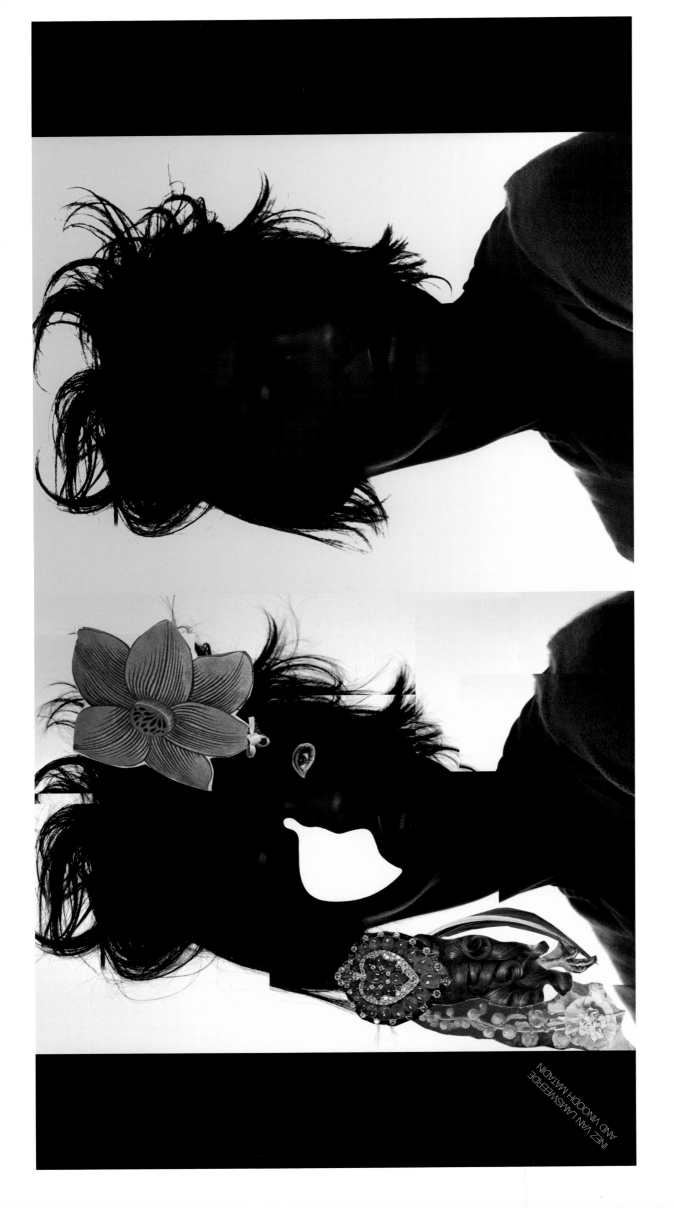

INEZ VAN LAMSWEERDE
AND VINOODH MATADIN

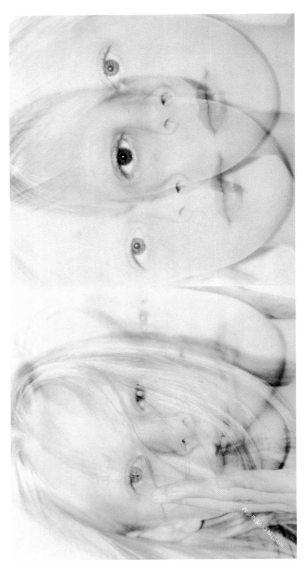

WOLFGANG TILLMANS

FABIEN BARON

ME COMPANY

For us, power speaks of the fundamental physical engines of the universe. It is the primal breath of the collapsing event horizon, the birth of perplexity, and the death of silence. Our image holds an unresolved dialogue among expressions of personality, introspection and the genesis of self is the theme. We see a person, digitized and ephemeral, beaming shyly through the mirrored halls of quantum uncertainty. It's not a photograph. It's a three-dimensional scan of a human head, the model of which became the basis for our manipulations and additions. Seeing through a glass darkly, we witness a person becoming power through sheer force of will. It's a portrait, but it's subversive. Fragments fly as tremendous energies pulse in tight twisting orbits, light is bent in wicked arcs, surfaces are unstable. Everything is surreal. Our work is created primarily with computers. Our process is convoluted. We talk, write, draw, sculpt, refine, systematize, build, compose, texture, surface, process, debate, think, play, categorize, experiment, recompose, light, and render. We feed the results back into this iterative gathering of materials and ideas. Progress towards the synthesis of the final image is an interactive feedback loop among ad-hoc teams of designers. It is recursive and malleable, open to change and opportunity. We channel a complex, ever changing wave of slow, incremental authorial changes, rapid intuitive leaps, and unexpected system-generated artifacts into a coherent pictorial statement. We believe that myths, stories, and fabrications are somewhere close to the heart of communication. ME COMPANY

37 VREELAND MEMOS FEBRUARY 2002 One day a mysterious package arrived at the Visionaire offices. It was a large box containing more than four-hundred original memos from Diana Vreeland to her staff at *Vogue*. The package had been sent to us by a contributor who preferred to remain anonymous but who had been on the receiving end of some of this legendary inter-office correspondence. In some ways, the experience was like stumbling upon fashion's Holy Grail. We had heard stories about these memos but were stunned to find out that they actually existed. Dating from 1966 to 1972, the memos, which were dictated to Vreeland's secretary from the sanctuary of her bathroom each morning, covered topics ranging from the wacky (the use of freckles or the utter importance of dog collars, for example) to the divine (the genius of Halston). But more importantly, the Vreeland memos provide a rare glimpse inside the mind of one of the most influential women in fashion history. With help from Alexander Vreeland and David Remnick at *The New Yorker*, we received permission from Condé Nast to publish nearly 150 of the memos in an edition of 4,000. We soon discovered just how many Vreeland fans there are out there: We received more single copy orders for VREELAND MEMOS than for any previous issue.

case Greg Foley

To: BARON DE GUNZBURG
MRS. SIMPSON
Copy to: MRS. SCHIFF
MRS. MELLEN
MRS. DI MONTEZEMOLO
MRS. HOVEY
MISS DONOVAN
MRS. INGERSOLL
MISS MCKENNA
MISS WINKELHORN
MISS HAYS
MR. DUHÉ
MRS. BLACKMON
MISS CANNÉ
MISS MIRABELLA
MRS. FRANKEL
MRS.GROSS
MISS SLAVIN
MISS MACRAE
MRS. BOOTE

From: MRS. VREELAND
Date: April 3, 1970
Subject: BLACK MODELS

I feel that really no photograph done of a black model, with the exception of one head, has any special "thing" about it.

I feel that the black models have been photographed exactly as we would do white models.

No strong voluptuous message of mystic comes through to me in the photographs we publish. Does anyone understand what I am saying?

This came home to me very much when I saw little Hylette Adolphe in "Satyricon" where she was so totally removed from the white world and so totally an addition to it.

I don't think that we study their hair or their skin.

We are now on the verge of going into the next Autumn's pictures in the new few weeks and please consider this.

Anyone who would like to discuss it with me, do come and see me.

Write memo

To: BARON DE GUNZBURG
MRS. SIMPSON
MRS. MELLEN
Copy to: MRS. SCHIFF
MRS. DI MONTEZEMOLO"
MRS. HOVEY
MISS DONOVAN
MRS. INGERSOLL
MISS MC KENNA
MRS. BUTLER
MISS WINKELHORN
MISS HAYS
MR. DUHÉ
MRS. BLACKMON
MISS CANNÉ
MISS MIRABELLA
MRS. FRANKEL
MRS. SCHON

From: MRS. VREELAND
Date: SEPTEMBER 16 1968
Subject:

RE: SERPENTS

Don't forget the Serpent...

The serpent should be on every finger and all wrists and all everywhere...

The serpent is the motif of the hours in jewellery...

We cannot see enough of them...

To: BARON DE GUNZBURG
MRS. SIMPSON
MRS. SCHIFF
MRS. MELLEN
MRS. DI MONTEZEMOLO
MRS. HOVEY
MISS DONOVAN
MRS. INGERSOLL
MISS MC KENNA
MRS. BUTLER
MISS WINKELHORN
MISS HAYS
MR. DUHÉ
MRS. BLACKMON
MISS CANNÉ
MISS MIRABELLA
MRS. FRANKEL
MRS. HOUSTON
MRS. LOEN GROSS

From: MRS. VREELAND
Date: May 11, 1969
Subject:

I went and spend an hour and a half with Halston.

I think he has a remarkable set up. I think his choice of fabrics and the opportunity that he gives to whom he visualizes as his clients which are obviously fashion-minded, well-built people is unique... He is the next best thing to having a top boutique at your disposal as the prices are so good and the clothes so utterly and completely modern. I do think we must give him the real treatment. I think what he is making is simply great.

To: BARON DE GUNZBURG
MRS. SIMPSON
Copy to: MRS. SCHIFF
MRS. MELLEN
MRS. DI MONTEZEMOLO
MISS MILINAIRE
MISS DONOVAN
MR. DUHÉ
MRS. INGERSOLL
MISS HAYS
MISS MC KENNA
MISS WINKELHORN
MISS HAYS
MISS PHILLIPS
MRS. BLACKMON
MISS MIRABELLA

From: MRS. VREELAND
Date: DECEMBER 9, 1966
Subject:

RE: PEARLS

I am extremely disappointed to see that we have used practically no pearls at all in the past few issues. In fact, many necklines could have been helped by pearls worn inside the dress that show inside the cutaway sides and back of most ordinary dresses on top...

I speak of this very often -- and as soon as I stop speaking the pearls disappear.

Nothing gives the luxury of pearls. Please keep them in mind.

To: BARON DE GUNZBURG
MRS. SIMPSON
Copy to: MRS. SCHIFF
MRS. MELLEN
MRS. DI MONTEZEMOLO
MRS. HOVEY
MISS DONOVAN
MRS. INGERSOLL
MISS MC KENNA
MISS WINKELHORN
MISS HAYS
MR. DUHÉ
MRS. BLACKMON
MISS CANNÉ
MISS MIRABELLA
MRS. FRANKEL

From: MRS. VREELAND
Date: JUNE 18 1968
Subject:

RE: SONNY AND CHER

Sonny and Cher are going to be here the end of June...

As we couldn't publish the pictures of Chér the last time she was here and her dream is to be in high fashion and she looks beautiful in it, are there not some pictures that could be taken then?

For instance a spread that could be done by Waldeck or Penati?

The great thing is to wash her face... and if you have any trouble with her tell her that I will talk to her and she simply has to realize that certain makeups, such as a thick opaque one with thick opaque eyelashes (such as she was done before) simply don't photograph... and this is all we can say about it...

There has to be a transparency, a gleam, a lightness and an amused expression or people look dead today and very old...

To: BARON DE GUNZBURG
MRS. SIMPSON
Copy to: MRS. SCHIFF
MRS. MELLEN
MRS. DI MONTEZEMOLO
MRS. HOVEY
MISS DONOVAN
MRS. INGERSOLL
MISS MC KENNA
MISS WINKELHORN
MISS HAYS
MR. DUHÉ
MRS. BLACKMON
MISS CANNÉ
MISS MIRABELLA
MRS. FRANKEL
MRS. HOUSTON
MISS SLAVIN

From: MRS. VREELAND
Date: OCTOBER 2 1968
Subject:

RE: ELSA PERETTI

I have seen several pictures now - one of Avedon which you will see in November and one of Waldeck which you will see in the Arts department...

This girl I know looks like another generation - her limbs and the way of using her body...

However she is a complete lifesetaway in my opinion - I think you could do the greatest most fascinating fashion pictures of her...

No-one has fussed with her hair...

No-one has taken trouble with the girl because the photographers are still looking for babies and I have to add, none of them are finding any...

I think to show clothes this girl is superb, but no-one has fussed with her... She has done her best and I believe - though of course I don't know - she has always felt unwanted and only used for clothes of a certain proportion...

She has a small bust, which with a proper bra, can be gotten around - and outside of that her body, legs, arms, wrist, and throat and brow are superb...

I suggest that she is refreshing and that you use her.../

I had never seen the memos. I knew my grandmother had dictated a lot of them over the course of her years at *Vogue*, but I had never realized that people actually saved and collected them. Since the issue came out, I have heard of people who did exactly that. I can only think that the staff at *Vogue* knew something special was going on at the time, that they felt they were part of something that had never happened before. There is a sense that because she was interested in fashion and because a lot of what she did and said was very entertaining, that my grandmother was a lightweight. In reading the memos it becomes clear that she had a huge burden of responsibility for a magazine that came out more than once a month and required a great deal of discipline and organization to manage. It always amazed me how much of *Vogue* was her vision and how clear she was about what she wanted. She had the knack for surrounding herself with extremely talented people and letting them do what they did best. I often hear people ask who really has the talent within an organization. Is the designer really designing? Is it the photographer who is making the picture or is it the stylist? One doesn't know who is really doing what. And not to take away from the tremendous contribution of all of the photographers, stylists, and writers she worked with at *Vogue*, but she was the captain of the ship and set a very clear and definite course. ALEXANDER VREELAND

THE CONDÉ NAST PUBLICATIONS Inc.

To BARON DE GUNZBURG From MRS. VREELAND Date DECEMBER 6, 1966

Copy to MRS. SIMPSON Subject:
 MRS. SCHIFF
 MRS. MELLEN
 MRS. DI MONTEZEMOLO
 MISS MILINAIRE
 MISS DONOVAN
 MR. DUHÉ
 MRS. INGERSOLL
 MISS HARLOW
 MISS MC KENNA
 MISS WINKELHORN
 MISS HAYS
 MISS PHILLIPS
 MRS. BLACKMON
 MISS MIRABELLA

RE: <u>COVER SITUATION</u>

Our cover situation is drastic....

I do not hear from anyone an idea or a suggestion of either a face
or something that would be suitable....

We are on the verge of a drastic emergency.

38 LOVE JULY 2002 In many ways, this issue was a response to the events of the past year. For us at Visionaire, love meant going back to our roots to create an issue with a literal human touch, something hand-made with an easy, uplifting message. For our contributors, love meant many different things. Steven Meisel contributed some of the first photographs he'd ever taken, shot on the street outside of New York modeling agencies ("I love...FASHION"); photographers Mario Sorrenti, Craig McDean, and Peter Lindbergh gave us glimpses into their personal lives through portraits of their kids; and Tim Noble and Sue Webster gave us "Instant Gratification", a self-portrait in dollar bills ("CAN'T BUY Love"). LOVE also featured thousands of feathers gathered by milliner Philip Treacy, thousands of flowers curated by pop singer Kylie Minogue, and the pop group Destiny's Child sent us their favorite fan letter. There were also words of love, a first for Visionaire: original poetry and prose by Joyce Carol Oates, Kenneth Koch, Jonathan Safran Foer, and T. Cole Rachel. Each issue came with a silver heart designed by legendary jeweler Elsa Peretti. All of the artwork and tokens of love were inserted by hand into 4,000 vintage novels making each issue an actual one-of-a-kind object and a true labor of love. The issue brought us back to the first days of Visionaire, when each issue was hand-assembled on the floor of Stephen's apartment, only then of course, the hands doing the assembling were our very own.

case Tiffany & Co. cover Greg Foley

VISIONAIRE 38
LOVE

TIFFANY & Co.

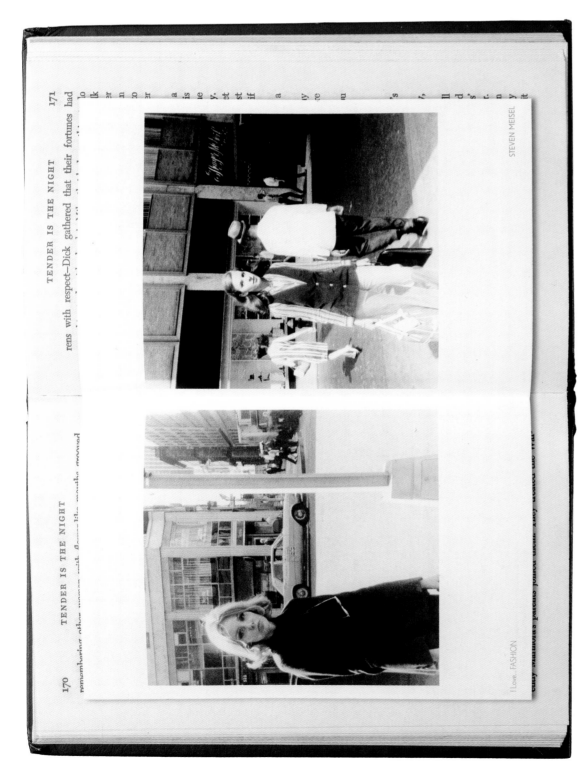

STEVEN MEISEL

i.Love. FASHION

Kylie Minogue

Amber Valetta

Craig McDean

Mats Gustafson

Setsuko Klossowska De Rola photo A. Canovas

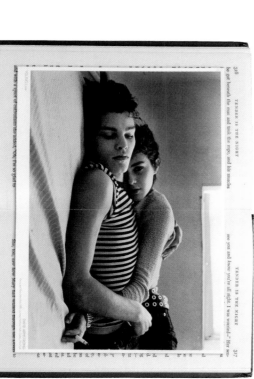

David Armstrong

Tobias Schweitzer & Stephen Gan

Philip Treacy

Nan Goldin

TIM NOBLE & SUE WEBSTER
Instant Gratification, courtesy Modern Art, London

CAN'T BUY LOVE

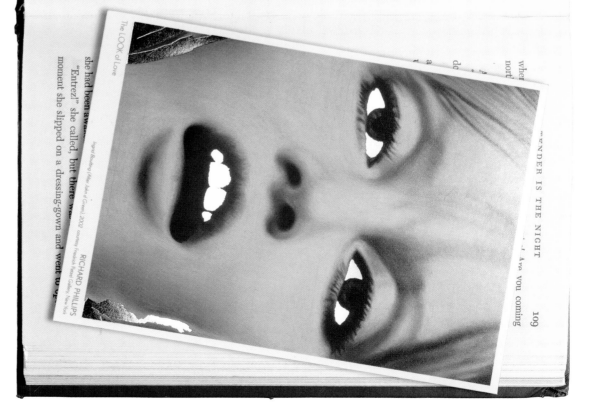

Nick Knight, Björk & Matthew Barney

Karl Lagerfeld photo Helmut Newton

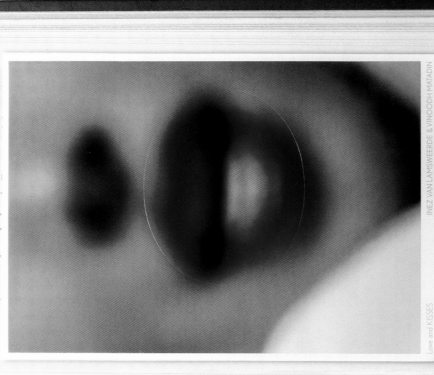

Elizabeth Peyton

Nicole and the Norths had resigned in order to do the things Abe had left undone till the last—in the taxi Rosemary reproached him.

"I thought if the test turned out to be good I could take it to California with me. And then maybe if they liked it you'd come out and be my leading man in a picture."

He was overwhelmed. "It was a darn sweet thought, but I'd rather look at *you*. You were about the nicest sight I ever looked at."

"That's a great picture," said Collis. "I've seen it four times. I know one boy at New Haven who's seen it a dozen times—he went all the way to Hartford to see it one time. And when I brought Rosemary up to New Haven he was so shy he wouldn't meet her. Can you beat that? This little girl knocks them cold."

Dick and Rosemary looked at each other, wanting to be alone, but Collis failed to understand.

"I'll drop you where you're going," he suggested. "I'm staying at the Lutetia."

"We'll drop you," said Dick.

"It'll be easier for me to drop you. No trouble at all."

"I think it will be better if we drop you."

"But—" began Collis; he grasped the situation at last and began discussing with Rosemary when he would see her again. Finally, he was gone, with the shadowy unimportance but the offensive bulk of the third party. The car stopped unexpectedly, unsatisfactorily, at the address Dick had given. He drew a long breath.

"Shall we go in?"

"I don't care," Rosemary said. "I'll do anything you want."

He considered.

"I almost have to go in—she wants to buy some pictures from a friend of mine who needs the money."

Rosemary smoothed the brief expressive disarray of her hair.

"We'll stay just five minutes," he decided. "You're not going to like these people."

She assumed that they were dull and stereotyped people, or

gross and drunken people, or tiresome, insistent people, or

lish who had been dissipating all spring and summer, so that

Love and KISSES

INEZ VAN LAMSWEERDE & VINOODH MATADIN

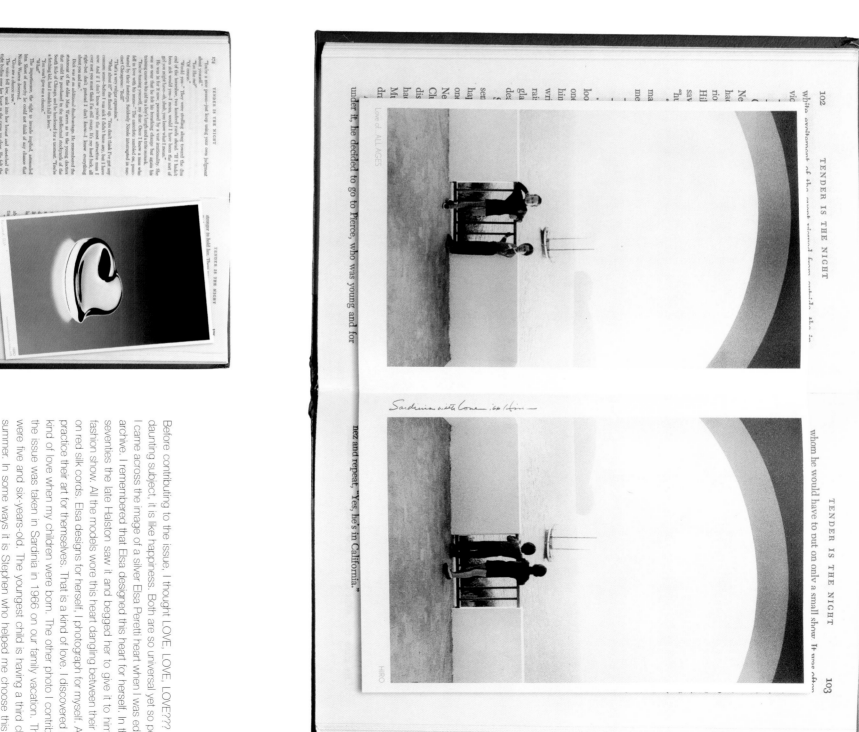

Before contributing to the issue, I thought LOVE, LOVE, LOVE??? What a daunting subject. It is like happiness. Both are so universal yet so personal. I came across the image of a silver Elsa Peretti heart when I was editing my archive. I remembered that Elsa designed this heart for herself. In the early seventies the late Halston saw it and begged her to give it to him for his fashion show. All the models wore this heart dangling between their breasts on red silk cords. Elsa designs for herself, I photograph for myself. All artists practice their art for themselves. That is a kind of love. I discovered another kind of love when my children were born. The other photo I contributed to the issue was taken in Sardinia in 1966 on our family vacation. The boys were five and six-years-old. The youngest child is having a third child this summer. In some ways it is Stephen who helped me choose this image. It is pinned on a bulletin board in my studio and he must have already been thinking about this issue the first time he saw it. HIRO

THANKS TO Slim Aarons Kamal Abassi ABC Die Cutting Shiho Abe Ivan Abujamra Rita Ackermann Wanda Acosta Robert Adams Ruven Afanador Agnès B Monique Agnew Air Yasutaka Akagi Shu Akashi John Akehurst

Azzedine Alaïa Jerome Albertini Miles Aldridge Tony Allen Pedro Almodóvar Emanuelle Alt Mahala Alzamora Beatrice Amaga Ushio Amagatsu Ned Ambler American Legend Mink Fritz Ammann Chuck Amos Michaël Amzalag

Nathan Andersen James L. Anderson Adeline André Scott Andrew Max Andrews Andreas Angelidakis Antoine Angruny Olivier Antoine Paola Antonelli Noriko Aoki Carlos Aponte Shinichiro Arakawa Nobuyoshi Araki

Frank Arcaro Elizabeth Arden Joey Arias Luis Arias Haim Ariav Mehmet Aricioglu Giorgio Armani AVR Media David Armstrong Bernard Arnault Art + Commerce Art Data Art Partner Chris Arvidson Marc Ascoli Nelson Asencio

Josef Astor Sithara Atasoy Athill Boys Marc Atlan Simon Atlee At the Movies Mai Au Kevyn Aucoin Nadja Auermann Mathias Augustyniak Richard Avedon Catherine Aymé Beth B Frank B. Enrique Badulescu Donald Baechler

David Bailey Jake Bailey Richard Baker Andre Balazs Balenciaga Philippe Balgan Elisabeth Ballet Balthus Arnaud Bani Anastasia Barbieri Miquel Barcelo Katy Barker Matthew Barney Baron & Baron Fabien Baron Baroness

Ivan Bart John Bartlett Stefan Bartlett Victoria Bartlett David Barton Susanne Bartsch Howard Batchen Kylie Bax Ed Baynard Cesar Bazan Alistair Beattie Rolando Beauchamp Michael Beauplet Jonathan Becker Glenn Beckford

Jean-Claude and Jocelyn Bedel Zoe Bedo Betty Bee Vanessa Beecroft Geoffrey Beene Janet Beller Vanessa Bellugeon Richard Bengtsson Davide Benzoni Antonio Berardi Paul Berends Joel Berg Eric Bergere Marina Berio

François Berthoud Aaron Betsky Bettina Philippe Bialobos Peter Bice Camille Bidault-Waddington Anne-Catherine Biedermann Big Sky Studio Pietro Birindelli Björk Evangeline and Manolo Blahnik Dike Blair Judy Blame Paco Blancas

Christian Blanken Bill Blass Angelica Blechschmidt Ross Bleckner Bless Anuschka Blommers Isabella Blow Micky Boardman Thelma Vilas Boas Andrea Boccaletti Jasper Bode Damien Boissinot Beat Bolliger

Tom Bonauro Tente Bonilla Managarm Boonthong Katrina Boorman John Brancati Davide Borella Bruno Borrione Michel Botbol Lionel Bouard Laurence Boue Didier Brijs Carol Brodie Jason Brooks Eddie Bowen David Bowie

Hamish Bowles box Mark Boyle David Bradshaw Pascal Braud Véronique Branquinho Tim Borton Mark Borthwick Jim Breese Herbert Breslin Enrico Bressan Olaf Breuning Carolin Brown Glenn Brown

Julie Brown Andrew Brucker Jean Brunel Carla Bruni Bob Brussel Gabrielle S. Brussel Kristopher Buckle Linda Buckley Maggie Buckley Richard Buckley Christopher Bucklow Henry Buhl Gisele Bündchen Bunita

Richard Burbridge Bureau Betak David Burton Jeff Burton Tim Burton Meghan Bush Nan Bush Richard Bush Dietmar Busse François Bustier Lisa Butler David Byrne Linda Byrne Sean Byrnes Paul Cadmus Peter Cain

John Callahan Masha Calloway Miguel Calvo Frank Camarda Samantha Cameron Naomi Campbell Reenato Campora A. Canovas Yves Carcelle Paul Carlos Carlotta Mark Carrasquillo Bill Carroll Patricia Carroll

Graydon Carter Cartier Ian Cartwright Leah Cary Mariuccia Casadio Sandra Casali James Casebere Tristan Cassiet Alan Castro Paul Catling Paul Cavaco C.P. Cavaty David Celaya César

Catherine Chalmers Dean Chamberlain Rebecca Chamberlain Lucinda Chambers Nicholas Chambers Chanel Angel Chang George Chard Jung Choi Chris Bishop Studio Janet Christea Anne Christensen Hussein Chalayan

Christian Dior Christie's Susan Cianciolo Luciano Cirelli Matthias Clamer Larry Clark Robert Clarke Ana Claudia Pedro Claudio Francesco Clemente George Clements Suzanne Clements and Inacio Ribeiro Helena Christensen

Lewis Cohen Preston Scott Cohen Billy Cole Sadie Coles Colette Fran Collin Lisa Collins Liz Collins Jean Colonna Color Edge Comme des Garçons Sofia Coppola Esther Coppoolse Grace Coddington

Patrice Fuma Courtis Charles Cowles Jennifer Cozens Cindy Crawford Gregory Crewdson Lia Crowe Rita Cruz Regan Cryole Antony Crossfield Chris Cunningham Stefani Cunningham Bice Curiger Jeffrey Costell

Roberto da Pozza Stephane Dafflon Sophie Dahl Beatrice Dalle François Damide Layla D'Angelo Pascal Dangin Danilo Susan Dann D.A.P. Shelagh D'Arcy-Hinds Vincent Darré Charles Darwin Ronnie Cutrone

Anthony Davies Peter Dayton Marion de Beaupré Alexandre de Betak Wiglius De Bie Geoffroy de Boismenu Jean-Charles de Castelbajac Bernard Danillon De Cazella Paolo De Cesare Esther de Jong Lou Lou De La Falaise Bruce Davidson

Ivan de la Fressange Thomas de Monchaux Mark de Montebello Alexandre de Paris Vicente de Paulo Carla De Souza Adolfo de Velasco Jonathon De Villiers Geraldine De Vulpian Hervé de Xaintraille Kitty Dean

Sophia Dean deBeers Frank DeCaro Gerard Decock Georganne Deen Anke Degenhard Jeffrey Deitch Hiluz del Priore Sophie Delaporte Joseph Delate Ina Delcourt Michael Delfino Jean-Phillipe Delhomme Britten Dean

Anna Della Russo Max Delorme Julie Delpy Thomas Demand Kim DeMarco Patrizio Di Marco Stevan Dohar Ann Demeulemeester Neil Denari Catherine Deneuve Jacqueline Denny Didier and Angelo Yaguel Didier Alessandro Dell'Acqua

Scott Devendorf Gayatri Om Devi Mlle. Pozzo di Borgo Patrizio Di Marco Generoso di Meo Diamond Information Center Philip-Lorca diCorcia Erin Donohue Martin Dörbaum Angel Dormer Joshua Dorsey Jean-Benoît Dunckel Destiny's Child

Dior Homme Yanick D'is Kathy Dixon Elisabeth Djian Stevan Dohar Dolce And Gabbana Christophe Doloire Dierdre Donohue James Dignan Christina Dimitriadou Jessica D'Este DIFFA Caroline Dougherty

Lucinda Douglas-Menzies David Downton Leonardo Drew Jodokus Driessen Minnie Driver Axel Ebert Markus Ebner Amy Eckert Michael Economy Anders Edström Malcolm Edwards Isabel Dotzauer Horst Diekgerdes Wk Eddy Desplanques Claire Dupont

Lukas Duwenhögger Julien D'Ys Rob Easteria Todd Eberle Tracey Emin Katy England Andrew Faiman Robert Fairer Jean-Louis Dumas James Duncan Anh Duong Arthur Elgort Joel Elkins Sean Ellis Sharon Ellis

Vicky Else Karen Elson Jennifer Elster Lucy Ewing Ellis Faas Andrew Fairman Robert Fairer Jason Farrer Cesar Fassina Meredith Etherington-Smith Joe Eula Paul Eustace Linda Evangelista Ethan Evans Jennette Everett

Rupert Everett Scott Ewalt and Toland Grinnell Tim Groen Rene Gruau Jamil GS Tatyana Gubash David Gubert Gucci Jessica Tan and Torkil Gudnason Carrie Guenther Pascal Guichard Michelle Feeney Tracy Feith Gay Feldman Gabriel Feliciano Fendi

Carla Fendi Maria Silvia Venturini Fendi Didier Fernandez Victoria Fernandez John Field Patricia Field Bernard Figueroa Larry Fink Avram Finkelstein Charles Firmin-Didot Peter Fischli / David Weiss Francisco Fisher Julia Freitag

Annie Flanders Sylvie Fleury Charlotte Flyvholm Jonathan Safran Foer Tom Ford Richard Forhez Eve Fowler Eric Fox Fox Entertainment Anne Francke Leonard Freed Dennis Freeman Don Freeman Katrin Freisager Jack Flanagan Goncalo Gaioso

Frenchways Travel Carmen Freudenthal Elizabeth Freund Mary Frey Sabisha Friedberg Mary Jane Frost Sadie Frost Catherine Fulmer Adam Fuss Carla Gabetti James Gager Mark Gagnon Jean-Paul Gaultier Frank Gehry

Nancy Gallagher Tom Gallagher John Galliano Giancarlo Gallotta Benjamin Galopin Jo Jo Garcia Tim Gardner Val Garland Anna Gaskell Owen Gaster Juan Gatti Thierry Gaugain Jeff Gaunt Christophe Girard Givenchy

Finn Geipel Andrew Gellatly Joyce George Mathys Gerber Nikki Gersten Latit Ghera Nicolas Ghesquiere Francis Giacobetti Christopher Giglio Odile Gilbert Oberto Gili Romeo Gigli Douglas Gordon Edward Gorey Garrick Gott

Hugo Glendinning Zaldy Goco Nicolas Godin Trish Goff Ariella Goggi Nathaniel Goldberg Nan Goldin Lori Goldstein Dennis Golonka Alex Gonzalez Wendy Goodman LeeAnn Goodwin Edward Jowdy Karen Joyce Patrick Gries

Jean-Paul Goude George Gozum Dan Graham Paul Graham Katie Grand Katy Grannan Peter Gray Vanessa Greca Elliott Green Marion Greenberg Lauren Greenfield Rebecca Greenfield Ranjit Grewal Tracy Grey Patrick Gries Mats Gustafson

Jonathan Griffith Sunhee and Toland Grinnell Tim Groen Rene Gruau Jamil GS Tatyana Gubash David Gubert Gucci Jessica Tan and Torkil Gudnason Carrie Guenther Pascal Guichard Olivier Guillemin Andreas Gursky Mats Gustafson

Guzman Aubyn Gwinn Huw Gwyther H. Stern Jewellers H5 Chris Habib Michel Haddi Scott Hagendorf Jacklin Han Haidée Tim Hailand Suzy Haines Katerina Hakansson Andrew Hall François Hallard Jess Hallett Erik Halley

Jason Halsey Pamela Hanson Lady Amanda Harlech Shalom Harlow Desirée Heiss Stephen Hendee Dylan Hennyson Nina Herala Alexandre Herchcovitch Hermès Oliver Herring David Hershkovitz Eva Herzigova Eric Hesmerg

Mitchell Healy Donald Hearn Pat Hearn Ashley Heath Patrick Harrison Kim Hastreiter Rachel Harris Patrick Harris Simon Henwood Aaron Hoag Jim Hodges Hiromix Hiro Hirata Hiro David Hazan

Michelle Hicks Steve Hiett Miki Higasa Malcolm Hill Bill Hipp Kenichi Hirata Noelle Hoeppe Hina Hohi Ken Holsher Karl Holmqvist Joseph Holtzman Marc Hom Takashi Homma

Gregory Homs and Dolphina Junko Honda Roni Horn Israel Horowitz Bert Houbrechts Martine Houghton Jane How Tim Howard Michael Howells Nikolaj Hübbe Colin Hume David Hunter Tom Hunter George Hurrell Peter Hurst

Mauricio Ianes Patrick Ibanez Idea Books Wendy Iles Kareem Iliya Iman IMG Kim Iglinsky Takaho Inoue Sam Irons Katsuko Ishida Eiko Ishioka Toyo Ito Martina Hoogland Ivanow Yuki Iwashiro Ben Jackson

Emma Jackson Jennifer Jackson Kim Jacobs Marc Jacobs Bill Jacobson Lisa Jacobson Mark Jacobson Peter Gray Jade Jagger Roger Gania James Jan Jansen Drew Jarrett Zuma Jay Patrick Jeandel Varla Jean-Merman Lee Jenkins

Adrian Joffe Tom John Nadine Johnson Daffyd Jones Leonie Edwards Jones Matt Jones Sarah Jones Stephen Jones Tom Jones Joshua Jordan Pierre Joseph Patrick Jouin Fred Jourda Edward Jowdy Karen Joyce

Wendy Juan Daryl K Yanni K Leong Ka Tai Greg Kadel Paris and Sophia Kafantaris Gemma Kanng Christine Kaliardos-Ballman William Kaliardos Alex Katz Johnny Katzie Rei Kawakubo Beverly Kaye Bronwyn Keenan Fernanda Kellogg

Renee Kaplan Donna Karan Sonia Kashuk Paul Kasmin Carolyn Kass Deborah Kass Cathy Kasterine Ted Katchmar Mari Katsura Sachio Kamiya Craig Kalpakjian Celso Kamura Jun I. Kanai Nadav Kander

Diane Kendal Anne Kennedy Richard Keo Heiko Keppel Lori Kessel Meena Khera Nargess Khosrowshahi Jodie Kidd Daniel Klajmic Calvin Klein Kelly Klein Steven Klein James King Scott King Patrick Kinmonth

Rowland Kirishima Kazaki Kiriya Kristen Kish Marianne Klaiman Russell Kleyn Setsuko Klossowka de Rola Harumi Klossowski Nick Knight Joerg Koch Kenneth Koch Harold Koda

Bettina Komenda Harmony Korine K.O.S. Elizabeth Koury Christina Koutsospyrou Tom Kovac Marcelo Krasilcic Gene Krell Barbara Kruger Christina Kruse Elke Krystufek Justine Kurland Rosemary Kuropat

Maco Kusunoki Christophe Kutner Jordi Labanda Labfac David LaChapelle Christian and Françoise Lacroix Havana Laffitte Karl Lagerfeld Ayo Laguda Rosemary Laing Luisa Lambri Helmut Lang Salim Langatta Jake Langbehn

Brigitte Lanvin Dennis Lanni Kate Larkworthy Sergio Larrain Emil Larsen Andreas Laurhoff Stephen Laurhoff Guy Laurent Katell Le Bourhis Nathalie Le Douarin Marcus Leatherdale
Fran Lebowitz Mark Leckey Vincent Lecoeur Jinin Lee Carol Leffuly Sylvain Lenis Tracy Leipold Thomas Lenthal Amanda Lepore Véronique Leroy Merryn Leslie Pierre Le-Tan Thierry Letrillart Anna Leu Dimitri Levas
Golan Levin Sam Levin Chris Levine David Levinthal Lewis Steve Lewis Tim Lewis Blanca Li Patrick Li Scott Lifshutz Lil' Kim Guy Limone Tiffany Limos Gentry Lin Peter Lindbergh Petra Lindblad
Angela Lindvall Armin Linke Lisa Marie Benjamin Liu Chrissy Lloyd Douglas Lloyd Patrick Lo Andrew Lockhart Angeline Loo Antonio Lopez Marc Lopez Jean-Marc Loubier Christian Louboutin Louis Vuitton Lisa Lovatt-Smith
Rachel Lowe Roxanne Lowit Camilla Lowther Andy Lloyd Avery Lozado Honey Luard Alexi Lubomirski Sarah Lucas Glen Luchford Mike Lundgren Alex Lundqvist Marina Luri Thom Lussier Serge Lutens Adelle Lutz
Diana Lyne Greg Lynn Adrienne Ma Joyce Ma Julien Macdonald Kevin Macintosh Alistair Mackie Dan MacMillan Stephane Marais Philippe Marchand John Marchant Martin Margiela Kai Margrander Angela Mariani Marie-Sophie
David Malin Nicolas Malleville Marie Mallerre Marcus Mâm Rûna Mannismaki Manolo MAP Stephane Marais Philippe Marchand John Marchant Martin Margiela Kai Margrander Angela Mariani Marie-Sophie Olivia Mariotti
Mary Ellen Mark Sandy Markman Matthew Marks Dwight Marshall Gaston Marticorena Richard Martin Tyler Martin Paulo Martinez Raul Martinez Roberto Masci Christopher Masciocchi Matrix Stacey McKenzie Andrew McKim Liz McKiver
Lorenzo Mattotti Edward Maxey Liz Mazurski Will McBride Rory McCabe Stella McCartney Laura McDaniel Craig McDean David McDonough Pat McGrath Joe McKenna Stacey McKenzie Andrew McKim Liz McKiver
Sam McKnight Kristen McMenamy Christine McNeil Donald McPherson Sean McPherson Alexander McQueen Me Company Syd Mead Antonia Medina Robert Medvedz Raymond Meier Steven Meisel Marcos Sanchez
Mejia Duncan Melanie Polly Mellen Andrea Menezes Suzy Menkes Metro Imaging Metro Studios Ted Meuhling Camille Michele Charles Miers Herve Mikaeloff Lyndall Milani Myriel Milicevic Mario Milizia David Miller
J. Abbott Miller Jessica Miller Risa Miller Arabella Mills Donald Milne Kylie Minogue Arthur Miranda Richard Misrach Missoni Angela Missoni Liza Mitchell Issey Miyake Hayao Miyazaki Isaac Mizrahi Mika Mizutani
MM, Paris Jim Moffatt Tracey Moffatt Elizabeth Mogilansky Sarah Moon Christopher Moore Demi Moore Jim Moore Moose Heidi Morawetz Mariko Mori Mark Morris Sarah Morris Trish Morrissey
Annie Morton Courtney Moss Kate Moss Tobias Mueller Thierry Mugler Astrid Muñoz Takashi Murakami Luigi Murenu Lawrence Mynott James Nachtwey Ted Nadeau Michel Natzinger Daisuke Nakayama Yoshitomo Nara
Russell Nardozza James Nares François Nars Allison Nassif Sophia Neophitu Yves Netzhammer Noki Leslie Nolen Scott Norkin Jessye Norman Serge Normand Chandra North Luis Núñez Marc Newson Camilla Nickerson
Sharon Niesp Seta Niland Ryue Nishizawa Tim Noble and Sue Webster Noki Leslie Nolen Scott Norkin Jessye Norman Serge Normand Chandra North Luis Núñez Marc Newson Camilla Nickerson Glenn O'Brien
Michael O'Brien Arnaldo Ferrara Ocanto Mariana Ochs Linda Ogawa Chris Ohm Olay Colour Brad Oldham Todd Oldham Amber Olson Maria Olson Fabio Ongarato Catherine Opie Kristin Oppenheim Frank Ordano Orfi
OrigamiUSA Martin Orpen Karla Otto Tony Oursler Kirsten Owen Rifat Ozbek Dick Page Dovanna Pagowski Filip Pagowski Guido Palau Maureen Paley Iris Palmer Gregory Park Marie Pasquier Patrimoine Photographique
Jimmy Paul Luciano Pavarotti Edward Pavlick Tony Payne Jeffrey Peabody Mr. Pearl Tom Pecheux Sheila Peevey Elizabeth Peyton Barbara Pfister Eric Pfrunder Thuy Pham Phebe Bijou Philips Peter Philips Richard Phillips
Elsa Peretti Emmanuel Perrotin Kristen Peters Neal Peters Vincent Peters Petros Petrohilos Isabelle Peyton Barbara Pfister Eric Pfrunder Thuy Pham Phebe Bijou Philips Peter Philips Richard Phillips
Photofest Mary Picarilo Jean-Jacques Picart Paloma Picasso Patricia Piccirini Alain Pichon Sylvie Picquet-Damesme Picto Lab Pierre et Gilles Jack Pierson Marcus Piggott and Mert Alas Ulises Pinasco Jose-Arman Pita
Orlando Pita Rafael Pita Edouard Piongeon Shannon Plumb Paul Podlucky Nora Pohl Adam Polina Thomas Pompidou Prathan Poopat Danny Pope Ruth Potter Phil Poynter Prada Miuccia Prada Massimo Prandi Giles Price
Richard Prince Princess Julia Eric Pryor Emilio Pucci Laudonia Pucci Ralph Pucci Elliott Puckette Frank Pugliese Andrée Putman Cyril Putman Quay Brothers Marc Quinn Quixote Jody Quon Paco Rabanne T. Cole Rachel
Sharon Niesp Seta Niland Sage Street Jimo Salako Philippe Salomon Amanda Salud-Gallivan Lou Salvatori Christopher Sams Luis Sanchis Daniel Sand Jil Sander Jochem Sanders Oliver Saillant Clara Saint Yves Saint Laurent
Chrystelle Saint Louis Augustin Sage Street Jimo Salako Philippe Salomon Amanda Salud-Gallivan Lou Salvatori Christopher Sams Luis Sanchis Daniel Sand Jil Sander Jochem Sanders Oliver Saillant Clara Saint Yves Saint Laurent
Andy Raiffe Rags Raglin Raina Carole Ramer Juan Ramos Barry Ratoff Frankie Rayder Missy Rayder Bob Recine Massimo Redaelli Alexandra Redgrave Dai Rees Gabrielle Reese Tuca Reines Brigitte Reiss-Anderson
David Remnick Kristell Renat Retamar Philippe Reynaud Eric Rhein Royal Rhodes Joao Ribeiro Mark P. Rice Andrew Richardson Terry Richardson Sophy Rickett Ribal Rifaat Camilla Rigg Christophe Rihet Pipilotti Rist
Ronnie Rivera Maggie Rizer Rizzoli Peter Robathan Kate Roberts Simon Robins Patrick Robyn Mick Rock Alexis Rockman Jerry Rockwell Scott Rodger Ed Rogers Scott Rogers Nancy Rohde
Carine Roitfeld Tim Rollins Valeria Romite Daniel Romualdez III Ugo Rondinone Roberta Ronsivalle Charlie Rose Andrea Rosen Kay Rosen Adrian Rosenfeld François Rotger Christian Francis
Roth Pascal Rousseau Paolo Roversi Wendy Rowe Paul Rowland Thomas Ruff Robert Rufino Stephanie Rutherford Sonia Rykiel Florian Sachsthal Tom Sachs Satoshi Saikusa Clara Saint Yves Saint Laurent
Jeanloup Sieff Roman Signer Ken Siman Laurie Simmons John Simms Taryn Simon John Simons Raf Simons Nicola Simpson David Sims Paul Sinclaire Basha Hagunjit Singh Richard Sinnott Kim Sion Martine Sitbon
David Slijper Hedi Slimane Esther Slury Rena Small Carter Smith David Smith Paul Smith Smythson of Bond Street Lord Snowdon Michael Sodini Bernward Sollich Helen Solomon Solstiss Brigitte Sondag Paul Song
Sarah at Colette Julie Saul Dr. Charles Saumerez-Smith Marie-Amelie Sauvé Peter Saville Lorenzo Scala Erin Scales John Scaristbrick Francesco Scavullo John Schabel Anja Schaefer Kenny Scharf Howard Schatz
Maurice Scheltens Marcus Schenkenberg Lisa Schick Claudia Schiffer Anne-Marie Schiro Barbara Schlaeger Collier Schorr Ian Schrager Chris Schramm Taber Schroeder Carole Schulze Niels Schumm Judith Schuster
Jerry Schwartz Tobias Schweitzer Jeremy Scott L'Wren Scott Steve Seal Stephane Sednaoui Bob Seidenman David Seidner Kazuyo Sejma Elfie Semotan Seren Productions Jorge Serio Andres Serrano Dennita Sewell
Sarah Seyfried Bianca Storni Kevin Shalit Stuart Shave Jason Shaw Anessa Sheikh Aisa Shelley Helen Shen Cindy Sherman Jody Shields Shinsuke Shilland & Co. Yo Shitara Ayson Shotz Alexandra Shulman
Kevin Summers Steen Sundland Sølve Sundsbø Supreme Leslie Sweeney Lee Swillingham Sybilla Philip Taaffe Mamio Tada Mari Takahashi Andre Leon Talley Alexi Tan Hiroshi Tanabe Hiroshi Tanaka Tanel Mei Tao
Alex Tart Koji Tatsuno Esther Tavor Niki Taylor Sam Taylor-Wood Timothy and Lady Helen Taylor Towa Tei Jurgen Teller Karl Templer Stella Tennant Lucien Terras Liza Tessi Mario Testino Twyla Tharp The Designers Republic
The "Lady" Bunny Andre Theoret Olivier Theyskens Diane Thistlethwaite Kirsten Thott Paula Thomas Nick Thornton-Jones Jessica Mynt Thinn 3Deluxe Liz Tilberis Wolfgang Tillmans Timo Olya Titova
Olga Tobreluts Stephen Todd Grazia Toderi Zang Toi Sidney Toledano Michael Toledo Tomáh Ally Torni Marcus Tomlinson Topolino Fred Torres John Toth Larry Towell Tessa Traeger Eric Traoré Ethan Trask Mary Trasko
Travel People Philip Treacy Donna Trope Emily Tsingou Barbara Turk Gavin Turk Christy Turlington Tyen Nikki Uberti Yoshihiko Ueda Piotr Uklanski United Talent Agency Ina Qu Unjierg Max Vadukul Francisco Valera Javier Valhonrat
Amber Valletta Kristen Vallow Mark Van Arminge Ed Van Der Eisken Caroline Van Der Voort Bernadette Van-Huy Inez van Lamsweerde and Vinoodh Matadin Gus Van Sant Peter Van Straaten Donna Vanderzee James Vanderzee
James Vance Christopher Scott Vann Olivier Védrine Carmen Mayrink Veiga Andres Veleneoso Elle Verhagen Josephine Verine Donatella Versace Gianni Versace Veruschka Gabriel Vigorelli Viktor & Rolf Visual Connexion
Roger Vivier Vladimir Raymond Voinquel Adam Vomit Julia Von Boehm Ellen Von Unwerth Jean-Georges Vongerichten Alexander Vreeland Diana Vreeland Milan Vukmirovic Carla Wachtveitl Ellie Wakamatsu Neville Wakefield
Kara Walker Tim Walker Jeff Wall Christopher Walsh Alexia Walther Michael Walton Ward Ashley Ward Duncan Ward Jenna Ward Stephane Wargnier Andy Warhol Cindy Warwick Oliver Wasow Junya Watanabe
Kate Waters Dan Weaks Gillian Wearing Veronica Webb Tristan Webber Andrew Weber Michael Weber William Wegman Alex Weidering Marta Weinhoff Jeremy Wells Ralph Wenig Anders Wenngren Mel West Richard Westall
Angelique Westerhoff Vivienne Westwood Charlotte Wheeler Emma Wheeler Adam Whitehead David Wike Mark Wilkins Hype Williams Sherry Williams
Jane and Louise Wilson Patti Wilson Duke Of Windsor Leah Mooney Winer Leslie Winer Antje Winter Katherine Winter Anna Wintour W. Wisniewski Lauren Wittels Brana Wolf Pamela Wong Sandra Wong Lee Wood
Christopher Wool William Wordsworth Hubert Woroniecki Randy Wray Angela Wright Eric Wright Sharon Wright Claudia Wu Danny Wu John Wulp Wyatt Li Xin Tomoko Yamagishi Naomi Yamamoto Yohji Yamamoto
Kazz Yanamura Mako Yamazaki Miwa Yanagi Tobin Yelland David Yellen Karine Chrane Yin Yukiko Yoko Yorgo Melanie York Henry Yuen Gaspard Yurkievich Lisa Yuskavage Z Photographic Suzie Zabrowski
Giovanni Zaccagnini Anne Zahalka Lauren Zara Alban Zanichelli Natasha Zarin Lauren Zebley Andrew Zeif Karim Zeriahen Manos Zorbas Zuleika And to everyone who over the years has helped us put our dreams into print.

CREDITS

1 SPRING
p16
RubenToledo
Nature's Pin-ups
p17
Pierre et Gilles
La méduse, 1990
clothing Adeline André
model Zuleika

2 TRAVEL
p20
Serge Lutens
Notes pour le projet d'un pavillon de mains dans une parfumerie marocaine
Bruce Weber
Clouds, San Francisco, 1991
pp22-23
Mats Gustafson
Romantic View of Istanbul, 1968

4 HEAVEN
p30
Pierre et Gilles
Marilonne au cœur blessé, 1991
styling Tomàh makeup Topolino Lio
p34
Pierre et Gilles
Sainte Monique et Saint Augustin, 1991
dress Adeline André
models Fanda and Salvatore
Saint Simeon le stylite, 1991
model Karim Zeriahen
Saint Louise de Gonzague, 1991
model Salvatore
Saint Etienne, 1991
model Hamid
Todd Oldham
hand embroidery Latif Ghera
p36
Pierre et Gilles
Salomé la décollation de St. Jean Baptiste, 1991
styling Adeline André makeup Topolino hair Tony Allen models Apple and Steffen

Francis Giacobetti
Bettina
p16
Adeline André
Bettina Sails the Seven Seas
Guzman
styling Catherine Laroche bustier Pearl makeup Brigitte Reiss-Andersen hair Gabriel Vignolelli model Camilla Rigg
Don Freeman
shell bowl Ted Meuhling
bottom row from left
Pierre et Gilles
Le pêcheur de perle, 1992
model Tomah
Edward Maxey
Stingray City, 1992
Bernard Figueroa
Gold Plated Shell Heel

7 BLACK
p46
Bill Cunningham
illustration Edward Gorey from *The West Wing* clothing Geoffrey Beene
illustration Edward Gorey from *The West Wing* clothing Comme des Garçons
p47
Peter Lindbergh
gloves Comme des Garçons
Max Vadukul
fashion editor Mika Mizutani makeup Pascal Guichard hair Yanick D'Is model Kristen McMenamy
p48
François Berthoud
clothing Helmut Lang

8 THE ORIENT
p52
Mats Gustafson
Shinichiro
Hiroshi

9 FACES
p56
Dwight Marshall
Mario Testino
p57
Mats Gustafson
Grace Coddington
John Scaristbrick
Patrik Andersson
Stephen Gan
Titout Punk
p60
Andres Serrano
The Morgue (Jane Doe Killed by Police) courtesy Paula Cooper Gallery, New York
p61
Raymond Meier
Rockface
Geoffroy de Boismenu
Abdul
Scott Lifshutz
Jerry Schwartz
Steven Klein
Joey Horatio
Mario Testino
Chiara Mastroianni
Anh Duong
Ann Duong
Antonio Lopez
Four Heads
Orlando Pita
Orlando Pita
Mei Tao
Alick
Carlos Aponte
Rei Kawakubo
Geoffroy de Boismenu
Alexandre de Betak
Ruben Toledo
Angel Dormer
Stephane Sednaoui
Natane
Ruben Toledo
Frank DeCaro
Bruce Weber
Joe McKenna

10 ALPHABET
p66
Tim Rollins and K.O.S.
The Scarlet Letter VI
Steven Meisel
model Hamish Bowles
Bill Cunningham
John Galliano spring/summer 1994

11 WHITE
p70-71
Ruben Toledo
Comme des Garçons spring/summer 1994
Manolo spring/summer 1994
Isabel Toledo spring/summer 1994
Issey Miyake spring/summer 1994
p72
Mats Gustafson
Helmut Lang spring/summer 1994
François Berthoud
Vivienne Westwood spring/summer 1994

12 DESIRE
p76
Steven Meisel
model Lou Lou De La Falaise
Stephane Sednaoui
Shalom
David Armstrong
Andrew at the Bowery, New York City, 1994
courtesy Matthew Marks Gallery, New York
David Seidner
Female Nude, 1994
Peter Cain
Bonneville, 1993
courtesy Matthew Marks Gallery, New York
Lisa Yuskavage
Tit Heaven #16, 1992
p77
Nan Goldin
Joey on my Roof, New York City, 1991
courtesy the artist
and Matthew Marks Gallery, New York

13 SEVEN DEADLY SINS
p80
Mary Ellen Mark
Indian Circus, '89
Teen Baby
p82
Inez van Lamsweerde and Vinoodh Matadin
styling Maarten Spruyt
shoe Jan Jansen
Inez van Lamsweerde and Vinoodh Matadin
clothing Vivienne Westwood makeup and hair Yanni K
image manipulation Karin Spijker
location Amsterdam Hilton model Kym
p83
Inez van Lamsweerde and Vinoodh Matadin
makeup and hair Elis Faas
image manipulation Karin Spijker
models Petra Lundblad and Cynthia
Inez van Lamsweerde and Vinoodh Matadin
clothing Vivienne Westwood makeup and hair Yanni K
image manipulation Karin Spijker
location Amsterdam Hilton model Kym

14 HYPE!
pp84-85
Inez van Lamsweerde and Vinoodh Matadin
clothing Anna Sui
captions Tim Groen makeup James Kaliardos hair Jimmy Paul lighting Jodokus Driessen
image manipulation Karin Spijker
model Leah Cary
pp88-89
Inez van Lamsweerde and Vinoodh Matadin
captions Tim Groen makeup James Kaliardos hair Jimmy Paul lighting Jodokus Driessen shoes Bernard Figueroa and Marc Jacobs clothing (bottom) Isaac Mizrahi
clothing (right) Geoffrey Beene
shoes Manolo Blahnik
captions Tim Groen, Marc Jacobs and Isabel Toledo hair Jimmy Paul lighting Jodokus Driessen
image manipulation Karin Spijker
models Leah Cary and Alex

15 CINDERELLA
p92
Ellen von Unwerth
stylist Cathy Kasterine
makeup Carmen Dell'Orefice, Baroness, and Varla Jean-Merman
p94
Inez van Lamsweerde and Vinoodh Matadin
styling Victoria Bartlett
paper cut Ruben Toledo
dress Vivienne Westwood
p96
Inez van Lamsweerde and Vinoodh Matadin
clothing Thierry Mugler
makeup and hair Elis Faas
lighting Jodokus Driessen
image manipulation Karin Spijker
model Alexandra
François Berthoud
dress Comme des Garçons
shoes Roger Vivier for Christian Dior 1955-57
courtesy The Costume Institute,
The Metropolitan Museum of Art, New York

16 CALENDER
p98
Inez van Lamsweerde and Vinoodh Matadin
chapeau de bain Danilo
bustier Dolce and Gabbana Sposa
makeup James Kaliardos
lighting Jodokus Driessen
model Rania
p99
Marcelo Krasilcic
styling Jason Farrer
clothing Yves Saint Laurent and Agnes B.
makeup Michael Delfino hair Chuck Amos
models Zuleima, Karren, and Ellie
p100
Rita Ackermann
Don't Worry It Won't Hurt, 1996
courtesy Andrea Rosen Gallery, New York
Jack Pierson
courtesy the artist
and Luhring Augustine Gallery, New York
p101
Ellen von Unwerth
styling Cathy Kasterine
shoes Manolo Blahnik
makeup Ashley Ward hair Ward
models Matthew Eckersley and Isis

17 GOLD
p104
James Nares
courtesy Paul Kasmin Gallery, New York
pp106-107
Philip Taaffe
Gold Iris Pages

18 FASHION SPECIAL
p110
Inez van Lamsweerde and Vinoodh Matadin
clothing Daryl K
makeup James Kaliardos hair Spijker
model Michelle Hicks
p111
Mario Testino
styling Carine Roitfeld
clothing Yves Saint Laurent
dancing shoes and tights Repetto
makeup Tom Pecheux hair Marc Lopez
photo assistants Thomas Nutzl,
Adam Whitehead, Alban Zanichelli
hair Taber Schroeder
pp112-113
Nan Goldin
styling Avram Finkelstein
clothing Helmut Lang
models (left) Leslie Winer, Leah Mooney Winer, James King, Rory McCabe, Sharon Niesp, Kathleen White (right) James King
pp114-115
Jean-Paul Goude
Crime and Punishment
clothing Azzedine Alaïa
makeup Beatrice Dalle
with a special cameo by the designer
pp116-117
Craig McDean and M/M, Paris
clothing Edward Enninful
styling Comme des Garçons
makeup Pat McGrath hair Eugene Souleiman
model Iris Palmer

19 BEAUTY
p120
Cindy Sherman
courtesy the artist
and Metro Pictures, New York
p121
Pamela Hanson
Three of Diamonds
p122
Inez van Lamsweerde and Vinoodh Matadin
styling Joop! makeup James Kaliardos hair Eugene Kruse, Chandra North, and Israel Horowitz
Mark Mattock
Four of Diamonds
James Kaliardos
Three Faces of Cecilia
model Cecilia Dean
Terry Richardson
makeup Francisco Valera hair Dennis Lanni
model Nikki Uberti
p123
Bruce Weber
styling Joe McKenna
makeup Dick Page hair Guido

20 COMME DES GARÇONS
p127
Nick Knight
art director Alexander McQueen
styling Katy England
clothing (left) Comme des Garçons spring/summer 1997
pin pin (right) Comme des Garçons autumn/winter 1996-97
clothing (right) Alexander McQueen spring/summer 1997
makeup Topolino hair Clovis
image manipulation Steve Seal
location Metro Studios, London
models Zoe Bedo and Devon
p128
Philip-Lorca diCorcia
Hong Kong
clothing Comme des Garçons
spring/summer 1997
p129
Mario Sorrenti
styling Andrew Richardson
clothing Comme des Garçons spring/summer 1997
model Shannon Plumb
Paolo Roversi
clothing Comme des Garçons spring/summer 1997
makeup Jim Breese hair Julien D'Ys
models Elena and Shadow

Ellen von Unwerth
Two of Diamonds
styling Paul Sinclaire
makeup Susan Sterling hair Jimmy Paul
photo assistant Ralph Wenig
model Myka

Inez van Lamsweerde and Vinoodh Matadin
styling Lori Goldstein
jewelry H. Stern Jewellers
makeup Kristopher Buckle hair Gavin
models Christina Kruse, Chandra North, and Kirsten

David LaChapelle
Five of Diamonds
styling Justin Laurie
diamonds H. Stern Jewellers
makeup Jorge Serio hair Renato Campora
suit and prop styling Kristen Vallow
model Amanda Lepore

Ruben Toledo
Six of Diamonds
jewelry H. Stern Jewellers

Steven Klein
Seven of Diamonds
jewelry H. Stern Jewellers
makeup Katerina Hakansson
hair Jimmy Paul model Adam Vomit
thanks to Sue Stemp and Ranjit Grewal

Sean Ellis
Eight of Diamonds
styling Isabella Blow
diamond H. Stern Jewellers
makeup Ellie Wakamatsu hair Jimo Salako
paint box operator Hank at Adpates
model Jodie Kidd

Terry Richardson
Nine of Diamonds

Enrique Badulescu
Ten of Diamonds
styling Kate Roberts
diamonds H. Stern Jewellers
makeup Anne Morton
model Anne Morton

Bruce Weber
Jack of Diamonds
styling Anne Christensen
jewelry H. Stern Jewellers
grooming Didier Malige
props Dimitri Levas
model Rusty

Inez van Lamsweerde and Vinoodh Matadin
Queen of Diamonds
styling Alexander McQueen for Givenchy Haute Couture headpiece Philip Treacy for Givenchy jewelry H. Stern Jewellers
lighting Jodokus Driessen
image manipulation Karin Spijker
model Iman

Mario Testino
King of Diamonds
styling Carine Roitfeld
union jacket John Galliano hat Stephen Jones for Christian Dior Haute Couture
diamond rings H. Stern Jewellers
makeup Tom Pecheux hair Marc Lopez
photo assistants Adam Whitehead and Thomas Nutzl location Studio Daylight, Paris
model John Galliano

p133
Visionaire
House of Diamonds
Peter Hurst
diamond H. Stern Jewellers
Karl Lagerfeld
Ace of Diamonds
diamond H. Stern Jewellers
makeup Max Delorme hair Philippe Baigan
model Timo

p134
M/M, Paris
House of Spades

p135
Lee Swillingham and Stuart Spalding
House of Clubs
photography Donald Milne
styling Katie Grand design Tim Lewis
photo assistant David Burton
Jason Halsey
thanks to Danny Pope, MAP 2, Photographic, Diane Thistlethwaite, and Patrick Harrison

pants Copperwheat Blundell
blouse Q dress Stella McCartney
models Elvis and Zora
Three of Clubs
vest Seraph pants Copperwheat Blundell
shoes Steinberg + Tolkien
makeup Val Garland hair Malcolm Edwards
model Rebecca Harper
Four of Clubs
jacket Alexander McQueen
pants Copperwheat Blundell blouse Q
shoes Converse
models Elvis and Zora
Five of Clubs
dress Jean Colonna knickers Dorothy Perkins
model Suzy Haines
Six of Clubs
hair Malcolm Edwards
image manipulation Eddie Bowen
model Vernon
Eight of Clubs
T-shirt Burro dress Jean Colonna
makeup Val Garland hair Malcolm Edwards
models Simon and Suzy Haines
Nine of Clubs
top Prada dress Gucci sandals Sonia Rykiel
makeup Val Garland
models Rebecca Harper and Suzy Haines
Jack of Clubs
shirt Q shirt and dress Alexander McQueen
makeup Val Garland hair Malcolm Edwards
models Elvis and Suzy Haines
Queen of Clubs
dress Helmut Lang
shoes Nike socks Hue
makeup Wendy Rowe hair Moose
model Rachel Harris
King of Clubs
T-shirt Burro jeans Wrangler
necklace Brick Lane Market
makeup Wendy Rowe hair Moose
models Ben Jackson, Simon, Suzy Haines

21 DECK OF CARDS
p132
Fabien Baron and Baron and Baron & Baron
House of Hearts
art direction and drawings Fabien Baron
photography Yoshihiko Ueda
dancer Ushio Amagatsu of Sankai Juku special thanks to Atsuhide Nakajima and Masako Okubo of the Korinsha Press,
Jun Kanai at Issey Miyake; Patrick Li, Malin Ericson, and Yuki Iwashiro at Baron & Baron, Scott Hagendorf at UTI, and Pascal Dangin at box
Ace of Hearts l'Eau d'Issey Pour Homme by Issey Miyake
Three of Hearts Fifth Avenue by Elizabeth Arden
Four of Hearts Envy by Gucci
Five of Hearts Alure by Chanel
Six of Hearts Obsession by Donna Karan
Seven of Hearts Chemistry by Clinique
Eight of Hearts Yohji Yamamoto
Nine of Hearts Comme des Garçons
Ten of Hearts Acqua di Gio by Giorgio Armani
Jack of Hearts La Dolce Vita by Christian Dior
Queen of Hearts Jil Sander No. 4
King of Hearts Bel Ami by Hermès

Ace of Clubs
makeup Wendy Rowe hair Moose
model Natalie
Two of Clubs
jacket Alexander McQueen

22 CHIC
pp138-139
Fabien Baron
Baron & Baron
New York City, June 1997
Mario Testino
Peru, from the series Visual Diary, 1997

Catherine Deneuve
Letter to Yves Saint Laurent
Paris, May 7, 1994
stationary Smythson of Bond Street, London

pp140-141
Manolo and Evangeline Blahnik
London, 1997
Emilio and Laudonia Pucci
Firenze, 1967
Mario Testino
Peru, from the series Visual Diary, 1997
Madonna
Gianni Versace
Donatella Versace
Piece of dress worn to Evita premiere
London December, 1996
Tim Street-Porter
Tony Duquette's ranch
Malibu, 1992
Missoni and Angela Missoni
Sumirago, 1997
Pierre Le-Tan
Set for the Tim Quartette
Paris, 1997
Paul Smith
London, 1997
Tessa Traeger and Patrick Kinmonth
Garlic from Fauchon
Paris, 1996
Paloma Picasso
Mon rouge
London, May 1997

Mario Testino
Attitude from the series *Visual Diary*, 1997
clothing Jean-Paul Gaultier
model Tunel

Karl Lagerfeld
Party Line #5 1999

Iñez van Lamsweerde
and Vinoodh Matadin
styling Nancy Rohde
clothing Viktor & Rolf Haute Couture
winter 1999 silk balloon and glitter clown
photo assistant Giovanna
styling Anne Christensen
makeup Lisa Butler hair Eugene Souleiman
The Club
image manipulation Karin Spijker
lighting Jodokus Driessen
photo assistants Pascal Braud, Frederic David,
Olivier Sallant, Bernward Sollich

23 EMPERORS' NEW CLOTHES

p. 159
Iñez van Lamsweerde
and Vinoodh Matadin
styling Nancy Rohde
clothing Viktor & Rolf Accessories
winter 1999 silk saturn and glitter clown
makeup Lisa Butler hair Haute Couture
styling Anne Christensen
model Li Xin

p. 160
Marcus Tomlinson
hair Odile Gilbert, Sylvain Lefern,
Dick Page, Tom Pecheux, Joe Strettel
Marc Lopez, Liza Mitchell,
Stephane Marais, Hervé de Kerinvalu
image manipulation Karin Spijker

Sean Ellis and Isabella Blow
clothing Jeremy Scott
hair Eugene Souleiman
laisers Chris Levine

Paul Graham
19.17 (from the series 33-18), 1996
© the artist

Roni Horn
Untitled (A Bank of Infinity) (detail),
courtesy Matthew Marks Gallery, New York

pp. 152-153
Christopher Bucklow
Guest (detail)
courtesy Paul Kasmin Gallery, New York

p. 154
Thomas Ruff
Nacht 19 I
courtesy Galerie Nelson, Paris

Craig Kalpakjian
Room (detail)
courtesy Galerie Nelson, Paris,
and White Cube, London

Lee Jenkins
Changoreset Hong Kong

Hiromix
courtesy Rocket Or Inc., Japan

25 VISIONARY

p. 198
Gavin Turk
Pop, 1993
waxwork in wood, glass, and brass vitrine
photo Hugo Glendinning
courtesy Jay Jopling, London

David LaChapelle
Fuck Modern Painting (detail), 1997
acrylique on canvas
photo Stephen White
courtesy Jay Jopling, London

Jeff Wall
Children's Pavilion (detail)
performance Robert Wilson
image Mariani Goodman Gallery, New York

Tony Oursler
Time, Sirca, 1994
Style + Me, 1996
courtesy Metro Pictures, New York

Jack Pierson
Untitled (Chem/Read), New York
courtesy Paul Kasmin Gallery, New York

26 FANTASY

p. 161
Eiko Ishioka
costume design and art direction for *The
Fall* from Richard Wagner's *Ring Cycle*
produced by the Netherlands Opera
from the book Eiko on Stage, Callaway Editions

Bert Houbrechts
clothing Raf Simons
hair Peter Philips
model Lynne

Marcus Mam
photography Eric Traore
art direction Lionel Bouard
bow and arrow Sarah Harmarnee
image assistant Marmotte
location Studio Zero

Steven Klein
for Shiseido

Serge Lutens
for Shiseido, 1981

Quay Brothers
Ex-Voto

p. 165
Raf Simons
menswear show spring/summer 1999

Tim Burton and Lisa Marie
Blue Girl with Pink Stitches

David Byrne
Señora La Habana
object realization Adele Lutz

Oliver Wasow
Untitled #530
courtesy Janet Borden Inc., New York

Daisuke Nakayama
Full Contact Fhase "Zero ~ 1 1999"
courtesy Espen+Art, Berlin
and Kamasawa Art Cocoon, Tokyo

Gregory Crewdson
Untitled, 1997
courtesy Luhring Augustine, New York

27 MOVEMENT

Nick Knight
art direction Peter Saville
styling Alexander McQueen
clothing Alexander McQueen
Haute Couture
model Christina Kruse

Elizabeth Peyton
U.S.A.
Michael Owen
courtesy Gavin Brown's Enterprise, New York

Fabien Baron
U.S.A.
Burning Desire, 1998, from the series
Forever, 1998, from the series
Isabella Blow's Fantasy
photo Robert Fairer
courtesy Modern Art Inc., London

Raymond Meier
Switzerland
Hornsdon Players, Hurliwit, Switzerland

Piotr Uklanski
from the series *Isabella Blow's Fantasy*
design Main Ericson, Yuki Iwashiro,
and Carolyn Kass
imaging Chris Bishop Studio
model Lia Crowe

Tracey Moffatt
Australia
Up in the Sky
courtesy Paul Morris Gallery, New York

Maurizio Cattelan
Italy
Stadium
courtesy Marian Goodman Gallery, New York

Nadav Kander
The Swamp

Jeff Burton
Hollywood
Untitled
courtesy Casey Kaplan, New York

Nan Goldin
Devil's Golf Course, Death Valley, California

Daniel Klajmic
Travecos at Copacabana

Justine Kurland
Men's Clothing
courtesy Lawrence Rubin Greenberg
Van Doren Fine Art, New York
and Patrick Painter, Santa Monica

29 WOMAN

p. 184
Katy Grannan
(series) 1998
(series) from the Poughkeepsie journal

Glenn Brown
Böcklin's Tomb after Chris Foss)
courtesy Patrick Painter Inc., Los Angeles

Nick Knight
styling Val Garland
hair Wendy Iles
for Givenchy
Haute Couture fall/winter 1999
model Aurélie Marnay

Terry Richardson
styling Andrew Richardson
makeup Frank b. hair Rolando Beauchamp

Gus Van Sant
Easter
photo David Cereja, story Harmony Korine
actors Cindy and Scott Gibson
location Mayfield, Kentucky

Armin Linke
Corner
Hotel Paris, Las Vegas
from *4Flight Project*

Chris Cunningham
Flex
courtesy Anthony d'Offay Gallery, London

Mario Testino
Parliament

Patricia Piccinini
Australia
Shoen 7 100-613
courtesy Tolarno Galleries, Melbourne

Anne Zahalka
Australia
Wood shopping, Royal Easter Show
courtesy Anna Schwartz Gallery, Melbourne
and Roslyn Oxley9 Gallery, Sydney

Alex Katz
U.S.A.
Wedding #1
Exit, Stet #6

Sharon Ellis
Night
courtesy the artist
and Christopher Grimes Gallery, Santa Monica

Gary Hume
Water Painting
© Gary Hume

David Armstrong
Scott Barrnis, Brooklyn, 1999
courtesy Matthew Marks Gallery, New York

Wolfgang Tillmans
Philip, close-up II
courtesy Andrea Rosen Gallery, New York

Oliver Wasow
Spring Green, Wisconsin
courtesy Janet Borden Gallery, New York

30 GAME

p. 190
David LaChapelle
U.S.A.
Mr. Olympia Finalists

Takashi Homma
Japan
Tokyo Game Boy

31 BLUE

Levi's Vintage Clothing
*Turn of the Century, 1 Pocket Sack Coat
in No. 2 Blue Selvage Denim*

32 WHERE?

p. 202
Mario Testino
Parliament

Armin Linke
Gruz Barcha Hydroelectric Channel Project,
Hatham, Pakistan
courtesy Global Book Project
www.arminlinke.com

Olivier Herring
Untitled

Andreas Angelidakis
Myself 1

34 PARS

pp. 212-215
Greg Lynn
*for Greg Lynn Form
case development Jaldolin Hahn*

Thomas Demand
Tunnel
courtesy 303 Gallery, New York,
and Victoria Miro Gallery, London

Philip Treacy
boots Hermès
makeup Tom Pecheux hair Marc Lopez
photo assistants Thomas Nutzi,
Alexi Lubomirski, Gonçalo Gaioso, and
Michael Beaujier stylist assistants
Antje Winter and Julia Von Boehm

Pedro Claudio
Untitled (Waterbox)

Daniel Klajmic and Isabella Blow
Toy
clothing Alexandre Herchcovitch
makeup and hair Celso Kamura
models Douglas and Daniel Rotelli
location Big Sky Studio

Carmen Freudenthal
and Elle Verhagen
Sperm
styling Carne Roitfeld
jacket Comme des Garçons
underwear Alessandro Dell'Acqua
boots Hermès
makeup Tom Pecheux hair Marc Lopez
photo assistants Thomas Nutzi,
Alexi Lubomirski, Gonçalo Gaioso, and
Michael Beaujier stylist assistants
Antje Winter and Julia Von Boehm

Solve Sundsbo
styling Simon Robins
makeup Petros Petrohilos, hair Peter Gray
Glenn Beckford location Big Sky Studio

Mats Gustafson
Love, MATES FOR LIFE

Setsuko Klossowska De Rola
ENDLESS Love

Tobias Schneizer and Stephen Gan
TEAM F For Love

35 MAN

p. 220
Mario Testino
cover Mario Testino
styling Carne Roitfeld
coat and Lilie Jean-Paul Gaultier
west Alexandra Prêt-A-Porter du Travail
makeup Tom Pecheux hair Marc Lopez
photo assistants Thomas Nutzi,
Alexi Lubomirski, Gonçalo Gaioso,
and Michael Beaujier stylist assistants
Antje Winter and Julia Von Boehm
model Édouard Pongson

Tim Haland
Untitled (Hall), 1997
courtesy the artist and CRG Gallery, New York

Ed van der Elsken
Motorcross, London, from the series A Manual
Wedding, Dublin, from the series A Manual

36 POWER

p. 227
Iñez van Lamsweerde
and Vinoodh Matadin

Mario Testino
Sperm...
photo Warren Du Preez
model/imaging Howard Bachten
imaging Ian Cartwright

Chris Levine

Warren Du Preez and Nick
Thornton-Jones
Spike
makeup Wendy Rowe
music/box and shoes Alexander Tayor
from the Body series
music box/machine Marian Newman
photo assistants Ben Dunbar, Dom Cooper,
and Emma Sweeney
digital manipulation Allan Finamore

37 MEMOS

pp. 232-235
Love, PLUS ONE
Copyright in these memos is owned by
The Condé Nast Publications.
The publication of the memos written by
Diana Vreeland was done with the permission
of the Estate of Diana Vreeland.

38 LOVE

Craig McDean
Me Company
© 2000

DESIRE

VISIONAIRE
No 9 · FACES
SUMMER 1993

VISIONAIRE

VOGUE

Metropolitan News

Vision Unbound, $10!

For something different in the way of fashion magazines, there is now Visionaire, a quarterly. The first issue came out this week. A witty look at fashion and art, it represents the personal vision of Stephen Gan, a 25-year-old former fashion editor of Details (until Condé Nast transformed it from a quirky downtown publication to a slick men's fashion magazine).

"I'm the editor, art director, layout person, messenger and janitor," Mr. Gan said. "One of the reasons I did this is to prove it's possible to do something if you have a vision, even if you have no financial backing."

And no advertisements, he might have said. The first issue of Visionaire, a limited edition of 1,000 numbered copies, consists of 80 unbound pages in a transparent envelope. The cover is a photograph of a rose by Mr. Gan, and the inside includes satiric artwork by Ruben Toledo, a portfolio of spring fashion by the photographer Bill Cunningham, poems and essays. Mr. Gan hopes to sell annual subscriptions for $40; meanwhile, copies of Visionaire at $10 each can be obtained by calling (212) 691-9282.

Stephen Gan's prototype for the first Visionaire.

A page from Stephen's sketchbook. Here, the funding for 1 SPRING is mapped out. The issue would cost $9,000 to produce. If every issue sold, we would just barely break even.

Photo for the cover of 1 SPRING. Cecilia Dean held the rose, and Stephen took the picture.

The New York Times, April 2, 1991. Visionaire's first press ever, an article by Anne-Marie Schiro about 1 SPRING, listed our home phone number. The phone started ringing at seven a.m. that day, and the issue sold out within two weeks.

Benjamin Liu, James Kaliardos, Ruben Toledo, Anneliese Estrada, and Isabel Toledo accordion-folding Ruben's contribution to 2 TRAVEL in our first "office," a two-room apartment on West 11th Street in New York City.

2 TRAVEL lands a spot in Vogue, which described us as a fashion journal that's "breaking all the rules." From the beginning, we received tremendous support from the press.

Precomputer layouts: Cecilia and Stephen gluing credits and silhouetting photos for Bill Cunningham's fashion report in 3 EROTICA.

We outgrow the apartment and assemble 4 HEAVEN at the Toledo studio with Anneliese, Jody Arias, James, and Cecilia.

Ruben and Isabel sewing his fashion saints series for 4 HEAVEN.

Elaine Gan, Greg Foley, and friends collating 5 THE FUTURE in the Toledo studio.

Razzia Bookstore windows featuring 6 THE SEA, which came in an accordion-fold format.

We outgrow the Toledo studio and move production to a factory in midtown. Greg Foley and Devanna Pagnowski packing issues of 6 THE SEA for subscribers.

Stephen and Ruben collaborate on a series of "shadow" images for 7 BLACK, featuring a dress by Isabel Toledo on model Teresa Stewart.

Greg and James eyeballing credits for 8 THE ORIENT.

James, Cecilia, and Stephen editing 9 FACES.

Bill Cunningham at work.

Cecilia, James, Greg, and Fumiaki Ishimitsu staring a white moment in our new all-white office in a carriage house on Watts Street. 11 WHITE is just around the corner.

Launch invitations for 9 FACES and 15 CINDERELLA.

Stephen Klein shooting for 11 WHITE. Jeremy Scott, fresh out of fashion school, appears fifth from the left.

Ruben with his hand-cut paper illustrations at the launch of 11 WHITE.

Invitations to the 12 DESIRE gallery launch and auction for DIFFA (Design Industry's Foundation Fighting Aids).

An invitation designed by Visionaire for the Summer this Séance.

Inez van Lamsweerde shooting model Leah in Anna Sui for the cover of 14 HYPE!

Visionaire provoked Raymond Meier with these fig prints, which he used to create his carriage scene for 15 CINDERELLA.

James, Cecilia, and Stephen at the launch party for 18 FASHION SPECIAL, at Mr. Chow, New York. Photo by Mario Testino.

An invitation designed by Visionaire for the Summer this Séance.

Spring Summer 1996 Hommina. Plus show features James asleep at the office. Stephen and James then modelled in the fashion show in Paris.

Liz Tilberis, James, Cecilia, Baroness, and Kerry Kenny working the blackjack table at the 21 Club during the launch party for 21 DECK OF CARDS. Photo by Patrick McMullan.

Our first book, Visionaire's Fashion 2000: Designers at the Turn of the Millennium, featuring Stella Tennant in Helmut Lang and Christian Dior Haute Couture, by Inez van Lamsweerde and Vinoodh Matadin.

A thousand people partied with Tom Ford and Gucci at El Flamingo in New York City for the launch of 24 LIGHT.

Wendy Juan, James, and Cecilia cutting the Versace gown worn by Madonna to the premiere of Evita. A piece of the gown was included as a 'Madonna relic' in each of the 5,000 issues of 22 CHIC.

Guest editor Mario Testino and the gogo boys at the launch of his issue, 22 CHIC. Photo by Roxanne Lowit.

Gogo boys showing copies of 22 CHIC 2000: Designers at the launch party in Paris.

The making of LIGHT, figuring out how to create a battery-operated publication.

Alexandre de Betak's computer rendering shows the transformation of Hervey Nichols in London for the launch party of 27 MOVEMENT.

Amanda Lepore greets James's father, Nicolas Kallantzis, at the masquerade ball for 26 FANTASY.

This novelty postcard, given to Stephen by Kate Moss for his birthday, provided the inspiration for the cover of 27 MOVEMENT.

Karl Lagerfeld enjoys the premiere issue of V, our bimonthly fashion magazine.

Visionaire's Fashion 2001: Designers of the New Avant-garde, featuring Shalom Harlow in Viktor & Rolf, by Inez van Lamsweerde and Vinoodh Matadin.

We 'go public' and move to our new offices, gallery space, and storefront at 11 Mercer Street in SoHo, New York, which used to be the Museum of Holography. Photo by Koichiro Shiki.

The birth of V, featuring actor Jude Law by Mario Testino.

Guests partied from midnight until five in the morning at the Opera. Photo by Mario Testino.

Exhibition in the Visionaire Gallery featuring the fan cards a half foot female torsos by Jorge Garcia. Photo by Jason Schmidt for 29 WOMAN contributor Beth B.

Herb Simons and Cecilia at the party hosted by Yves Saint Laurent and Colette for Visionaire's Fashion 2001: Designers of the New Avant-garde, at the Opera Garnier in Paris.

Midnight on the grand staircase at the Opera.

The Visionaire and V team poses for Self Service magazine. From left: Jake McCabe, Ethan Tirask, James, Cecilia, Stephen, Alix Browne, and Jorge Garcia. Photo by Jason Schmidt.

Exhibition in the Visionaire Gallery featured an Hermes rocking horse made from two miniature Kelly bags, an adult-size Chanel double stroller by Karl Lagerfeld, a Louis Vuitton toy boat, along with (not pictured) giant Missoni teddy bears, and a Fendi fur giraffe.

Exhibition in the Visionaire Gallery of Front Row Backstage, one of many book collaborations with Mario Testino.

Exquisite Corpse: Visionaire redesigns the surrealist game as a DVD and as an interactive installation at the Carlton Arts Festival in São Paulo, Brazil. From top: Nick Knight, David Sipper, and Craig McDean.

A thank-you illustration from Jean Louis Dumas, president of Hermes, for 32 WHERE?

Invitation to the launch party for 32 WHERE? Postcards were mailed to our friends around the world, who posted them back to Visionaire. The well-traveled postcards, complete with stamps and postmarks from other countries, were then resent as invitations to the party.

DJ Lady Bunny gets down with guest Peter Bici at the 32 WHERE? launch party in New York City.

Invitation to the launch party of 31 VREELAND MEMOS at the Carlyle Hotel. Each key was dabbed with red nail polish à la Diana Vreeland.

Veruschka and Marisa Berenson host the celebration of 31 VREELAND MEMOS along with Alexander Vreeland. Photo by Rebecca Greenfield.

Stephen's fan from India showing the original inspiration for 36 LOVE.

Karl, Stephen, and Herb barbecuing at their 'Café Society' party, after Stephen received the Creative Visionary Award from the CFDA (Council of Fashion Designers of America). Photo by Tatiana Gaz.

David Bowie and Iman pay a visit to Visionaire. From left: Stephen, Iman, James, Greg, Cecilia, Ethan, David Bowie, Dario Stewart, Terence Koh, Young Kim, Alessandro Magania, Jake, and Alix.

'Dreaming in Print: A Decade of Visionaire,' at the Museum at the Fashion Institute of Technology, in New York City.

Exhibition for 31 BLUE contributor Mario Miura at the Visionaire Gallery.

Visionaire is a publication created (and still being produced)
by STEPHEN GAN, CECILIA DEAN, and JAMES KALIARDOS.
The book DREAMING IN PRINT was edited by the trio.

Special thanks to KARL LAGERFELD
and GERHARD STEIDL and his team for helping us realize this dream in print.

managing director ELAINE GAN
art direction / book design GREG FOLEY
production JAKE MCCABE TENZIN WILD
text ALIX BROWNE
Visionaire team ANNE WARNOCK JAMES VANCE FLORENTINO PAMINTUAN GIORGIO PACE
TICOY INFANTE KATHRYN GRACEY DOVANNA PAGOWSKI FUMIAKI ISHIMITSU KAREN PARK-GOUDE
global communications JORGE GARCIA
design associate JASON DUZANSKY
design assistants DANKO STEINER TATIANA GAZ AOIFE WASSER FLORE BOTTARO JOAN COSTES MIDORI MATSUO
editorial assistants CHRISTOPHER BOLLEN PATRIK ERVELL LINDSAY THOMPSON EMILY ROSS YUKIKO KUSANO
MIHO MOCHIZUKI REBECCA SONKIN GREG ALLEN
copy editor LAUREN NEEFE

creative team ALESSANDRO MAGANIA ZEKE MOON JOHNSON CARA S. KEPPNER BRIAN PHILLIPS HUW GWYTHER
PAUL DAVIES PIERRETTE KIM SONIA PHILLIPS PIERRE CONSORTI MISSY LEVIN SANDRA GARCIA BEN SEIBEL
JOHN MISERENDINO JOAKIM ANDREASSON JOHANNA MASTERS OLYA TITOVA KRISTALL RICHARDSON
SEAN EALEY TERENCE KOH MAUREEN MEYER ABBI STERN PHILLIP DUNCAN DARREN SCHOPPERLE

thanks to BILL CUNNINGHAM ISABEL & RUBEN TOLEDO MAREAN ROMUALDEZ POMPIDOU NEALE ALBERT
ANNELIESE ESTRADA LITA BOSSERT TOMOMI ISHIMITSU GREGORY PARK HEIDI BLACK THELMA BRUSSEL
ALEXANDRE DE BETAK SABISHA FRIEDBERG LEE ANN KAZAN PASCAL NARBONI RAJA SETHURAMAN GIOVANNI TESTINO

all still-life photography DAN FORBES

cover photography Inez van Lamsweerde and Vinoodh Matadin
makeup Pat McGrath hair Jimmy Paul
lighting Jodokus Driessen printing Pascal Dangin at Box
model Angela Lindval

Copyright © 2002 Edition 7L, Paris for this edition
scanning Steidl's digital darkroom printing Steidl, Göttingen
distribution Steidl Düstere Strasse 4 D-37073 Göttingen
tel +49.551.49.60.60 fax +49.551.49.60.649 mail@steidl.de

ISBN 3-88243-819-3
Printed in Germany